Art Doine's
CAMERA WORKSHOP

*All About*
*35mm Photography*

**Other Books Written and/or Photographed
by Michele and Tom Grimm:**

*The Basic Darkroom Book*
*The Basic Book of Photography*
*Florida*
*Bruce and Chrystie Jenner's Guide to Family Fitness*
*Hitchhiker's Handbook*

AND THESE CHILDREN'S BOOKS:

*My Brown Bag Book*
*What Is a Seal?*
*What I Hear*
*Twisters*
*Can You Walk the Plank?*

# All About
# 35mm Photography

A Complete Guide to Choosing and

Using 35mm Cameras and Equipment

## by Michele and Tom Grimm

With photographs by the authors

MACMILLAN PUBLISHING CO., INC.

New York

Dedicated, with love,
to Helen Hannan

Copyright © 1979 by Tom Grimm and Michele Grimm

Macmillan Publishing Co., Inc.
866 Third Avenue, New York, N.Y. 10022
Collier Macmillan Canada, Ltd.

Library of Congress Cataloging in Publication Data
Grimm, Michele.
  All about 35mm photography.
    1. Miniature cameras.  2. Photography—Handbooks,
manuals, etc.  I. Grimm, Tom, joint author.
II. Title.
[TR262.G72    1979b]        770'.28        78-31455
ISBN 0-02-545750-0

First Printing 1979

Designed by Jack Meserole

Printed in the United States of America

# CONTENTS

Diffusion/Filter; Flash Bracket; Remote Automatic Sensor; Tilting Head; Automatic Exposure Signal; Open Flash Button; Angle of Illumination; Wide-Angle/Telephoto Flash Attachments; Zoom Flash Head; Filter Attachments; Slave Units; Ring Light; Flashbulbs; Synchronization Test

## 6 Accessories for 35mm Cameras

## ACKNOWLEDGMENTS

The authors wish to thank the numerous camera and equipment manu-
facturers and distributors for their cooperation in providing up-to-date
information about various photographic products, with special gratitude
to Canon, Nikon, and Olympus for loaning us new camera models for
field testing.

We also wish to thank the following companies and organizations
which provided some of the illustrations appearing in this book on the
pages indicated: Pennsylvania Dutch Tourist Bureau, 2; Minolta Corp.,
4, 73, 176; Rollei of America, Inc., 8; Pentax Corp., 9, 31; Canon
USA, Inc., 28; Olympus Camera Corp., 17; Canadian Government
Office of Tourism, 20, 44, 85, 135, 149, 219; E. Leitz, Inc., 5, 21;
Nikon, Inc., 25, 81; Grand Teton Lodge Co., 82; Bahamas News
Bureau, 139; EPOI, Inc., 142, 165; Eastman Kodak Co., 177; Ken-
tucky Department of Public Information, 205 (top); San Diego Con-
vention and Visitors Bureau, 205 (bottom); Rock City Gardens, Tenn.,
207.

There are as many types and brands of cameras as there are automobiles, and like the car makers, camera manufacturers offer an immense variety of options and accessories. Faced with boastful ads in photography magazines and shelves of shiny cameras in photo stories, you may find it difficult to make an intelligent choice of photographic equipment.

"What kind of camera should I buy?" is the one question that professional photographers, photography instructors, and camera store salespersons are asked again and again. There are no easy answers. In fact, the questioner must first explain what type of photography he or she intends to do.

If architectural photography is your special interest, a view camera would be a good choice because it features controls that will overcome distortion and depict buildings just as you see them. If you only want to record family and seasonal events, such as birthdays and Christmas, then an Instamatic-type camera with flash is ideal, or a Polaroid-type camera, if you want to have the pictures immediately. For travelers who like to show slides of their vacation trips, a versatile 35mm camera is the best choice. For anyone interested in fashion photography, cameras with a large film format, such as $2\frac{1}{4}\times2\frac{1}{4}$-inch or $6\times7$ cm, are appropriate choices.

Amateurs who are beyond the snapshot stage, and professional photographers in general, have settled on one kind of camera that is their favorite—the 35mm. The name, by the way, refers to the width of the film used in such cameras.

The 35mm camera emerged in 1913 when Oskar Barnack, a design engineer at the E. Leitz company in Germany, created a still camera, the original Leica, that could use existing 35mm movie film. Because

sprocket holes run along both edges of 35mm film, the actual image area of a negative or transparency made with a 35mm still camera measures 24×36mm.

Deciding to purchase a 35mm camera is one step, but choosing the best brand and model is like entering a maze, because there are so many alternatives. This book presents a detailed discussion of the features to be found on 35mm cameras, lenses, and accessories, and offers guidelines to help you select the camera and equipment that are ideal for your purposes. It also presents, with illustrations, many of the basic and creative photographic techniques you can use with 35mm cameras and equipment.

*All About*
*35mm Photography*

# 1
## Components of 35mm Cameras

Many photographers are apprehensive when they purchase a 35mm camera because they want to be sure of getting the latest model. "That's always a problem," a salesman for a well-known camera manufacturer told us. "We bring out new models of 35mm cameras every year, which means most people's cameras will already be obsolete a few months after they buy them.

"Most years the model changes are minor," he confided, "although our ads are designed to make readers think the improvements are major and will make a difference in the quality of their photography."

The idea, of course, is to sell more cameras. Such full-page come-on ads certainly excite the considerable number of photo hobbyists who are "equipment freaks" and consider buying any new camera model or photographic gadget. They seem to think of cameras as toys rather than as useful tools for taking pictures.

Recently, however, there have been some *significant* changes in 35mm cameras. There are now enough improvements to make most camera owners, amateur and professional, consider whether they should replace their present equipment.

One trend is toward more compact 35mm cameras, which means they are lighter, less bulky, and more convenient to use.

Another switch is to automatic exposure, utilizing the camera's built-in exposure meter to electronically set the shutter speed or lens aperture (or both) with amazing accuracy.

Also, new light-sensitive cells, called photo diodes, have been developed which offer improved camera exposure metering systems, especially under low light and rapidly changing light conditions.

Auto winders and motor drives, which make the camera instantly ready for the next shot by automatically advancing the film and cock-

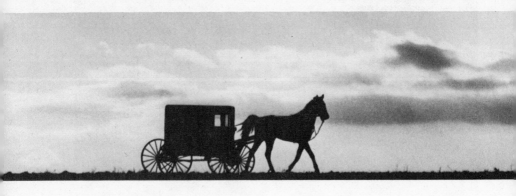

ing the shutter, are being offered as built-in or accessory features on more and more 35mm cameras.

A special control for making multiple exposures also is being included on an increasing number of models, allowing photographers additional ease in making creative pictures.

These and a variety of other features, from mirror lock-ups to hot shoes for camera-coupled automatic electronic flash units, are found on some 35mm cameras and not on others. Prospective camera purchasers also are faced with a lot of manufacturers' abbreviations that may be confusing, like CdS, CLC, LED, FP, GPD, and so on. To help you understand and keep track of the various features to consider when buying a 35mm camera, we've made a checklist. The topics listed below will be discussed in detail in this and the following chapters.

## Checklist for 35mm Cameras

TYPE
  Single-lens reflex (SLR)
  Rangefinder

SIZE AND WEIGHT
  Compact
  Standard
  Miniature

EXPOSURE SYSTEM
  Automatic
    Aperture-priority
    Shutter-priority
    Multi-mode

Manual
  Light-emitting diodes (LED)
  Match needle

EXPOSURE METER TYPE
  Silicon (SPD)
  Gallium (GPD)
  Cadmium Sulfide (CdS)
  Selenium

METER READING
  Center-weighted
  Overall averaging (integral)
  Spot (selective)

Regardless of the brand or model of camera, a photographer must thoroughly understand its operation to make eye-catching images, like the silhouette shown here.

SHUTTER TYPES AND MATERIALS
Leaf-type
Focal plane
Cloth
Metal
Metal foil

SHUTTER SPEED CONTROL
Automatic
Manual
Electronic
Mechanical

APERTURE CONTROL
Automatic
Manual

FOCUSING MECHANISM
Fine or coarse focusing screen
Microprism spot
Microprism collar
Split-image rangefinder
Interchangeable screens
Rangefinder
Auto-focus

VIEWFINDER
Fixed
Interchangeable

VISIBLE EXPOSURE INFORMATION
(VIEWFINDER READOUT)
Needle
Light-emitting diodes (LED)

Aperture
Shutter Speed
Over-/underexposure
Automatic/manual mode
Flash ready signal

LENS MOUNT
Bayonet
Screw

FLASH USE
Socket(s)
Hot shoe
Synchronization switch
X, M, FP
Automatic exposure

MOTOR DRIVE
Accessory
Built-in

AUTO WINDER
Accessory
Built-in

CAMERA FEATURES
Automatic exposure override
Exposure compensator
Film speed (ASA) dial
Depth of field preview
Battery check
Multiple exposure control
Shutter release lock
Self-timer

A recent revolution in 35mm camera design is responsible for the introduction of more compact models with sophisticated automatic exposure controls. Many models accept new accessories, like auto winders (attached to the bottom of the camera) to instantly advance the film and cock the shutter, and camera-coupled automatic electronic flash units.

CAMERA FEATURES (*Cont.*)
   Mirror lock-up
   Film load indicator
   Film transport indicator
   Film type indicator

Viewfinder eyepiece cover
Viewfinder light
Interchangeable backs
CAMERA SYSTEMS AND ACCESSORIES
COST

## Camera Types—Reflex and Rangefinder

There are two types of 35mm cameras: reflex and rangefinder. Basically, those terms refer to different viewing systems. The first 35mm cameras were of the rangefinder type, but the most popular type today is the reflex. More properly it is called a SINGLE LENS REFLEX, commonly abbreviated SLR. Some cameras that use a larger film format, such as $2\frac{1}{4} \times 2\frac{1}{4}$, are known as TLRs, twin lens reflexes.

With a SLR, a single lens is used to transmit the subject to the photographer's eye and to the film. When viewing, light rays pass through the lens, then reflect off a mirror into a pentaprism that inverts the image so the photographer sees it right side up in the viewfinder.

When shooting, the shutter release button is pressed to open the shutter and the mirror flips out of the way, momentarily blocking the photographer's view while allowing the light rays to be transmitted by the same lens to the film. After the exposure, the shutter closes and the mirror returns to its original position for viewing. (See diagram, page 5.)

With a rangefinder camera, there are two lenses: one transmits light rays to the viewfinder for the photographer's eye, and the other transmits light rays to the film.

A single lens reflex has a number of advantages over a rangefinder

As shown in this cut-away diagram of a 35mm single lens reflex camera, light rays passing through the lens reflect off a mirror into a pentaprism, where the image is turned right side up for viewing by the photographer. When the shutter release button is pressed, the mirror flips up out of the path of the light rays so they can reach and expose the film at the rear of the camera.

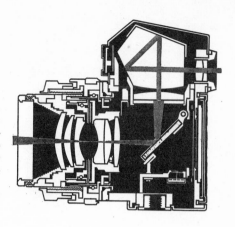

With 35mm rangefinder cameras, the photographer views the subject through one lens, while another lens transmits the subject to the film. (Another windowlike opening is part of the rangefinder mechanism for focusing the subject.)

**Left** In this close-up picture, made with a rangefinder camera, the flower is not properly framed because of parallax error—the viewfinder showed the subject from a different angle than the main lens. **Right** To avoid cutting off the top and left side of the flower, the photographer compensated for parallax error by carefully aiming the camera lens to frame the full subject.

camera. Of major importance is the fact that the photographer's eye sees exactly what the film sees, because the same lens is used for viewing as well as for filming the subject.

Rangefinder cameras will do a good job of portraying the subject on film as the photographer views it, except when close-ups are involved. That's when PARALLAX ERROR is likely to occur. Because the lens that shows the subject to the photographer is not in the same position as the lens that transmits the subject to the film, the subject as framed in the viewfinder will not be seen in its entirety by the filming lens when a rangefinder camera is very close to the subject. This means PARALLAX CORRECTION (i.e., reframing) is required when shooting close-ups, or part of the subject will be cut off in your picture. Leicas are an exception; as the lens is focused, a framing mask in the viewfinder adjusts to correct for parallax, so you see exactly what the film will record.

Another reason single lens reflex cameras are more popular than rangefinder types is that the lenses on SLRs can be changed. You can easily switch from a normal to a wide-angle or a telephoto lens. A rangefinder camera, however, has a permanently mounted normal lens. Again, Leicas—and some Minolta rangefinder models—are exceptions. Even when lenses can be interchanged on rangefinder cameras, the image size of the subject seen in the viewfinder remains the same, regardless of the lens attached. An accessory viewfinder is required to produce an image that is the same size as the image being recorded by the film. When lenses are changed on a SLR, the image the photographer sees in the viewfinder is the same size as the image the film will record.

In most cases, the shutters on rangefinder cameras are built in the

permanently mounted lenses, and their mechanical design of over-lapping metal blades (i.e., leaf-type shutters) limits the maximum shutter speed to 1/500 second, or slower. These speeds may not be quick enough to stop fast action, such as you find in sports photography.

Single lens reflex cameras, on the other hand, have their shutters built into the camera body, and their design (i.e., focal plane shutter) permits speeds as fast as 1/1000 or 1/2000 second—quick enough for stop action photography.

Built-in exposure meters are common on many rangefinder models, but often they are less sensitive or exacting in their light readings than the through-the-lens exposure meters incorporated in SLR cameras.

Are there *any* advantages that rangefinder cameras have over single lens reflex cameras? Yes—the most notable being their smaller size and lighter weight, quieter operation, and the fact that rangefinder cameras cost less than SLRs. When compared to the newer COMPACT SLRS, however, the size and weight of regular rangefinder cameras are no longer special advantages. No wonder that the modern compact SLR has become the most popular of all 35mm cameras. It's small, versatile, and offers accurate electronically-controlled exposures.

However, mention must be made of a new breed of MINIATURE 35MM RANGEFINDER CAMERAS that are tiny, light, and sophisticated. Advertisements have compared the size of some of them to two 35mm film boxes. An example is the Minox 35EL, which measures $4 \times 2\frac{1}{2} \times 1\frac{1}{4}$ inches (add 2 inches when the lens is opened out for use), weighs 7 ounces, and features aperture-priority automatic exposure.

Another is the Rollei LED, which is a pocket-size $4 \times 3 \times 2$ inches with its lens collapsed, weighs 8 ounces, and has a built-in meter for LED readout manual exposure control. The remarkable thing, con-

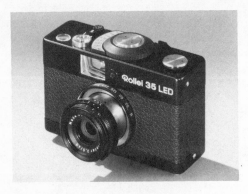

Miniature 35mm rangefinder cameras are extra small and lightweight but still cover a full-size frame of 35mm film.

sidering their size, is that these and other miniature 35mm rangefinder cameras shoot full-frame images. The limitation with such cameras is that their lenses are permanently mounted and cannot be changed to wide-angle or telephoto types.

There are other small cameras that also use 35mm film, but they do not produce the full 24×36mm image size. These are called HALF-FRAME CAMERAS, and they take pictures that are one half the size of standard 35mm images. Because the half-frame image area measures 18×24mm, twice as many pictures can be made on a roll of film. The three standard lengths of 35mm film produce 20, 24, or 36 exposures, but they yield 40, 48, or 72 exposures when used in a half-frame camera. Half-frame cameras are used by budget-minded people who want snapshot size prints or a single-copy filmstrip. For a filmstrip, the camera must be used vertically. Each image is shot in sequence on color transparency film, which must be returned by the processor uncut and unmounted.

## Camera Size and Weight—Compact, Standard, Miniature

The size of a camera has always been important to photographers. Before the 35mm camera arrived, light-sensitive plates and sheet films were common, and large. They measured 8×10, 5×7, or 4×5 inches, and cameras had to be big enough to accommodate them. Even roll films for less cumbersome cameras measured at least 2¼ inches in width. Until more sensitive and finer grain films evolved, photographers required large negative sizes in order to get sharp, high quality prints.

As films and chemical processes improved, so did the technical quality of pictures taken with 35mm cameras. Photographers, including

Single lens reflex (SLR) cameras are easy to identify because there is a hump on top—it's the pentaprism that enables the photographer to see through the single front lens.

professionals, began to switch to these convenient, lighter weight cameras. Photojournalists especially favored them, because they no longer had to lug around bulky 4×5 press cameras with cases or pockets full of film holders.

Newer metal alloys and plastics permitted construction of even lighter 35mm cameras. Now solid state electronics are replacing mechanical components, making it possible for manufacturers to shrink the size of 35mm cameras.

The newest array of 35mm SLR cameras are compact, and normally they feature electronically-controlled automatic exposure. The leader in small size SLRs was the Olympus OM-1, and it was followed by Pentax, Konica, Nikon, and Canon models. Still present, of course, is the telltale sign of a single lens reflex camera, the necessary hump on the top of the camera that is the pentaprism required for through-the-lens viewing. However, the overall SLR camera size has been significantly reduced to match or beat the size of 35mm rangefinder cameras, except the miniature full-frame models previously mentioned (see page 7).

Because of improved optic designs aided by computer formulas, many of the lenses made for compact 35mm SLRs have been reduced in length and diameter and contribute to the camera's streamlining.

While small size is an attractive feature, particularly if you are like the increasing number of photographers who carry more than one camera at a time, an important consideration is the camera's weight. Even compact models can be heavier than they look.

For an honest comparison of models, you must weigh the camera body and camera lens separately. The weight of camera bodies for compact 35mm cameras ranges from slightly less than 1 lb (460

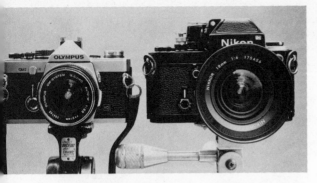

In addition to sizes of camera bodies, critical comparison of SLR compact (left) and standard (right) models should include their weights, lenses, and various features.

grams) to 1¼ lb. The weight of lenses varies according to the design and the number of optical elements. A wide-angle lens usually is lighter in weight than a normal lens, and a normal lens is lighter than a telephoto lens. Also, the wider the maximum lens opening, the heavier the lens.

For instance, compare 50mm (normal) lenses available for Pentax compacts. The lens with the widest aperture, f/1.2, weighs 13.5 ounces (385 grams), while the f/1.7 lens weighs half as much—6.5 ounces (185 grams). The f/1.4 is in between, weighing 8.4 ounces (240 grams).

In practical terms, the f/1.2 is the best choice if you will be doing a *significant* amount of shooting under low light conditions, because it is one full f/stop greater than the f/1.7 lens and lets in twice as much light. (See page 14, where a discussion of f/stops begins.) However, for general photography, the f/1.7 lens is more than adequate for proper exposures; besides, it is half as heavy and half the price of the f/1.2.

## Camera Exposure Systems—Automatic and Manual

The heart of modern 35mm cameras is their built-in exposure systems. Using a hand-held exposure meter with a 35mm camera is more the exception than the rule these days. Not only do most SLRs feature built-in meters that read the light coming through the lens, but many of them also automatically determine the exposure by electronically controlling the lens aperture or shutter speed.

Whether the exposure is set automatically by the built-in meter system, or manually by the photographer, the camera's FILM SPEED DIAL

**Top** On many single lens reflex cameras, the shutter speed dial is located on top of the camera body. Some models, like the one shown, incorporate the film speed dial, too. It must be set for the ASA (film speed) of the film in the camera in order to calibrate the built-in exposure meter. Here the film speed dial is set at ASA 100; the shutter speed dial is set at 1/125 second. **Bottom** On most rangefinder cameras, the shutter speed dial is located on the main lens. Also found on the lens is the film speed dial to calibrate the camera's built-in exposure meter for the speed (ASA) of the film you are using. As with the SLR camera, this rangefinder camera also has its film speed dial set at ASA 100 and the shutter speed dial set at 1/125 second.

must be set to the ASA number of the film being used. This adjusts the meter so it will make the correct exposure or give the correct exposure reading. (The ASA number indicates the relative sensitivity of a film and is also called the *film speed*—see page 34.)

Exposure is determined by adjustment of two controls: shutter speed and lens aperture. The shutter speed determines *how long* light is allowed to strike the film, while the aperture determines *how much* light is allowed through the lens.

Mechanically-set shutter speeds are indicated on a dial by numbers that are fractions of a second. The SHUTTER SPEED DIAL on SLR cameras is most frequently found on top of the camera. On a few models, such as Nikkormat and Olympus OMs, it is a ring on the front of the camera that surrounds the lens mount. Some shutter speed dials also incorporate the film speed (ASA) dial.

On SLRs, shutter speeds usually range from 1 second to 1/1000 second, with each speed reducing the previous speed by one half. Standard shutter speeds are 1, 1/2, 1/4, 1/8, 1/15, 1/30, 1/60, 1/125, 1/250, 1/500, 1/1000 second. A few cameras have speeds as short as 1/2000 second.

On cameras with shutters that are controlled electronically instead of mechanically, actual speeds vary according to the exposure reading and are automatically set on or anywhere in between the standard speeds. In addition, longer exposures of 2, 4, 8, or 16 seconds can be determined automatically or can be set manually on the shutter speed dial. A few models will hold the shutters open automatically for as long as 30 or 60 seconds.

On all SLRs and on some rangefinder cameras is another shutter position, marked "B," which is used for manually-controlled time ex-

Shutter speeds control how long the light registers on the film, and the speed you choose affects the way action is shown in your picture. A slow speed allowed the water spray to blur slightly and adds to this photo's impact.

posures. When the dial is set to "B," the shutter remains open for as long as the photographer depresses the shutter release button. (A locking CABLE RELEASE can be screwed into the shutter release button to open the shutter and avoid camera movement that might be caused by the photographer holding in the button during a time exposure.)

On a few shutter speed dials you may notice a "T," which is another setting for time exposures. In the "T" position, when the shutter release button is pressed, the shutter remains open until the shutter release is pressed a second time; you do not have to keep the shutter release depressed in order to keep the shutter open.

The "B" rather than the "T" control is found on current models of 35mm cameras, except that some Nikon cameras have both designations. The letter "B," by the way, is an abbreviation for "bulb" and goes back to the early days when photographers squeezed a rubber bulb to open the shutter by forcing air through a rubber hose. When set to "B," the shutter would stay open for as long as the photographer squeezed the bulb.

Another designation on some shutter speed dials is "A," or "AUTO," which refers to "automatic" and is the proper setting when you want the camera's metering system to set the shutter speed automatically. An "A" or "AUTO" on the shutter speed dial means the camera has APERTURE-PRIORITY AUTOMATIC EXPOSURE CONTROL; you set the lens aperture (f/stop), and the camera automatically sets the shutter speed for the proper exposure.

The shutter speed dials of 35mm SLRs have another designation, "X," or one of the shutter speed numbers that is a different color (usually red). This indicates the *maximum* shutter speed that can be used with electronic flash. The shutter must be fully open when the

The lens aperture (f/stop) determines how much light is allowed through the lens. This lens opening is adjusted to help control the darkness or brightness of your picture and the amount of picture area that will be in sharp focus.

flash goes off, which is called FLASH SYNCHRONIZATION, or else the film will be only partially exposed.

Because of the shutter design in 35mm single lens reflex cameras, the fastest shutter that can be used with electronic flash is frequently 1/60 or 1/125 second; some models have special "in-between" synchronization with speeds for electronic flash, such as 1/80, 1/90, or 1/100 second. Read the camera's instruction booklet to learn the specific shutter speed for "X" (electronic flash) synchronization. Note that an electronic flash will be properly synchronized also when the shutter is set at speeds *slower* than the one designated "X."

The shutter speed control for 35mm rangefinder cameras (except Leica) normally is a ring that is part of the permanently attached camera lens.

In addition to shutter speed, another exposure control on any camera is the lens aperture, or opening, which might be compared to the iris of your eye. The size of the opening is adjusted by a ring that encircles the lens. The relative sizes of lens openings are indicated by a series of numbers called F/STOPS. The smaller the number, the wider the opening.

There are standard f/stop numbers, although all lenses do not necessarily have the full range: f/1, 1.4, 2, 2.8, 4, 5.6, 8, 11, 16, 22, 32, 45, 64. The f/stops with decimals are referred to as one point four, two point eight, etc., or without reference to the decimal point, such as two eight, five six, and so on.

The *maximum* f/stop opening varies considerably from lens to lens. Normal lenses usually have the widest maximum apertures, which means they let in the greatest amount of light. Frequently the widest opening on a normal lens is not a "standard" f/stop number. Instead,

it may be f/1.2, 1.7, 1.8, or 1.9. Most commonly, the smallest f/stop on a normal lens is f/16 or f/22.

Besides the range of f/stop numbers on the aperture ring, there may be an "A" or "EE" marking, which refers to "automatic" or "electric eye." When an "A" or "EE" is found on the aperture ring of a lens, it means the camera has SHUTTER-PRIORITY AUTOMATIC EXPOSURE CONTROL; you set the shutter speed and the camera automatically sets the lens aperture (f/stop) for the proper exposure.

Don't be confused by other "A"s that may appear on the body of a camera or lens, particularly an "A" that is on or by a switch that has nothing to do with automatic exposure control. Some camera models have built-in metering systems that give you a choice of switching between Averaging ("A") or Spot ("S") exposure readings (see page 19). Some lenses require you to switch to an "A" or "M" for automatic or manual adjustment of the lens aperture (see page 36).

There are a few advanced models of 35mm cameras that offer MULTI-MODE AUTOMATIC EXPOSURE CONTROL. Minolta was the first, introducing in 1977 a SLR compact model, the XD11, which gave the photographer the choice of switching to aperture-priority (A) or to shutter-priority (S) for automatic exposures, or to the manual (M) mode.

Following right behind was Canon with its A-1 multi-mode model, which offered a choice not only of aperture-priority (Av) or shutter-priority (Tv), but also PROGRAMMED (P) AUTOMATIC EXPOSURE CONTROL. The programmed mode takes over exposure decisions completely, automatically setting the shutter and aperture combination that is correct for the amount of light being read by the camera's metering system. In sudden shooting situations, this lets the photographer concentrate

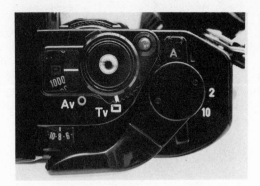

Canon's A-1 multi-mode automatic exposure model can be set for aperture-priority (AV = Aperture value) or shutter-priority (Tv = Time value). When in the shutter-priority mode, as shown here, the shutter speed dial can be set to "P" (Programmed) to let the camera make all the exposure decisions.

on the action or composition instead of spending the time to adjust exposure settings.

Besides these three automatic exposure selections, and a manual exposure mode, the Canon A-1 will automatically figure exposure when one of the special, compatible electronic flash units is inserted in the camera's hot shoe (which holds the unit and makes the necessary electrical connections). This automatic flash exposure feature is increasingly common with any camera system that has automatic exposure control, whether aperture-priority, shutter-priority, or a multi-mode type.

While the trend in 35mm cameras is to automatic exposure systems, most all models also allow you to select the exposure *manually* by switching from "A" or "AUTO" to the desired shutter speed and lens aperture. Information regarding exposure selection is presented inside the viewfinder on *both* automatic and manual exposure cameras. It may be a needle that fluctuates according to the amount of light being read by the built-in exposure meter, or a series of light-emitting diodes (LEDs) that blink on and off or give a digital reading of the f/stop and shutter speed numbers.

With the most common LED SYSTEM, a row of diodes, you adjust the aperture or shutter speed until the center diode glows to indicate proper exposure. If another diode along the scale lights up, it indicates either over- or underexposure.

With the so-called MATCH-NEEDLE SYSTEM, you turn the shutter speed dial or aperture ring until a needle is aligned with another needle or with index marks in the viewfinder. If the needle is not matched or set within those marks, it indicates either over- or under-exposure.

The honeycombed light receiver around the lens identifies this rangefinder camera as having a batteryless selenium exposure meter.

## Types of Camera Exposure Meters

Current models of all 35mm cameras have built-in exposure meters, but they vary according to the type of light-sensitive cell. These include selenium, cadmium sulfide, silicon, and gallium arsenide phosphide.

The first type of camera meter was the SELENIUM CELL, and it is used in very few of today's 35mm cameras. The reason is that its sensitivity is much less than that of modern metering cells. Also, the selenium meter does not read the light coming through the lens; it usually features a honeycombed light receiver on the front of the camera body or lens. One advantage of a selenium meter is that it requires no batteries to operate.

The introduction of the CADMIUM SULFIDE CELL (cds) permitted many improvements in 35mm cameras, and it continues to be popular in some metering systems. For the first time, it allowed readings of the light coming through the camera lens, which gave more accurate exposure information. Especially important was the CdS cell's greater sensitivity.

At least two problems with CdS cells are apparent. When exposed to very bright light, it may take a minute or so for the cell to lose its memory of the bright light and make accurate readings in dim light. Also, CdS cells are not equally sensitive to all colors and may give inaccurate readings when certain filters cover the lens, especially red ones.

CdS meters require a small battery to operate. In cold weather, particularly at freezing temperatures, the battery becomes sluggish and can cause inaccurate readings.

The latest in metering cells are photo diodes, which eventually will supersede the use of selenium and CdS cells. Currently the most popular types incorporated in cameras are SILICON PHOTO DIODES (SPD) and GALLIUM PHOTO DIODES (GPD).

Most importantly, they do not suffer bright light "memory" as do CdS cells. This means photo diodes are superior for use in cameras with automatic exposure systems because they immediately adjust to extreme changes in light conditions. In addition, they give accurate readings when filters of any color are on the camera lens.

The gallium arsenide phosphide cell developed by Asahi Optical Company for Pentax cameras is supposed to be superior to silicon and silicon blue cells in regard to operation at hot and cold temperature extremes. Generally, however, cell response is a matter of temperatures affecting the *batteries* that power the GPD and SPD cells (when battery technology improves, so will the accuracy of all metering cells used at extreme temperatures).

The size, number, and voltage of batteries vary considerably, depending on the number of metering cells and whether the camera has an automatic exposure system. One-cell CdS nonautomatic cameras often require only a single, fat, dime-size 1.5 volt battery, while some automatic SPD-equipped cameras require larger 6-volt batteries. Battery life also varies according to type and use; light-emitting diodes (LEDs) can cause considerable battery drain, as can automatic exposure systems unless they are turned off when not in use. Read the camera operation booklet thoroughly regarding battery type, placement, and expected life. Just to play it safe, many photographers carry spare batteries in their gadget bags.

Regardless of the type of cell used for built-in meters, cameras make

different types of exposure readings. These are overall readings (sometimes called averaging or integral readings), spot readings (also called selective readings), and the current trend, center-weighted readings.

The first through-the-lens meters made OVERALL READINGS. This means everything you see in the viewfinder is read by the meter and gives an average exposure for the overall scene or subject.

SPOT READINGS limit the meter's coverage to a certain portion of what you see in the viewfinder. Frequently this is the area covered by the focusing circle. Whatever part of the scene or subject is in that spot is read by the meter. By measuring light in limited areas, you can make very accurate readings without moving closer to the subject. Separate readings can be taken from camera position of the bright (highlight) and dark (shadow) areas in your composition, which you then average for the best exposure. Also, a spot meter can be aimed so it covers equal portions of bright and dark areas to give a direct average exposure reading.

Some cameras have a switch that allows the photographer to select either an overall or spot reading. This permits considerable versatility in making accurate meter readings. For instance, if your subject is backlighted, a spot meter can avoid reading the light shining toward the camera. With an overall meter reading, unless you get closer to fill the viewfinder with your backlighted subject, the light shining toward the camera will give a reading that will make your subject underexposed.

For cameras with automatic exposure systems, the favored metering method is a CENTER-WEIGHTED READING. This type gives emphasis to the subject that is in the middle of your picture, but it also reads everything else in the viewfinder. The specific degree of meter sensitivity in

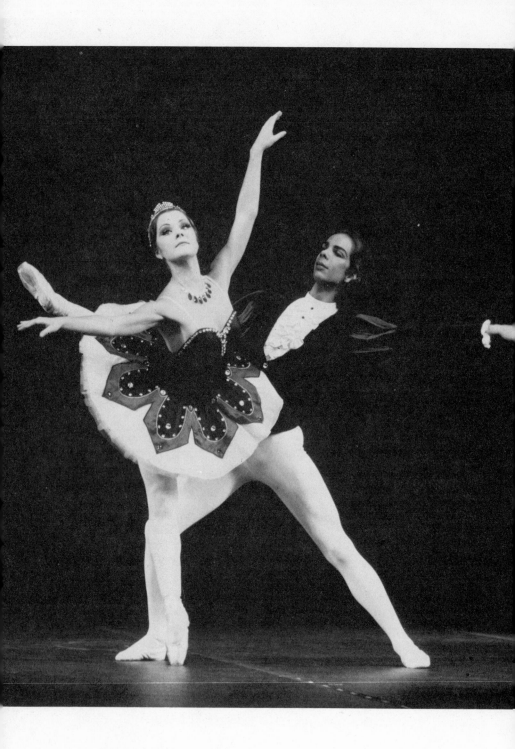

**20** COMPONENTS OF 35MM CAMERAS

With a spot meter you can make pinpoint exposure readings in the subject area. If an overall reading was made for this picture, the meter would be influenced too much by the dark background and would result in the dancers being overexposed.

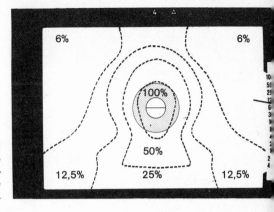

To show the design of its center-weighted metering system, some SLR cameras include a diagram of the focusing screen in the instruction manual that indicates how much the various areas influence the meter reading.

various areas of the viewfinder depends on the manufacturer's arrangement of meter cells in the camera.

Some camera instruction booklets present a diagram of the center-weighted coverage, and some camera models have a circle or index marks on the focusing screen to indicate the central area that influences the reading most. Experience with your particular camera will reveal the design and extent of its center-weighted metering, and you will learn how to aim the camera for the most accurate exposure readings.

## Shutter Types and Materials

There are two types of shutters: focal plane and leaf. LEAF-TYPE SHUTTERS are found on most rangefinder cameras in their permanently-attached lenses. These are mechanical, spring-operated metal leaves that overlap to prevent light from striking the film. When the shutter release button is pressed, the leaves open to make the exposure. Because of their mechanical design, they are limited in making short exposures, with 1/500 second the fastest shutter speed possible. On some rangefinder cameras, the maximum shutter speed is 1/250 second.

FOCAL-PLANE SHUTTERS are found in all current 35mm single lens reflex cameras (and Leica rangefinder cameras). They are metal blades or curtains of opaque cloth or metal foil that are located in the camera body just in front of the film. They travel in a horizontal or vertical direction and are capable of speeds up to 1/2000 second.

Focal plane shutters actually "paint" the film with light, because there are two curtains or sets of metal blades that travel, one after the

other, across the plane of the film. The shutter speed determines the delay between the moment the first curtain or set of blades opens and the moment the second curtain or set of blades follows it.

## Shutter Speed Controls

There are two kinds of shutter speed controls, automatic and manual. Automatically operated shutters are electronically controlled, while manually operated shutters may work mechanically or electronically.

For shutters with automatic control, you turn the shutter speed dial to "A" or "AUTO." After you select the lens aperture (f/stop) you want to use, the camera's light meter electronically sets the shutter speed for the proper exposure.

One problem with most electronically controlled shutters: If the camera batteries go dead, the shutter will not operate. In case this happens, some cameras with electronically operated shutters have a single "emergency" shutter speed that operates mechanically so you can still take pictures.

Most cameras with automatic shutter control also can be adjusted manually by turning the shutter speed dial to a specific shutter speed. Because the shutter is operated electronically, some even allow you to select a shutter speed between two marked shutter speeds. For example, you can set the dial between 1/30 and 1/60 setting to give a shutter speed of 1/45 second. Read the camera instruction booklet to see if it is possible to set "in-between" shutter speeds and how exacting they may or may not be.

When you set the speed of a mechanically operated shutter, you should be sure the shutter speed dial is set on a *specific* marked num-

ber or else the exposure will be inaccurate; do not set the dial between marked shutter speeds. (Leicaflex and a few other cameras are exceptions—see your camera manual for specific advice.)

## Aperture Controls

In the newer cameras with shutter-priority automatic exposure systems, the lens opening is controlled automatically and electronically by setting the lens aperture ring to "A" or "EE." When you move off the "A" or "EE" mark, the f/stops can be set manually on the lens.

Most modern lenses on SLR cameras are equipped with AUTOMATIC APERTURE or DIAPHRAGM CONTROL, which should not be confused with automatic exposure control. Automatic aperture control means that the lens will always be at its maximum opening until the shutter release is pressed. Then the lens aperture will automatically stop down to the f/stop determined by an automatic exposure system or preselected manually by the photographer. Afterward, the lens reopens to its maximum aperture.

Automatic aperture control makes it easy to view and focus through a SLR's viewfinder, because the lens is wide open and transmits the maximum amount of light possible. With cameras not equipped with automatic aperature control, you must open the lens to its widest opening to permit sharp focusing, and then close down the lens to make an exposure meter reading (called STOP-DOWN METERING) before pressing the shutter release to make the exposure. In addition, when the lens is stopped down to small openings, it is difficult to see your subject in the viewfinder, and this can contribute to haphazard picture composition.

Some cameras have a switch so you can select either automatic (A)

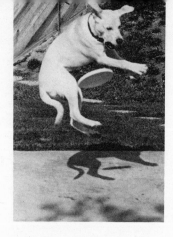

A good action shot, but not a sharp picture. Critical study reveals that the photographer focused more on the background than on the dog, and the blur is compounded because the shutter speed was a little too slow to totally freeze the action.

or manual (M) aperture control. In the manual position, it may activate the camera's built-in meter so you can make an exposure reading, or it can be used to visually check depth of field with the f/stop you've selected (see page 35).

## Focusing Mechanisms

All lenses for 35mm cameras can be adjusted for focus, except extreme wide-angle fish-eye lenses, which do not require it. The distance to the subject on which the lens is focused is indicated on a FOCUSING SCALE, graduated numbers that represent feet, meters, or both. The point beyond which everything will be in focus, infinity, is indicated by an oblong figure eight: ∞.

The earliest method of focusing a camera lens was to measure or guess the distance to the subject and then set that distance on the numbered focusing scale opposite the lens POINT OF FOCUS INDEX MARK. More critical focusing became possible when rangefinders were built into cameras. In today's 35mm rangefinder cameras, two small and separate lenses on the front of the camera transmit twin images of the subject into the viewfinder. You simply turn the LENS FOCUSING RING until the two images come together, which indicates that the subject is in focus. This is a very fast and effective method for focusing a camera lens.

On single lens reflex cameras, because the viewing lens is the same as the lens that transmits the image to the film, what you see in the viewfinder will be fuzzy until the subject is brought into sharp focus by turning the lens focusing ring. Camera makers have a variety of

This diagram shows the type of interchangeable focusing screen supplied with Nikon cameras. It features a Fresnel screen with a split-image rangefinder spot surrounded by a microprism collar. The darker circle represents a 12mm reference circle.

aids to assist you in focusing the interchangeable lenses on SLR cameras. These include a fine or coarse focusing screen, a microprism collar, a microprism spot, and a split-image rangefinder. All SLRs have one or more of these features, and some models have INTERCHANGEABLE FOCUSING SCREENS so you select the focusing aid you like best.

The basic focusing screen is ground glass, coarse or fine, that covers the entire viewfinder area. Usually it is combined with a Fresnel screen that makes the viewing area uniformly bright; without it, the center portion of the ground glass would be brighter than its corners. To focus, you turn the lens focusing ring until the image on the ground glass looks sharp.

Quick focusing is important to many kinds of photography, so special aids have been incorporated in the center of most focusing screens. A common one is a MICROPRISM SPOT, a bright round area that seems to shimmer until the image is brought into focus. Increasingly popular these days is a SPLIT-IMAGE RANGEFINDER that occupies a small circular area in the center of the focusing screen. It has two halves, split horizontally or diagonally. Until the lens is properly focused, any line in your picture that is bisected by the split-image rangefinder appears as a broken line in the viewfinder. This type of aid is especially helpful with wide-angle lenses, or when focusing in dim light, or when very fast focusing is required. It is less useful with telephoto lenses because half of the split image becomes dark.

Frequently a split-image rangefinder spot will be surrounded by a MICROPRISM COLLAR or CIRCLE to further assist in sharp focusing. Like the microprism spot, this circle shimmers until the image is brought into focus.

On some models, focusing screens with these and other focusing

aids, such as cross hairs or vertical and horizontal reference lines, can be changed to suit the photographer. They either slip in or out, or the entire pentaprism is removed from the camera so the screens can be interchanged. If the pentaprism is removable, other viewing devices can be attached, such as waist-level (top-viewing) finders. There are viewfinder attachments that magnify the image for very critical focusing or permit viewing at right angles (see page 162).

## Auto-Focus

Automation is the byword that guides technological improvements in cameras these days, so it was inevitable that an auto-focusing system would be developed. In 1978 a small rangefinder camera, Konica's C35AF, was the first 35mm with auto-focus to be marketed. It features a little module developed by Honeywell Corporation that uses integrated circuitry to link a mirror system and motor that will automatically focus the lens. All the photographer has to do is center the main subject in the viewfinder and shoot (exposure is controlled automatically too).

Although initially the auto-focus feature has only been incorporated in a camera that is considered more of the snapshot variety (it also has a built-in electronic flash), other camera manufacturers have licensing agreements permitting them to use Honeywell's auto-focus module, and undoubtedly it eventually will become part of sophisticated single lens reflex cameras. Skeptics should just remember that automatic exposure was once considered to be of dubious value, but it is an important feature in many of today's SLR cameras.

This diagram identifies the viewfinder readout information found in the Canon AE-1 SLR camera.

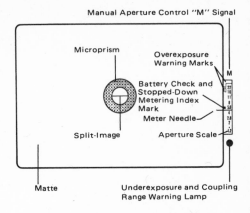

Manual Aperture Control "M" Signal

Microprism

Overexposure Warning Marks

M

Battery Check and Stopped-Down Metering Index Mark

Meter Needle

Split-Image

Aperture Scale

Matte

Underexposure and Coupling Range Warning Lamp

## Viewfinder Readout

Since the viewfinder is constantly being used for focusing and framing, it is an inconvenience to remove the camera from your eye in order to check exterior camera and lens dials for exposure information. Manufacturers of more recent SLR cameras are solving that problem by making your exposure selections visible in the viewfinder. The extent and manner of presenting this information, dubbed viewfinder readout, varies from model to model.

Cameras with automatic exposure control frequently have the most complete range of information. Usually there is an indication whether the camera is in the automatic or manual mode by the appearance of the letter "A" or "M" in the viewfinder. The selected shutter speed or f/stop, or both, also are indicated. On some models the aperture is a direct reading of the f/stop marked on the lens, which is transmitted by a tiny opening and lens into the viewfinder. A needle or LED may indicate the chosen f/stop and/or shutter speed on a scale that appears inside the viewfinder. Sometimes the f/stop and shutter speed are displayed in LED digital numbers.

Other information presented in the viewfinder usually includes signals that indicate whether the selected shutter speed and f/stop will cause under- or overexposure. Some cameras have a LED in the viewfinder that lights up when a compatible electronic flash unit mounted in the hot shoe is recycled and ready to fire.

Viewfinder readouts make it easy for you to know what the exposure will be and whether you should reset the f/stop and shutter speed to get the results you want. Changing the f/stop affects depth of field

and thus the photograph's overall focus (see page 77), while changing the shutter speed affects the way motion is portrayed in your picture (see page 203).

On cameras with only manual exposure control, the viewfinder may have just a match needle or LED readout to indicate when the exposure is correct according to the built-in meter; the specific f/stop and shutter speed you selected may not be visible in the viewfinder.

## Lens Mounts

As mentioned previously, 35mm rangefinder cameras have a permanently-mounted lens, with the exception of Leicas. All single lens reflex cameras, however, can be fitted with a variety of lenses. The interchangeable lenses designed for specific cameras have either bayonet or screw mounts. Most convenient and common on modern cameras are BAYONET MOUNTS, which permit lenses to be changed with great speed. You align a mark on the lens with a mark on the camera, insert the lens, and turn it slightly until the lens clicks into locked position. (Some lenses, like Canon's, use a breech lock; you turn a ring on the lens instead of the lens itself to lock the lens to the camera.) This perfectly aligns the lens and camera connections that are necessary for built-in light meter readings and automatic exposure aperture control.

SCREW MOUNT lenses are less common because lens and camera threads must be carefully aligned before the lens can be screwed on, and this takes time and patience. Also, the extent of mechanical connections between screw-mount lenses and cameras is limited on some

A hot shoe (arrow), used for mounting an electronic flash to a SLR or rangefinder camera, eliminates the need for a connecting cord between the flash and camera.

models and will not allow the automatic exposure features that are the trend today.

Screw mount lenses often can be adapted with bayonet mounts. These are sometimes called UNIVERSAL "T" MOUNTS ("T" meaning thread), with a bayonet end that fits on a specific model or series of cameras. However, some of the camera connections that permit automatic aperture or exposure control may not function, so stop-down metering is required, and f/stops must be adjusted manually. Whether screw mount, bayonet mount, or screw adapted to bayonet mount, be sure any lens you buy will make the required connections so it will function fully with your camera, particularly if it has automatic aperture or automatic exposure control.

## Flash Use

To permit photography with flash, 35mm cameras have special flash connections. Particularly popular these days is a HOT SHOE, a built-in bracket usually located on SLR cameras on top of the pentaprism housing. It holds the flash unit and makes direct electrical connections so a flash cord is not required.

Because electronic flash is most common today, rather than flash guns that use replaceable flashbulbs, the hot shoe is generally synchronized for electronic flash only. (This is frequently indicated on the hot shoe with an "X," the symbol for electronic flash.) SYNCHRONIZA-TION means the flash fires when the shutter is fully open, so the entire film frame will be exposed.

A hot shoe is a nice convenience, but it has a major drawback—it limits the positioning of your flash. For instance, the flash lighting is okay when you hold the camera horizontally, but if you frame your subject vertically, as for a portrait, a flash unit mounted in a hot shoe will be to one side of the subject and cause unnatural shadows.

Fortunately, most cameras also have a FLASH CORD SOCKET that will accept connecting cords from an electronic flash or flashbulb unit so it can be removed from the hot shoe. The standard sockets accept "PC" type plugs, the best of which are threaded so they cannot be pulled from the socket accidentally.

Proper synchronization for electronic flash and for flashbulbs requires different electrical circuitry, so on some cameras you will find two flash sockets, one marked "X" for electronic flash and the other marked "M" or "FP" for flash bulbs. (Also see page 151.) On models with a single flash socket, there will be a switch that you change from "X" to "M" or "FP" to assure proper synchronization, or else the switching is done automatically within the camera.

Some cameras with automatic exposure systems have specially designed electronic flash units that make exposures with flash more foolproof. Usually, when connected to the hot shoe, they automatically set the shutter speed required for flash synchronization. On some camera models the lens aperture also is automatically set, or you pre-set it manually to one or another designated f/stops for automatic operation. A few of these CAMERA-CONTROLLED AUTOMATIC FLASH UNITS have a LED signal in the viewfinder which indicates when the flash is fully recycled and ready for use. CAMERA-INTEGRATED FLASH is another name for these automatic units.

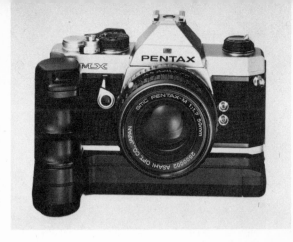

This Pentax auto winder attachment, which screws to the base of the camera body, features a convenient hand grip with its own shutter release trigger. The unit, powered by four AA-size batteries, will automatically cock the shutter and advance the film up to two frames per second.

## Motor Drives and Auto Winders

A number of professional photographers, particularly photojournalists, have been using cameras with MOTOR DRIVES for a number of years. Simply stated, motor driven cameras automatically cock the shutter and advance the film after every exposure. More precisely, they have the ability to do this faster than the photographer can, and they make it possible to expose up to five frames of film per second! They should not be considered movie cameras (which expose twenty-four frames per second), but motor drive cameras do allow photographers to make action pictures they might otherwise miss, and to take a sequence of photographs in rapid succession. Also, a switch on some motor drives can be activated to quickly rewind exposed film into the cassette.

Most motor drives are accessories, and the camera must be designed to accept this add-on unit (a few cameras have built-in motor drives). Some drawbacks of motor drives, which usually require a considerable number of batteries to power them, are their noise, extra weight, and considerable cost.

Another SLR camera accessory that also automatically advances the film and cocks the shutter after every exposure is called an AUTO WINDER; it is battery powered and will take up to two frames per second (an Olympus model gets 3 f.p.s.). They are lighter (because fewer batteries are required) and less costly than motor drives, and they are becoming one of the most popular options to use with cameras that have automatic exposure systems. The camera, of course, must be designed to accept the auto wind unit. (A few models have a built-in single frame auto winder.) Auto winders will not rewind film; you

must manually rewind the exposed roll of film into its cassette. For additional discussion of these two accessories, see page 169.

## Automatic Exposure Override

On cameras with automatic exposure systems, the most versatile models have a provision for switching from the "A" or "EE" setting in order to adjust the lens aperture and shutter speed manually. You may want to set the exposure manually when you think the automatic exposure control will give an incorrect exposure.

An example is when there is strong backlighting on your subject. Because the light is shining toward the camera, it can influence the camera's exposure meter more than the light reflected from your subject, and this could result in an underexposed subject if your camera is in the auto exposure mode.

However, instead of switching to manual exposure control, many cameras have another feature that allows you to lock in an exposure while in the automatic mode. This is called automatic exposure override. Depending on the camera model, it is activated by slightly depressing the shutter release button or by pushing a special EXPOSURE MEMORY LOCK button or lever.

This override feature enables you to make a meter reading of the most important part of the scene or subject while in the automatic mode, then re-aim the camera for the composition you want before taking the picture. Normally, of course, the exposure reading will change whenever you move the camera to reframe the subject, or when-

ever the light changes. However, automatic exposure override will hold a preselected exposure reading despite changing light conditions or aiming the camera in a different direction.

For instance, with a backlighted subject, you can move in close so only the subject fills the viewfinder and the meter cannot be affected by the backlight. Then you press the automatic exposure override (i.e., memory lock) to hold that exposure while you return to your original position, recompose the picture in the viewfinder, and shoot.

This feature is an easier and faster way to control exposure than by switching from the auto exposure mode to manual. That's because when the camera's meter is in the manual mode, you must physically adjust the lens aperture ring, shutter speed dial, or both, until the meter needles or LEDs indicate the exposure is correct. In the auto exposure mode, the camera makes those adjustments for you. (Also see page 59.)

## Exposure Compensator

Most cameras with automatic exposure systems have another way for the photographer to readjust exposure according to personal desires. This is called an exposure compensator, usually a dial that is adjusted to give automatic exposures that are one to two f/stops over- or under-exposed. The dial is marked with a plus (+) and minus (−), usually the numbers 1 and 2, and sometimes dots or lines to indicate half stops. When you want the camera to make automatic exposures that are one f/stop *over* the normal exposure, you would turn the dial to (+) 1. Or, as another example, for automatic exposures two f/stops *under*

Most of the dials and controls on SLR cameras and lenses can be viewed from above. (The protrusion at the upper right is a hand grip for the motor drive attached to this camera, which helps the photographer handle the extra weight of its batteries.)

normal exposure, you'll set the dial to (—) 2. This exposure compensator helps give you creative control over an automatic exposure system and is an important feature to have. (See page 203 for more details.)

When over- or underexposures greater than an exposure compensator's f/stop range are required, or when a camera with automatic exposure does not have an exposure compensator, the camera instruction booklet usually suggests that you change the film speed (ASA) dial to calibrate the built-in exposure meter for the amount of over- or underexposure desired (see pages 57 and 200).

### Film Speed (ASA) Dial

All 35mm cameras with built-in exposure meters have a dial that must be set according to the speed of the film you are using. Film speed, which indicates a film's relative sensitivity to light, is expressed by an ASA number. The higher the number, the more sensitive the film (see page 57). The film speed dial usually is located on the top of the camera body or on a ring around the lens mount. Sometimes it is incorporated in the shutter speed dial or ring. On some of the miniature models with automatic exposure, the film speed selector is in the front of the camera.

The dial gives a wide range of film speeds, sometimes from 6 to 6400 ASA. There's not enough room to inscribe all the numbers, and only these are commonly listed: 6, 12, 25, 50, 100, 200, 400, 800, 1600, 3200, 6400. In between each of these numbers, however, there are usually two lines, dots, or notches to indicate the other ASA settings that you can use to calibrate the meter for the speed of your film. The

## Film Speeds

| | | | | | |
|---|---|---|---|---|---|
| 6 | **25** | 80 | 250 | **800** | 2500 |
| 8 | 32 | **100** | 320 | 1000 | **3200** |
| 10 | 40 | 125 | **400** | 1250 | 4000 |
| 12 | 50 | 160 | 500 | **1600** | 5000 |
| 16 | 64 | **200** | 640 | 2000 | **6400** |
| 20 | | | | | |

total range is listed above, with the commonly inscribed numbers in boldface.

Frequently another set of smaller numbers is given, which is DIN and represents the European system for indicating the speed of film.

A wise trend by film manufacturers is to include the speed of the film in the name of the film—at least color films—so you easily tell the film's ASA. Kodachrome 64 film, for instance, has an ASA of 64, while Fujicolor F-II 400 has a film speed of 400. The film's ASA is also listed on the film package, the film cassette, and the film instruction sheet. With Kodak films labeled "professional," the specific speed (ASA) for a particular film is only printed on its film instruction sheet.

To avoid over- or underexposure, it's important that the film speed dial be set on the ASA that's correct for your film. Beware of poorly designed dials that do not lock on the film speed you have set; some are easily knocked off the selected ASA number, and the result will be over- or underexposures.

## Depth of Field Preview

With modern lenses on single lens reflex cameras, you view the scene through the lens when its aperture is wide open. When the lens is closed down to the f/stop that has been selected for the actual exposure, the depth of field increases. This means more of the picture area will be in focus. The smaller the lens opening, the greater the depth of field (i.e., the extent of focus).

The actual depth of field is indicated in feet, meters, or both, opposite the DEPTH OF FIELD SCALE that is engraved on most lens barrels (also see page 78). However, sometimes you can get a *visual* idea of

depth of field by closing down the lens aperture while you are looking through the viewfinder. This is made possible on many SLR models by a DEPTH OF FIELD PREVIEW BUTTON or LEVER. When this button is pressed, and you rotate the lens aperture ring, your eye will see in the viewfinder what the film will see. Of course, as you turn the ring to the smaller f/stops, such as f/16 and f/22, the image gets very dark. Moreover, the value of this device as a check of depth of field is limited by the sharpness of your own eyesight.

On some lenses there is a switch marked "A" (Automatic) and "M" (Manual), and it must be set to the "M" position so the lens can be stopped down manually for a depth of field check.

Use of the depth of field control is helpful when you are photographing in bright, glaring situations, as when sunlight is glistening off water or snow. By pressing the depth of field button or lever when the lens is stopped down, you'll be able to study the scene through the viewfinder without being blinded.

On less convenient camera models, the depth of field preview button or lever may be a switch that also is used to turn on the exposure meter. As you adjust the aperture ring to match the needle in the viewfinder that indicates exposure is correct, the image gets bright or darker. This is frequently called STOP-DOWN METERING. When the depth of field preview device is released (i.e., the meter switch is turned off), the lens reopens to its widest aperture for the brightest possible viewing. On a camera lens with automatic aperture control, the lens remains at its widest opening for easy viewing while you turn the aperture ring to set the exposure. This is sometimes called open aperture or full aperture metering.

## Battery Check

Since most 35mm cameras rely on battery power for meter readings or automatic exposure control, it is important that the camera has a way to signal the battery condition. This may be a button that deflects a needle, or a LED that lights up, to indicate the batteries are still good. In some models, a LED flashes to warn you the batteries are weak and should be replaced.

## Multiple Exposure Control

In the early cameras, accidental double exposures were a considerable problem, so manufacturers designed 35mm cameras to advance the film every time the shutter is cocked. Today's photographers have been asking for an easy way to make multiple exposures, so now that feature is being built in to more and more cameras. It allows you to cock the shutter in order to make one or more additional exposures on the same frame of film; the film does not advance, nor does the film frame counter.

When multiple exposure provision is not built in, you have two ways to make extra exposures on the same film frame. One method is to expose the entire roll, rewind it, and then reload it (carefully rematching your own index marks on the film and camera) to make another set of exposures.

A second approach involves more steps but works with most cameras. After the initial exposure, take up the film's tension in the film cassette by turning the rewind knob; hold that knob, then press the

**Left** Multiple exposures can be made with most SLR cameras, even if there is no special multiple exposure control. You should refer to your camera manual for details. After making the initial exposure, the general procedure is to turn the film rewind crank until you feel tension in the film cassette. **Right** Then hold the crank so the film cannot move, press the film rewind release button (usually located on the base of the camera—see arrow), and cock the shutter for the next exposure.

rewind release button; and, finally, recock the shutter by moving the film advance lever. The film will not advance, although the film frame counter will. After the second exposure, the film can be advanced as usual, unless this double-exposure procedure is repeated for multiple exposures. One problem is that the film pressure plate on some cameras could be weak and may not hold the film in exactly the same position, so the exposures may not overlap exactly as you expected.

## Shutter Release Lock

Some 35mm cameras have a shutter release lock to prevent accidental exposures. This is especially important on cameras with auto winders or motor drives and on cameras featuring automatic exposure systems that are activated when the shutter release is slightly depressed.

## Self-Timer

Most models of 35mm cameras have a built-in self-timer that trips the shutter after a short delay. The delays range from 2 to 10 seconds. The specific times are rarely noted on the self-timer lever, but the camera's operation manual usually tells what they are. After cocking the self-timer by turning this lever, which is located on the front of most SLR cameras, you press a special button or the regular shutter release to activate the self-timer. If you change your mind, the self-timer action can be canceled on some models, but on most cameras you must use the self-timer once its lever has been cocked.

On rangefinder cameras, self-timers are frequently built in the

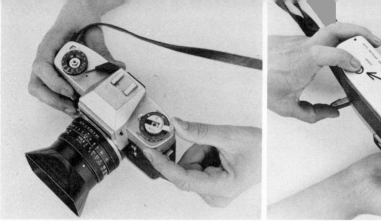
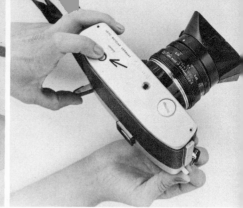

permanently attached lens. The cocking lever is usually indicated by a "V."

The self-timer has more uses than the common one of delaying the shutter release so the photographer can leave the camera and be included in the picture. With long exposures, the self-timer can be used to avoid jiggling the camera and blurred results, because the shutter can be released without the photographer touching the camera. Also, to shoot from high or awkward positions, you can attach the camera to a tripod, trip the self-timer, and then hold onto the tripod legs and position the camera where you want it. Or, when using cord-connected flash some distance from the camera, you can position the camera on a tripod, trip the self-timer, and then walk away to hold the flash at the spot you selected.

## Mirror Lock-Up

On 35mm SLR cameras, when the shutter release is pressed, the mirror that reflects the image to the viewfinder automatically flips out of the way of the light entering the lens so the image can reach the film and be recorded. Some models have a mirror lock-up feature that will get the mirror out of the way manually. With time exposures, some photographers are concerned that the flipping action of the mirror might jar the camera and cause a slight blur in the picture, so they manually lock up the mirror before pressing the shutter release. Of course, this is done after you've used the viewfinder to frame your subject, because you can't see anything when the mirror is locked up.

In other cases, the mirror must be locked up because the optics of

some lenses extend far into the camera body. If you intend to use such lenses, like some types of fish-eye lenses, make sure the mirror in your camera can be locked up out of the way.

## Film Load Indicator

An occasional problem of photographers using 35mm cameras is taking pictures and then discovering the camera is not loaded with film. A few turns on the film rewind crank will tell you if there is film in the camera, but some models also have a special film load indicator that signals whether or not the camera is loaded.

## Film Transport Indicator

Even when there is film in the camera, it is not uncommon for a photographer to think pictures are being recorded and then discover the film was not advancing. Frequently this is caused by loading film in the camera improperly. To check whether the film is advancing, the common procedure is to take up the tension on the film rewind crank/knob, and then watch to make sure it turns in the *opposite* direction when you move the film advance lever and cock the shutter.

Some newer models, however, have a moving signal that indicates when the film is actually advancing. Be warned that *the film frame counter operates whether there is film in the camera or not;* do not assume film is advancing because the numbers in the frame counter are advancing.

To remind you of the film type and number of exposures on the roll in your camera, place the film's box flap in a memo holder on the back of the camera.

## Film Type Indicator

A few 35mm cameras have a transparent window in the camera back that allows you to see the film cassette loaded inside your camera, so you know exactly what kind of film is being used. Others have a FILM MEMO HOLDER on the back where you can slip in the end flap from a box of film to remind you of the type you've loaded in the camera. These holders also can be purchased as stick-on accessories.

Also, a manually set dial to designate film type is provided on cameras by most manufacturers. Usually this dial has two pairs of symbols: a sunburst to indicate daylight film, and a lightbulb to indicate tungsten film. They are in two colors: white, which stands for black-and-white film, and any other color to indicate color film. The dial is just to serve as a reminder, and it is not connected to any mechanism within the camera.

## Viewfinder Eyepiece Cover

A small attachment often is included with cameras that have an automatic exposure system, although it may not be mentioned in the camera's instruction booklet. This is an accessory or built-in cover for the viewfinder's eyepiece. Because metering cells for automatic exposure systems are located most often in the viewfinder, stray light entering through the eyepiece can strike them and cause underexposures. The eyepiece cover should be used for correct automatic exposures when your eye is not in position to block the extraneous light that can enter through the eyepiece and affect the meter reading, as during a

time exposure. Alternately, you can cover the eyepiece with your hand. A few cameras have metering systems that are not affected by such stray light—or automatically account for it in exposure readings; check your camera manual for such advice.

Underexposures also may occur when photographers who wear glasses are not getting close enough to the viewfinder eyepiece to block the light; an accessory rubber EYECUP attached to the viewfinder eyepiece will help and also will keep eyeglass lenses from being scratched.

## Viewfinder Light

In dim light, it is often difficult, if not impossible, to see the match-needles in the viewfinder in order to set the proper exposure. A few manufacturers have installed a small light in the viewfinder so you can see to make the needle alignment for correct exposures. This isn't necessary in models where LED displays are used, because diodes light up in the viewfinder to indicate the exposure.

## Interchangeable Backs

A few 35mm reflex cameras feature backs that can be removed and interchanged with other types, notably a bulk film back, a data back, and a Polaroid film back. Most are expensive.

A BULK FILM BACK permits a great number of exposures, usually up to 250, to be made on one roll of film that has been bulk loaded; normal film lengths give 20, 24, or 36 exposures per roll.

A DATA BACK allows the photographer to record pertinent data on each film frame. Depending on the data back's design, you can record

the date (year, month, day); the aperture, shutter speed, and frame number; and combinations of numerals and letters for your own code system. Another style of data back has a built-in clock that records the date, hour, minute, and second the picture is made, or a special plate on which you can write any data you want to appear on the film. Data backs are most frequently used by photographers doing scientific or industrial work.

With a POLAROID FILM BACK, you can take instant pictures, which professionals sometimes do to make sure composition and lighting are perfect before making exposures on 35mm films.

## Camera Systems and Accessories

Depending on your intended use of a camera, it may or may not be important to have a wide range of lenses and accessories available for your special model. Manufacturers refer to an extensive line of camera accessories as a camera system.

Some of the more popular options have already been described in this section, including interchangeable focusing screens, interchangeable viewfinders, camera flash units with automatic exposure control, and interchangeable backs.

An extensive selection of lenses also should be available from the camera manufacturer, including fish-eye, wide-angle, normal, telephoto, zoom, macro, close-up, and perspective-correction (PC) types (see Chapter 3). In many cases, lenses from other manufacturers also can be adapted for use on your camera.

As pictures in photographic magazines and sales brochures testify, the number and kinds of accessories available as part of a camera sys-

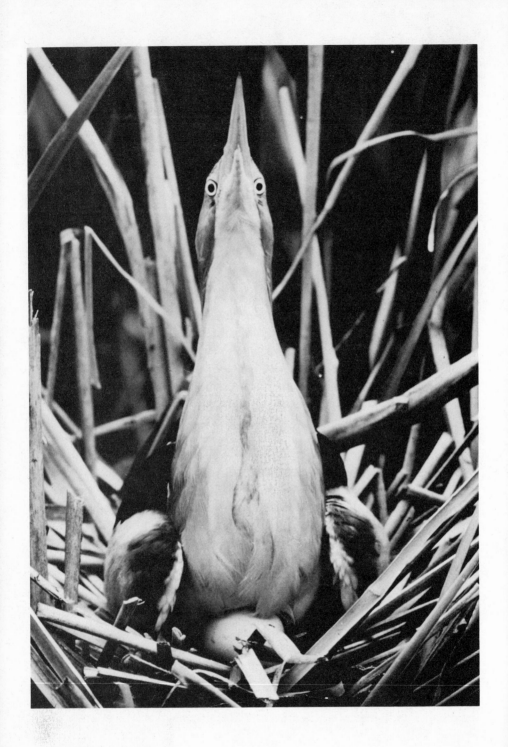

The "best" cameras and equipment are those that enable you to take the kinds of pictures you enjoy most. A nature photographer stalking in a Canadian marsh caught this nesting bittern trying to blend in with the reeds.

tem can be overwhelming. They can include extension tubes, bellows, lens reversing adapters, microscope adapters, slide copiers, copy stands, and cable releases (see Chapters 3 and 6). For motor drives or auto winders, there are power packs that permit use of rechargeable batteries or AC current, and time control and remote control units to trip shutters automatically or from a great distance (see Chapter 6).

There are lens hoods, caps and filters, and lens adapters for odd-size or different model lenses (see Chapters 3 and 4). You can buy viewfinder magnifiers, eyepiece correction lenses, and right-angle viewing attachments (see Chapter 6). The selection seems never-ending, as with Nikon, which lists more than 300 accessories for use on its various 35mm SLR cameras.

## Cost

Certainly the cost of a camera influences the type you purchase. Fortunately, the profusion of 35mm manufacturers and ever-changing models has made the marketing of cameras very competitive. The best advice is to shop around for the lowest prices. There are frequent camera sales, and most camera stores will give you a discount of 20 percent, or even more, if you ask for it. For comparative pricing, be sure you give the exact camera model and lens information.

We have four special tips for camera buyers.

1. Do not offer a camera in trade because the amount you receive often is identical to the discount you could have gotten anyway; sell your old camera independently with a classified newspaper ad.
2. Make sure the camera has a factory warranty; if you buy a used

camera, be certain the camera store includes a warranty of its own.
3. Know the store's return policy, and get it written on the sales slip; some discount stores will not accept return merchandise and you may be stuck with a camera you don't like.
4. Finally, don't buy a camera with an unbelievably low price from a stranger; it may be stolen, and you'll have no warranty or option for returning it. Serial numbers of stolen cameras and lenses frequently are on file with camera repair shops, and your equipment may be confiscated if it is discovered to be "hot."

## The "Perfect" Camera

Even with the checklist and descriptions of camera features, you may still be confused about the best camera to buy. Our purpose was to acquaint you with some of the options available, but we admit that sorting out the possibilities is not an easy task. We suggest you review the checklist and make note of the features that seem important to you, then look for that kind of camera.

Brochures describing particular models usually are available in camera stores, along with demonstrations, or you can write to the camera manufacturers for descriptive literature.

In summary, we'll make a few personal recommendations. Going along with the recent trends in 35mm cameras, we think compact SLR models are worth special consideration. Their small size and lighter weight should make casual photography more fun because you'll have less of a burden to tote around.

Likewise, an automatic exposure system should contribute to your

enjoyment of photography. We like the aperture-priority systems, which give you control over depth of field. However, for frequent fast action photography, such as with sports, shutter-priority automatic exposure is the wiser choice because you select the shutter speed. The ultimate, of course, is a camera that offers both shutter-priority and aperture-priority exposure systems.

Regarding built-in exposure meters, we feel the newer silicon and gallium photo diode cells are superior to CdS (cadmium sulfide) cells, because they react more quickly to extreme changes in light intensity.

For automatic exposure systems, center-weighted metering is important. For manually controlled exposures, a built-in spot (selective) meter is worthwhile for easy and accurate exposure readings.

A viewfinder that presents a uniformly bright image prevents eye fatigue and makes composition easier. For fast and accurate focusing, a microprism focusing spot or collar is desirable, especially when incorporated with a split-image rangefinder.

The viewfinder readout should include information about both shutter speed and aperture; if the camera has automatic exposure, an indication of whether the camera is in the automatic or manual mode also should be visible in the viewfinder.

When changing lenses, a camera with a bayonet lens mount is more convenient and faster to use than one with a screw mount.

A battery check is especially important when the camera has an automatic exposure system; the camera may be inoperable if the batteries are dead. Also, in cameras with automatic exposure systems, automatic exposure override and an exposure compensator are necessary for full control of exposures.

Provision for an auto winder will permit more versatility with your camera. A depth of field preview button can be useful, too, and a multiple exposure provision is nice but not necessary.

Finally, you should be aware that a camera's color has nothing to do with its function or quality. A number of camera makers, who supply camera bodies in black as well as the traditional chrome metal finish, infer that the black models are bought by professional photographers. As you might suspect, this is only an appeal to the purchaser's vanity, and the price of a black camera body is higher than the same camera body with a chrome finish.

**2**

Exposure
Systems

For many people, the most perplexing thing about photography is exposure. They may not understand the basic concepts of exposure, or how to figure it properly. No wonder cameras with automatic exposure systems have become so popular so quickly. However, to be a good photographer, you still need to know all about exposure to have complete control of the camera and your photographic results. This chapter explains the concepts of exposure and how to use exposure meters and automatic exposure systems most effectively.

## What Exposure Means

When light focuses through a camera lens and strikes a film, it acts on that film's light-sensitive surface, called the EMULSION. The light affects in varying degrees the silver particles, called SILVER HALIDES, which are part of all photographic films, both black-and-white and color. It creates an invisible image, called a LATENT IMAGE, which remains unseen until the film is developed. Depending on the type of film, and the processing it receives, the eventual visible image is either negative or positive (i.e., a transparency).

One of the most important considerations when judging the quality of a negative or positive is its DENSITY, which means how light or how dark the overall image appears. Density is determined, to a great extent, by the amount of exposure the film received. Properly exposed films have good density (not too dark, not too light), while films exposed incorrectly often are described as being underexposed or overexposed. The density of under- or overexposed film depends on whether it is a negative or a positive.

A negative that is light and without much detail in the image has

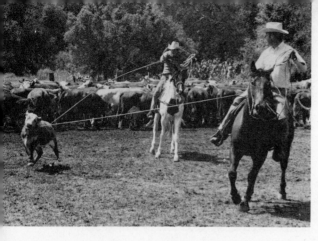

Whatever the subject, one important aspect of any photograph is proper exposure.

been underexposed. This is often described as a "thin" negative; not enough light reached the film, so the negative is lacking in density. When it is printed or enlarged to a positive image, an underexposed negative will produce a dark print. (In reality, however, steps can be taken in the darkroom to get a print of good density from an underexposed negative.)

Because it is the opposite of a negative, a positive film that has been underexposed will be dark. Again, not enough light reached the film, so the result is a dense image that is difficult to see.

When a positive film has received too much light, it is overexposed. There is not enough density to give good detail to the image.

On the other hand, a negative that is dark has been overexposed. It is called a "dense" negative, and the image is so uniformly dark it is hard to discern details in it. (As with thin negatives, darkroom procedures are available that often permit a print with good density to be made from an overexposed, dense negative.)

## How Exposure Is Controlled

Just two camera controls determine exposure: shutter speed and lens aperture. As already explained, the aperture (also called lens diaphragm or f/stop) determines the amount or intensity of light that is allowed through the lens, and the shutter speed determines the amount of time the light has to act on the film.

The aperture and shutter speed are set manually by the photographer or automatically by cameras with automatic exposure systems. With most automatic systems, the photographer still must set either the aperture *or* the shutter speed before the camera sets the other

| Aperture Numbers | Shutter Speed Numbers | |
| --- | --- | --- |
| 1.4 | B (or T) for time exposures | |
| 2 | 1 | 60 |
| 2.8 | 2 | 125 |
| 4 | 4 | 250 |
| 5.6 | 8 | 500 |
| 8 | 15 | 1000 |
| 11 | 30 | 2000 |
| 16 | | |
| 22 | | |

exposure control; introduced in 1978, Canon's A-1 was the first SLR that was programmed to automatically set *both* aperture and shutter speed.

Different sets of numbers are used to indicate the relative size of the lens opening and the speed of the shutter. Above are the APERTURE NUMBERS commonly inscribed on lenses for 35mm cameras. (The numbers represent fractions that reveal the ratio of the diameter of the lens opening to the focal length of the lens—see page 54.) *The smaller the number, the larger the lens opening.*

Also above are the SHUTTER SPEED NUMBERS commonly found on 35mm cameras. They represent fractions of a second, i.e., 4 equals ¼ second. *The higher the number, the faster the shutter speed.*

The aperture and shutter speed that you choose in order to make a correct exposure that produces a negative or positive image with good density depend on two other factors: light intensity and the sensitivity of your film.

An exposure meter, built in or separate from the camera, helps you determine the proper combination of aperture and shutter speed by reading the intensity of light emitted or reflected by your subject. (Less commonly, the meter is used to read the amount of light falling on your subject.)

Before the meter can do its second important job, indicating the correct exposure, it must be calibrated according to how sensitive your film is to light. As outlined earlier, the relative sensitivity of a film is called its "speed" and is indicated by a number. These are generally known as ASA numbers, in reference to the now defunct American Standards Association that established them. (In some parts of the world a different film speed rating system is used, called DIN for the

An exposure meter is only as good as the photographer using it. In this case, the photographer decided to underexpose to create a more dramatic effect.

German organization that established that standard, Deutsche Industrie Norm.)

The ASA film speed numbers that indicate the relative sensitivity of films were listed on page 35. Remember, the higher the number, the more sensitive the film is to light. These numbers (and sometimes DIN numbers) are indicated on exposure meter dials. When a number does not specifically appear on the dial, owing to space limitations, it is represented by a line, a dot, or a notch.

To correctly calibrate an exposure meter for the speed of the film you are using, its ASA number must be set on the film speed dial. Once this is done, the meter will guide you in selecting the proper aperture and shutter speed that will make a good exposure for that speed of film.

In summary, determining proper exposure seems an easy task:

1. Find out the speed of your film; its ASA number is printed on the film box, the film instruction sheet, and the film cassette.
2. Set that ASA on your exposure meter's film speed dial.
3. Point the meter, or camera with built-in meter, at the subject and make a reading.
4. Align the meter needles to determine the proper exposure. With built-in meters you do this by turning the lens aperture ring or the shutter speed dial. Instead of match-needles, some 35mm cameras with built-in meters have LED readouts in the viewfinder that indicate when exposure is correct.

On hand-held meters you turn a dial to align the needles and then choose the aperture/shutter speed combination that is best for your purposes.

A handheld exposure meter allows you to see the various f/stop and shutter speed combinations that will give a correct exposure. For example, light reflecting from the subject moved the needle to 16 on this sophisticated meter's scale. To set the meter for the correct f/stop-shutter speed combinations, the exposure dial then was turned until 16 was opposite the solid white triangle. (Don't confuse it with the film speed calibration triangle mark, which has been set to ASA 200.)

As you will notice, the hand-held meter's exposure scale reveals one of the most important concepts regarding exposure: different combinations of lens openings and shutter speeds produce equal amounts of exposure. For example, whether you shoot with an aperture of f/5.6 at a shutter speed of $\frac{1}{125}$ *or* f/11 at $\frac{1}{30}$, the exposure is the same. Any other combination shown on the exposure scale also will produce an identical exposure.

By studying the relationship of f/stops and shutter speeds aligned on the scale, you can see that if you let in *less* light by changing to a smaller lens opening, you must compensate by letting the light expose the film for a longer period of time. Thus, for example, if you cut the intensity of light reaching the film by two f/stops by switching from f/5.6 to f/11, you must compensate by increasing the time of the exposure by shooting two speeds slower, which means switching from $\frac{1}{125}$ to $\frac{1}{30}$. It will be of great value for you to understand this interrelationship between f/stops and shutter speeds.

How much is the light being affected when you change f/stops or shutter speeds? Simply stated, if you change from one f/stop to the next *larger* f/stop, the exposure is doubled ($2\times$). Conversely, if you change from one f/stop to the next *smaller* f/stop, the exposure is cut in half ($\frac{1}{2}\times$).

The same is true regarding shutter speeds. If you switch from one shutter speed to the next *slower* shutter speed, the exposure is doubled ($2\times$). And, conversely, if you change from one shutter speed to the next *faster* shutter speed, the exposure is cut in half ($\frac{1}{2}\times$).

This relationship can be extended throughout the scale. For instance, opening up the lens by two f/stops, *or* slowing down the shutter

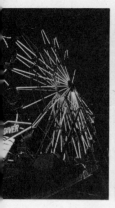

Adjusting the shutter speed has a significant effect on how the subject appears in your picture. **Left** Here a fast shutter speed (1/250 second) was used to stop the action. **Right** More eye-catching is this photo of the same Ferris wheel, exposed at a very slow shutter speed (1 second).

by two speeds, will increase exposure four times (4×). Conversely, closing down the lens by two f/stops, *or* stepping up the shutter by two speeds, will cut the exposure to one quarter (¼×) of the original exposure.

Undoubtedly it's easy for you to understand the relationship of one shutter speed to another, because we're talking about fractions of a second. The numbers double as you go in one direction, or are reduced by one half when you go in the opposite direction. (You'll note this doesn't exactly hold true when you go from ⅛ to 1/15 and 1/60 to 1/125, or vice versa, but these two small discrepancies are discounted because the effect on exposure is insignificant.)

Comprehending the relationship of one f/stop to another may not be as simple, because the adjacent numbers do not appear to double or halve mathematically, as do shutter speeds. An f/number is really a fraction that reveals the ratio of the diameter of the lens opening to the focal length of the lens.

First, what is meant by FOCAL LENGTH? In practical terms, it is a number commonly expressed in millimeters (mm) that photographers use to identify types of lenses. For 35mm cameras, a lens with a small focal length number, say 28mm, indicates the lens is a wide-angle type, while one with a larger focal length number, such as 500mm, tells you it is a telephoto lens. A normal lens for 35mm cameras is 50mm.

In technical terms, however, focal length is the distance from the optical center of a lens to the point behind the lens where light rays from an object at infinity are brought into focus. The distance is measured in millimeters.

Now, if you take the focal length of any lens, say 40mm for exam-

When the shutter speed is increased to make a stop action photo, open up the lens aperture to compensate for exposure.

ple, and divide it by the diameter of any selected lens opening, say one that measures 5mm, the result is the f/number, which in this case is f/8. In other words, the diameter of the aperture is ⅛ of the lens focal length.

As was mentioned, adjacent f/numbers, unlike adjacent shutter speed numbers, do not seem to represent a doubling or halving of the light. Remember, however, that the area of any circle, including a lens aperture opening, is measured by squaring its radius and multiplying the result by pi (3.14+). If you actually calculated and compared the areas of the aperture opening for each f/stop number marked on a lens, you would see that the *larger* adjacent f/stop opening has double the area and therefore admits twice the amount of light. Likewise, the *smaller* adjacent f/stop opening covers half the area and therefore admits one half the amount of light. This is true for adjacent f/numbers all along the aperture scale: f/1.4, 2, 2.8, 4, 5.6, 8, 11, 16, 22, 32. Using f/8 as an example, its larger adjacent f/stop, f/5.6, lets in two times the light that f/8 does, while its smaller adjacent f/stop, f/11, lets in one half the light that f/8 does. (Actual aperture area calculations and comparisons will reveal that some f/numbers have been rounded off for general use: f/1.4=1.415; f/2.8=2.83; f/5.6=5.66; f/11=11.32; and f/22=22.63.)

Knowing the exposure relationships of f/stops and shutter speeds will help you when making an exposure. For instance, say your camera's shutter speed is set at ⅟₆₀ and you make an exposure meter reading that places the f/stop at f/8. However, your subject is moving and you decide to stop the action by shooting at a faster shutter speed, ⅟₅₀₀. You adjust the shutter speed dial from ⅟₆₀ to ⅟₁₂₅ to ⅟₂₅₀ to ⅟₅₀₀,

The f/stop you use is one factor that determines how much of your picture will be in focus (i.e., depth of field).

which is three speeds faster. Because this cuts down the time the light has to expose the film (to $\frac{1}{8}\times$), the aperture must be opened up to let in an equivalent amount of light ($8\times$).

You can take another exposure reading, of course, but that wastes time because all you really have to do is open up the lens three f/stops, from f/8 to f/5.6 to f/4 to f/2.8. The revised exposure of $\frac{1}{500}$ at f/2.8 is equal to the original exposure reading of $\frac{1}{60}$ at f/8.

Such practical application also works when you decide to change the f/stop determined by an exposure meter reading. For instance, the meter reads a scene at $\frac{1}{125}$ at f/8, but you decide you need to shoot at f/16 in order to increase depth of field (the area of your picture that will be in focus—see page 77). Instead of taking another meter reading after you close down the lens from f/8 to f/11 to f/16, which is two f/stops ($\frac{1}{4}\times$), you just slow down the shutter two speeds ($4\times$) from $\frac{1}{125}$ to $\frac{1}{60}$ to $\frac{1}{30}$, to compensate for the loss of light. The final exposure, f/16 at $\frac{1}{30}$, is equal to the original meter reading of f/8 at $\frac{1}{125}$.

In making exposure adjustments, here are some other things to know. You can set the aperture control ring anywhere you wish, which means it does not have to be on a specific f/number. Modern lenses have something called CLICK STOPS, which are notches you can feel as you rotate the aperture control ring. They are located at each inscribed f/stop, and on some lenses, halfway in between those numbers. The in-between position is known as a HALF-STOP. Manufacturers have included click stops as a convenience to help you know exactly where the numbered f/stops and half-stops are. But you also can adjust the ring to positions between these click stops.

Regarding shutter speeds, unless the camera instruction booklet

says otherwise, you should *only* set the shutter speed control dial to the specific speeds inscribed on the dial. Otherwise, the shutter speed will not be accurate, and there may be some damage caused to the shutter mechanism. One exception to this rule concerns cameras that have electronically operated shutters. In general, their shutter speed dials can be set anywhere, although the inscribed speeds normally "click" into position. Also, adjusting the dial to a position in between those marked shutter speed numbers will be only an approximation of the actual shutter speed.

Electronic shutters are common to cameras with aperture-priority automatic exposure systems. In the auto exposure mode, after you set the f/stop, the camera automatically sets the shutter speed for the proper exposure. The actual speed of an electronic shutter can be almost anything, such as $\frac{1}{364}$, although the shutter speed readout in the viewfinder may indicate only the nearest "standard" shutter speed, say $\frac{1}{250}$, especially if the readout information is a LED type.

It is also important for photographers to know the relationship of film speed numbers (ASA), because this is necessary for understanding and altering exposure.

As you recall, the relative speed (i.e., sensitivity) of a film is indicated by an ASA number; the higher the number, the more sensitive the film is to light. Another approach is to say that the higher the ASA number, the less exposure the film requires. In practical terms, you want to know how much more sensitive is one film than another, and how much less exposure is required. For the answers, all you need do is compare the ASA numbers of the films. An ASA that is double another ASA means that the film with the higher number is twice as sensitive, or as most photographers say, it is twice as *fast*. Thus a film

of ASA 64 is twice (2×) as sensitive, or as fast, as a film of ASA 32.

Likewise, an ASA 200 film has double the speed, meaning it is twice (2×) as fast, as a film with ASA 100. A film of ASA 400 is twice (2×) as fast as an ASA 200 film, and the ASA 400 film is therefore four times (4×) as fast as an ASA 100 film. As you see, it is easy to figure out the relative speed of films by comparing their ASA numbers.

Now comes the important part. What do differences in film speed mean in terms of exposure? Simply stated, a film that is twice (2×) as fast as another film requires only half ($\frac{1}{2}$) the exposure. Also, a film that is four times (4×) as fast as another film requires only one quarter ($\frac{1}{4}$) the exposure. This information can be applied directly to f/stops and shutter speeds.

For example, you have three cameras loaded with films of different speeds—ASA 100, 200, and 400—but only the camera with ASA 100 film has a built-in exposure meter. That's no problem because you can use one meter reading to figure the exposures for the other two films.

Say the meter in the camera with ASA 100 film gives an exposure of $\frac{1}{125}$ at f/5.6. Since the ASA 200 film is twice (2×) as fast, it requires only half ($\frac{1}{2}$) the exposure. That means you can shoot it at $\frac{1}{125}$ and use a smaller f/stop, f/8. *Or* you can keep the same f/stop, f/5.6, and increase the shutter speed to $\frac{1}{250}$. For the camera with ASA 400 film, which is 4 times (4×) as fast as the ASA 100 film, you need only one fourth ($\frac{1}{4}$) of the exposure. That means you close down the aperture two f/stops *or* increase the shutter by two speeds: $\frac{1}{125}$ at f/11 *or* $\frac{1}{500}$ at f/5.6.

These exposure concepts should become second nature to you once

you become familiar with f/stop numbers, shutter speed numbers, and film speed (ASA) numbers. Understanding their relationship is the first step toward effective use of your camera's exposure metering system, whether it is manual or automatic (also see page 200).

## Using the Camera's Exposure Meter

Exposure meters built into today's 35mm cameras are convenient and accurate, but you must master the use of the specific meter in your camera. The best guides are your camera's instruction booklet and some practice.

The first step in operating any meter is to set the film speed dial to the ASA number of the film you are using. Next, turn on the meter. On some models there is a special meter switch, but on many others the meter is activated when you slightly pull or push the lever used to cock the shutter.

Such off/on meter switches are designed to conserve the power of the batteries that operate the meter. If your meter does not operate when turned on, the battery (or batteries) may be dead or have dirty contacts. Meter battery life is usually one year, but cameras with automatic exposure systems may require that batteries be replaced more frequently. Some cameras have a method for checking the battery power, or a LED warning signal that indicates the batteries should be replaced. It is always a good idea to carry spare exposure meter batteries. This is especially true for cameras with automatic exposure control that have electronic shutters, because some models will not operate, even in the manual mode, if the batteries are dead. A few

have an "emergency" mechanical shutter speed that can be set when the electronic shutter will not work (usually because of battery failure).

The manner in which you use the meter for determining exposure depends on whether it makes center-weighted, overall (also called averaging or integrated), or spot (also called selective) readings. It also depends on whether your camera has automatic exposure control or is designed or set for manual adjustment of shutter speed and lens aperture.

The trend favors CENTER-WEIGHTED METERS, which are found on most cameras featuring automatic exposure control. A center-weighted meter gives more importance to the subject that appears in the center of your viewfinder and less to the subjects on the perimeter, especially in the top corners of a horizontally held camera. Manufacturers figure photographers usually center their main subject, so they designed the meter to give greater influence to the central portion of the picture you frame in the viewfinder. This center area may be marked on the camera's focusing screen. A drawing in the camera instruction booklet often indicates the specific degree of meter sensitivity in various areas of the viewfinder.

Center-weighted meters are designed to simplify metering and give more accurate readings, and this is essential in cameras with automatic exposure control. In the auto mode, you turn on the meter, set the f/stop of an aperture-priority model or the shutter of a shutter-priority model, compose the picture you want in the viewfinder, and press the shutter release. The meter reacts and automatically sets the shutter speed or f/stop that will give the best exposure.

That's quite simple, and the results are usually good in many situations. However, what if the most important part of your picture is not

Center-weighted or spot meters make it easier to get accurate exposure readings from the camera's position when the background is very dark (as in this photo) or very bright.

in the center? The camera-chosen exposure may not be appropriate, and the results could be very disappointing.

In such cases, the photographer must take control. You have three ways to do this: switch to the manual mode, activate the automatic exposure override, or adjust the exposure compensator.

The first method eliminates the camera's automatic exposure feature, and you manually adjust the shutter speed and aperture controls until the exposure meter readout indicates a correct exposure. Knowing the area appearing in the central portion of the viewfinder will have the greatest influence on the exposure reading, you aim the camera so the main subject is centered. After setting the exposure, you re-frame the subject in your viewfinder for the composition you want, and take the picture.

On cameras with automatic exposure control that have an override feature, you can lock in an exposure before taking the picture. This means you are free to aim the camera to make an automatic reading on any subject, and then lock in that exposure by slightly pressing the shutter release or pressing a special "memory lock" button. Afterward you re-aim the camera for the desired composition before fully pressing the shutter release to take the picture. (Also see page 32.)

A third approach to altering automatic exposure is to adjust the exposure compensator dial that is included on some models. It allows you to make automatic exposures that will be underexposed or overexposed. You turn the dial, which is usually marked in half-stops, to the amount of underexposure ( − ) or overexposure ( + ) desired, up to two stops. This is convenient when you judge that the normal automatic exposure will be incorrect because the meter reading is being made on something that is too dark or too bright (see page 65). You

compensate for this by setting the dial for a specific amount of overexposure or underexposure so the automatic exposure system will record the image the way you want it. (Also see page 203.)

Spot or averaging meters, or center-weighted meters, are found in cameras where exposure is manually controlled. An averaging meter reads all the light coming through the lens, while spot meters read only a designated portion of the image seen in your viewfinder. Some cameras are equipped with both types and have a switch marked "A" and "S" to select Averaging (overall) or Spot metering. A spot meter allows you to make an exposure reading on a portion of your subject or scene without having to get close to it. Regardless of the type, you turn on the meter, aim it, then adjust the shutter speed and/or aperture until the meter needle or LED in the viewfinder indicates correct exposure.

## Aiming an Exposure Meter

The mechanics of exposure meter systems have been outlined, but the most significant aspect of making a reading is aiming the meter correctly so the resulting exposure will produce the image you want on the film.

First, it is important to know just how much of the subject area your meter is reading. Technically, this is called the meter's ANGLE OF ACCEPTANCE, and it is indicated in degrees (°). In practical terms, it is easiest to make exposure readings with a single lens reflex camera that has a built-in meter, because you see through the lens exactly what the meter is reading. Of course, it is imperative that you know the type of

This hand-held exposure meter has a light acceptance angle of 30°. From the camera position, it will read an area that is similar in size to what you'd see through a SLR camera equipped with an 85mm lens (which has an angle of view of 29°).

30°

meter incorporated in the SLR: averaging (also called integrated or overall), center-weighted, or spot (also called selective).

With an averaging type, everything you see in the viewfinder is being read by the meter. With the center-weighted type, the meter reads everything you see in the viewfinder, but it gives emphasis to whatever appears in the center portion of the viewfinder. To guide you in making the best exposure reading, that center area may be marked on the camera's focusing screen or indicated on a diagram in the camera's instruction booklet. The area covered by a spot meter is limited to only a small portion of what is covered by the lens, and this is marked on the camera's focusing screen so you know exactly which part of the scene in your viewfinder is being read by the meter.

On rangefinder cameras with noninterchangeable lenses (which means all brands but Leica), the built-in meter usually is of the averaging type and reads the entire picture area that you see in the viewfinder.

Hand-held meters are averaging or spot types, and some can be switched from one to the other. Instructions accompanying hand-held meters indicate the meter's specific angle of acceptance. This may range 30° to 60° for averaging meters and 1° to 10° for spot meters. Some hand-held spot meters have a lens and viewfinder so you can see exactly what the meter is reading, and a few have a zoom control so you can vary the angle of acceptance.

When you know what area the hand-held meter is reading, and what area your camera lens is covering (i.e., its angle of view—see page 74), you can judge exposures more accurately. For instance, if a hand-held meter has an angle of acceptance of 50°, you know it is

For precise measurement of light, a hand-held spot meter with a lens and viewfinder can be aimed to read as little as one degree (1°) of the subject area.

reading an area that is similar to the area covered by a 50mm lens, which has an angle of view of 46°.

A basic question to consider at this point is just what an exposure meter does. In short, it reads and *averages* the intensity of the light reflected from or radiated by the subject area included in the meter's angle of acceptance. This reading of the subject's average brightness is presented to you in terms of the f/stops and shutter speeds to use for the best exposure.

For an exposure meter to do its job accurately, you must do two things: correctly set the meter for the speed (i.e., ASA) of the film you are using, and properly aim the meter. The first is not a problem (unless you're forgetful when you change to a faster or slower film), but the second thing can cause incorrect exposures and subsequent disappointment with your pictures.

To aim an exposure meter so it gives an accurate reading of what you are going to photograph, the relative brightness of the subjects in your picture must be considered. In some cases, the bright areas are referred to as HIGHLIGHTS and the dark areas as SHADOWS. When the subjects covered by your meter appear to have equal bright and dark areas, the exposure reading will result in a photograph with intensities of light that resemble what you saw in your viewfinder.

However, if the greatest portion of the scene you were reading was bright, the meter, because it averages all the light, would suggest an exposure that would produce a photograph that appears darker than the scene you actually saw. Likewise, if the greatest portion of the subjects your meter is reading is dark, it will suggest an exposure that produces a picture with subjects that appear brighter than when you photo-

Making an exposure reading of a snow scene takes special concentration because its brightness can cause your picture to be underexposed.

graphed them. These meter readings misguided you and caused an underexposed picture in the first instance, and an overexposed result in the second case.

To repeat, it is important to remember that exposure meters average the light, and this fact will guide you in aiming the meter in order to get a reading that will produce the photographic result you're after.

For example, let's say you're taking a portrait of a friend who's illuminated by strong sidelight. Thus one side of her face is bright, and the other side is dark. If your hand-held meter or camera with a built-in meter was pointed so the meter's angle of acceptance includes both sides of her face, meaning it reads equal amounts of highlight and shadow, the photograph would present the person as you viewed her: one side of her face is bright, the other side is dark. However, in studying your subject, you'll notice that neither side of her face has much detail.

Now you decide that the most dramatic portrait would be one with more detail in the bright side of her face (i.e., in the highlights) and less detail in the dark side (shadows). To get an exposure that would achieve this, you aim your meter so it mostly covers the bright side of her face. Since the meter averages this bright light, which results in less exposure, everything in the photograph is somewhat darker and so the highlights now have greater detail, just as you desired. Of course, the shadows also have less detail.

On the other hand, if you wanted to emphasize the detail in the shadowed side of the face, you aim your meter to read mostly that dark area. Overexposure would be the result, lightening up the shadows for more detail in the dark side of the face. However, the highlight

Making an exposure reading of a subject on overcast days is easier than on sunny days, because bright highlights and dark shadows are absent and the subject is more evenly illuminated.

areas would be brighter too, which would probably be distracting because details in that side of the face would be washed out. (For sidelighted portraits, exposing for the highlights instead of the shadows is usually the choice that produces the most pleasing photograph.)

Here are a few more examples to show you that knowing an exposure meter's specific coverage (i.e., angle of acceptance) and that it averages the intensity of the light it reads will guide you in making accurate meter readings in various lighting situations.

Say you're taking a picture of an illuminated sign at night. If a dark sky around the sign predominates in the scene you have framed in your viewfinder, it can wrongly affect your meter reading. The meter will indicate an extensive exposure is required because so much of the subject area is dark. This results in an overexposed sign and a sky that's too bright. For a more accurate exposure, you should make certain your meter reading is mostly of the sign. Fill your frame with the sign by getting closer when you make the reading, then step back to your original position to take true picture. Or use a spot meter that reads more of the sign than the sky.

Another example when careful metering is required for the most pleasing picture is when your subject is backlighted. If too much of the backlight is read by the meter, it will cause underexposure and your subject will appear almost as a silhouette. For an exposure that shows detail in your subject, get closer so your meter mostly reads the subject rather than the bright backlight.

Shots of snow or a sandy beach can be troublesome because your meter perceives very bright areas and indicates readings that result in underexposure. This gives detail to the snow and sand, but the overall

scene as you saw it may appear unnaturally dark in the photograph. You should compensate by giving more exposure than the meter indicates.

Becoming familiar with your exposure meter system is basic to successful photography; it insures that you aren't constantly playing a guessing game and wasting film. Photographers who buy cameras with automatic exposure control should especially take notice because many think they can just point and shoot, and let the metering system worry about the exposure. In general shooting situations that's true, but there are times when you should use the camera's automatic exposure override or compensator. Technical instructions for their operation are usually outlined in detail in the camera's instruction manual.

## Exposures with Flash

You should also become familiar with methods for determining and setting exposures when flash equipment is used. Electronic flash units are most common today, making flash bulbs and reflectors a thing of the past for most 35mm camera users. And in this age of electronic advancement, many of the electronic flash units control exposure automatically. Also, some of the recent automatic exposure cameras are designed for use with special flash units that give even more exacting flash exposure control.

Most of those camera-coupled (integrated) flash units automatically set the camera's shutter speed for proper flash synchronization when the flash unit is inserted in the camera's hot shoe and turned to the automatic mode.

Flash is discussed in detail in a following chapter, but in summary,

exposure for flash is determined by the distance the flash is from the subject. The actual f/stop to use is calculated by dividing that distance into the FLASH GUIDE NUMBER, a number that depends on the speed of your film and the light output of the flash unit. (For proper flash synchronization, 35mm cameras with focal plane shutters—all SLR and Leica rangefinder models—have a maximum speed at which they can be set, usually $\frac{1}{60}$ or $\frac{1}{125}$ or a special speed in between.)

With electronic flash units with automatic exposure control, you set a specific f/stop on the camera lens, and the flash automatically adjusts the power of its light output according to the distance of your subject. Also, there are special lenses, like Nikon's GN (for Guide Number) and Canon's CAT, which automatically change the f/stop as the lens is focused in order to give correct flash exposures.

## Figuring Multiple Exposures

Your camera's instruction booklet may also describe techniques for making multiple exposures (see page 37). On some of the newer 35mm SLR models, a special multiple exposure control disengages the film advance mechanism (and film frame counter) so the shutter can be recocked for additional exposures on the same frame of film.

Mechanics aside, the photographer's main concern is figuring exposure when making multiple exposures. There's little problem at night or when the background is black, if the various images do not overlap, because you can use the normal exposure for each one. However, when the subjects overlap, or the background is light, the film will be overexposed if the normal exposure for each subject is used. Instead, you must underexpose each shot so the combined exposures will produce a

picture that appears properly exposed. This usually takes some experimental work, depending on your subjects, the extent of overlapping, and lighting conditions. As a rule of thumb, when making a double exposure, cut the normal exposure for each shot in half. For example, if both of your subjects give a meter reading of $\frac{1}{125}$ at f/5.6, then shoot each one at $\frac{1}{125}$ at f/8 (or hold the f/stop at f/5.6 and increase the shutter speed to $\frac{1}{250}$).

## Exposures When Using Lens Attachments

There are some other exposure considerations, which depend on the lenses or lens attachments you mount on a SLR camera. Keep in mind that the most convenient lenses have automatic aperture control. This means the lens aperture is always at its widest opening, even when the aperture control ring is being adjusted for the proper exposure (sometimes called OPEN APERTURE METERING). This enables you to always see the brightest image possible through the viewfinder, which is ideal for sharp focusing, for checking composition, and for aligning the built-in meter needles or index marks for correct exposure. When the shutter release is pressed, the lens automatically stops down to the preselected f/stop while the shutter opens to expose the film, and then the lens reopens to its maximum aperture.

On lenses without automatic aperture control, the image in your viewfinder gets darker as you stop down to set the lens aperture to the proper f/stop for exposure.

Even if lenses have automatic aperture control, that convenient feature may be lost when lens attachments are inserted between the lens and camera. These attachments include extension tubes and bel-

lows, lens converters or tele-extenders, and lens reversing rings. Depending on their design, they may or may not disengage the automatic aperture control. If they do, you will have to adjust the aperture manually before releasing the shutter to make an exposure.

Be advised that cameras with automatic exposure systems featuring shutter-priority will not function in the automatic mode when such lens attachments are used. That's because the camera connections that adjust the lens aperture are disengaged. Therefore, if you plan to purchase a camera with automatic exposure control and you expect to make frequent close-up photographs with extension tubes or a bellows or a reversed lens, an aperture-priority automatic camera is your best choice. After focusing the lens at full aperture, you manually stop down for the depth of field desired, then press the shutter release and let the camera automatically set the shutter speed for the proper exposure.

Certainly the use of automatic exposure controls in 35mm cameras has enabled photographers to concentrate more on their subjects and composition, but you must not think that automatic exposure systems are foolproof. Experience with your particular camera will reveal its limitations regarding automatic exposure and will help you learn how to overcome them.

**3**

Lens Choice
and Use

Many photographers become perplexed trying to figure out which one of the many modern cameras is best for them to buy, but deciding on which lenses to purchase can be even more frustrating. While there are a hundred or so models of modern 35mm cameras, there are literally thousands of lenses. Besides lenses made by camera manufacturers specifically for their own models, there are lenses from other optic makers that can be used with a variety of camera brands.

This chapter describes not only the numerous types of lenses and lens attachments for 35mm cameras, it also gives suggestions for their use. This should help you decide which lenses and lens attachments are best for the kinds of pictures you like to take.

First, you should be aware that most rangefinder cameras are equipped with a lens that is permanently attached (Leicas are the exceptions). You cannot change lenses on such cameras, although close-up lenses can be attached to the front of the regular lens so you can move closer to the subjects and get a larger size image on the film.

Lenses can be changed on all 35mm single reflex cameras, which is one of the main reasons for the SLR's popularity. What's wrong with just using the so-called normal lens that the manufacturer usually sells with a camera? Nothing. In fact, it reproduces the subject or scene in about the same proportions seen by the human eye. However, there are many other lenses that increase the camera's versatility, and these offer photographers greater choices for creativity.

The following is a list of types of 35mm lenses and lens attachments:

GENERAL LENSES                     Telephoto
  Wide-angle                      Zoom
  Normal                          Macro

Most camera manufacturers, like Minolta, make a number of different lenses for their own models. Also, lens manufacturers make various lenses that can be used with several brands of cameras.

SPECIAL LENSES
Fish-eye
Perspective correction (PC)
Mirror

LENS ATTACHMENTS
Tele-extenders (or lens converters)
Close-up lenses
Lens reversing rings
Extension tubes (or rings)
Extension bellows

Microscope adapter
Telescope adapter

SPECIAL EFFECTS ATTACHMENTS
Filters
Soft focus
Cross screen (or star)
Multiple image
Split field
Fish-eye converter

## Lens Focal Length

Before discussing each type of lens and lens attachment in detail, including reasons and ways to use them, you should know that lenses are commonly classified by FOCAL LENGTH. Focal length can be defined as the distance from the optical center of a lens set at infinity to the point where the light rays passing through the lens come into focus (i.e., the focal plane). That distance is measured in millimeters (mm) and is engraved on the metal retaining ring holding the front optics of the lens.

The focal length of lenses for 35mm SLR cameras, which ranges from 6mm to 2000mm, indicates the general lens type: wide-angle, normal, or telephoto. Any lens between 13mm and 35mm is considered a WIDE-ANGLE, lenses between 50mm and 55mm are called NORMAL or standard, and any lens with a focal length of 85mm or longer is said to be a TELEPHOTO. There are some extreme wide-angle lenses, more

commonly known as FISH-EYE LENSES, that have focal lengths ranging from 6mm to 17mm. (These lens type classifications are only for 35mm SLR cameras; cameras with larger or smaller film formats have lenses with different "standard" focal lengths, such as 80mm, which is considered a normal lens for 2¼-inch square (6×6cm) cameras.)

ZOOM LENSES have variable focal lengths and are not so easily classified. A 28-45mm lens can be considered a wide-angle zoom, a 43-86mm is sometimes called a short telephoto zoom, a 70-210mm or an 80-200mm lens often is termed just a telephoto zoom, and lenses with greater focal lengths, such as 180-600mm or 360-1200mm can be described as long (or super) telephoto zooms.

MACRO LENSES are designed for close-up work, but they can be used for general photography and also are classified by their focal length, such as 55mm (normal) and 105mm (short telephoto).

Besides identifying the general type of lens, focal length indicates the relative size of a subject's image. *The longer the focal length, the larger the subject's image size.* Because the size of the image is proportional to the focal length of the lens, you can figure how much larger or smaller the subject's image will be before you switch to another lens. For example, changing from a 50mm lens to a 100mm lens will double the size of the subject's image. Similarly, replacing a 50mm lens with a 500mm lens will increase the size of the image ten times.

## Lens Angle of View

Another thing to know is the ANGLE OF VIEW of a lens, which indicates in degrees (°) how much of an area the lens will cover. *The longer the focal length, the narrower the angle of view.* To realize the wide

**Left** Wide-angle lenses inherently have greater depth of field and usually some distortion. (Notice alignment of the wagon's wheels.)  **Right** Telephoto lenses enable you to make full-frame pictures of a subject, even when it is physically impossible to get close to the subject.

| Lens Type | Focal Length (mm) | Angle of View (°) |
|---|---|---|
| Fish-eye | | |
| Circular format | 6 | 220 |
| | 7.5 | 180 |
| | 8 | 180 |
| | 10 | 180 |
| Rectangular format | 15 | 180 |
| | 16 | 170/180 |
| | 17 | 180 |
| Wide-angle | 13 | 118 |
| | 15 | 110 |
| | 17 | 104 |
| | 18 | 100 |
| | 20 | 94 |
| | 21 | 90 |
| | 24 | 84 |
| | 28 | 75 |
| | 35 | 63 |
| Normal (standard) | 50 | 46 |
| | 55 | 43 |
| Telephoto | 85 | 29 |
| | 100 | 24 |
| | 105 | 23 |
| | 120 | 21 |
| | 135 | 18 |
| | 150 | 17 |
| | 180 | 14 |
| | 200 | 12 |
| | 250 | 10 |
| | 300 | 8 |
| | 350 | 7.5 |
| | 400 | 6 |
| | 500 | 5 |
| | 600 | 4 |
| | 800 | 3 |
| | 1000 | 2.5 |
| | 1200 | 2 |
| | 1600 | 1.5 |
| | 2000 | 1.2 |

With the camera mounted on a tripod placed at the edge of a cliff, this marina was photographed with four lenses of different focal lengths. The 21mm lens, a wide-angle lens, covers the greatest angle of view, while the longest telephoto lens used, a 400 mm, shows the least angle of view.

21mm wide-angle lens

50mm normal lens

150mm telephoto lens

400mm long telephoto lens

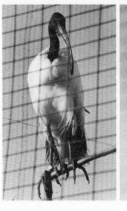

If you understand depth of field, you can almost make a bird cage disappear. **Left** Taken with a 400mm telephoto lens, this shot of an ibis was made at a small lens aperture, f/22, which increases depth of field and shows the cage wires in front and behind the bird. **Right** When the same lens was opened to its widest aperture, depth of field was reduced so much that the wires went out of focus and literally disappeared.

range in angles of view, just consider that 6mm fish-eye (extreme wide-angle) lens will cover 220°, while a 1200mm (extreme telephoto lens) covers only 2°. A normal lens of 50mm has a 46° angle of view. These represent diagonal measurements of the subject area covered by a lens, not just its horizontal or vertical coverage.

On page 75 is a list of the angles of view for 35mm SLR camera lenses of the most common focal lengths (actual degree of coverage may vary slightly, according to the lens' manufacturer).

## Lens Depth of Field

In addition to focal length and angle of view, another aspect of lenses to know about is depth of field. Depth of field refers to how much of your picture area will be in sharp focus, and it is measured from the point in focus nearest the camera to the point in focus farthest from the camera. Depth of field is determined by three factors: the focal length of the lens, the aperture at which the lens is set, and the distance at which the lens is focused.

There are some rules of thumb regarding depth of field which you should remember. First, *the shorter the focal length, the greater the depth of field*. This means that wide-angle lenses inherently get more of the picture area in focus than do normal or telephoto lenses.

Secondly, *the closer the point at which the lens is focused, the shallower the depth of field*. This means depth of field is inherently greater when you are focused on distant subjects than when you are focused on subjects nearby.

A third rule is *the smaller the lens aperture used, the greater the*

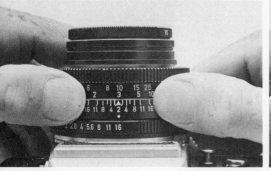 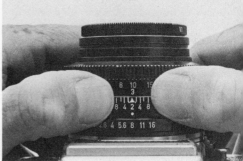

*depth of field.* This means more of your picture will come into focus as you stop down the lens.

Depth of field is a vital but often neglected control for creating the images and impact you want in your pictures. For instance, to show the relationship between subjects in the foreground and in the background, they should both be in focus. Unless you put your knowledge of depth of field to work, you may take a picture with front or rear subjects out of focus, and thus your photograph will not be what you wanted.

How do you make sure subjects in both the foreground and background will be in focus? There are some choices: Close down the lens to a small f/stop, like f/11 or f/16, refocus the lens on a point that is one-third beyond the foreground subject and two-thirds in front of the background subject, shoot at a greater distance from the subjects, or switch to a lens of shorter focal length.

On the other hand, if you want your subject to stand out from the background, the background should be out of focus. How can you be certain the foreground subject will be sharp and the background fuzzy? Here are some choices for getting shallow depth of field: Open up the lens to a wide aperture, like f/2 or f/2.8, change the lens focus to a point in front of the subject (exact distance will depend on the f/stop being used—see depth of field discussion), shoot closer to the subject, or switch to a lens of longer focal length.

There are three ways photographers can determine depth of field more exactly. Most commonly they refer to the DEPTH OF FIELD SCALE engraved on the lens. This is a set of matched numbers, identical to f/stop numbers, extending both left and right from the lens' point of

A depth of field scale, represented by opposing pairs of f/stop numbers, shows you the limits of the picture area that will be in focus. **Left** In this example, shooting at f/16, look opposite the "16s" on the depth of field scale to the distance numbers on the focusing ring (top numbers are feet; bottom numbers are meters). With the lens focused at 10 feet, everything between 6 feet and 25 feet will be in focus. **Right** When a wider f/stop is used, depth of field decreases. Here the lens is still focused at 10 feet, but the aperture has been opened up to f/8; now the picture area that will be in focus ranges between a little before 8 feet to almost 15 feet.

focus index mark. The smallest numbers (which represent the widest apertures) are closest to the focus mark.

The spaces between the numbers on the depth of field scale will be wider on wide-angle lenses and narrower on telephoto lenses than they are on normal lenses. In some cases, because of limited space, not all numbers are engraved on the scale. They may be represented by lines, or you may just have to imagine them being there. For instance, the scale may show only paired numbers of 4, 8, 11, and 16, with lines (or nothing) to represent 2, 2.8, 5.6, and the lens' maximum aperture opening. In the case of Nikon lenses, depth of field scales are shown in white, yellow, green, and pink lines, which are coded to the colors of the f/stop numbers on the aperture control ring.

After focusing on your subject and making a meter reading to determine exposure, you can check the depth of field to determine how much of what you framed in the viewfinder will be in focus in your picture. Find the paired numbers (or lines) on the depth of field scale that correspond to the f/stop you are going to use. Now look exactly *opposite* those two numbers (or lines) to the distances engraved in feet (or meters) on the lens focusing ring. They indicate the near and far limits of focus. There isn't space to engrave numbers for all distances, so you'll have to figure some approximations.

Of course, if you change the f/stop or readjust the focusing ring, the depth of field will change accordingly.

Another way photographers check depth of field is by doing it visually through the viewfinder. Pressing the DEPTH OF FIELD PREVIEW BUTTON will stop down the lens to the aperture selected for exposure, so you can see your subject exactly as the film will. However, the

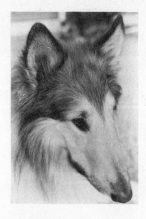

Depth of field is very limited when you are close to your subject and are using a wide f/stop, so critical focusing is required (in this case, on the collie's eye).

accuracy of this method for determining what the depth of field will be in your picture is dependent on the photographer's own eyesight. Also, at smaller apertures, the subjects become dark and it is more difficult to judge their sharpness through the viewfinder.

The most accurate method for checking how much of your picture will be in focus is to consult a DEPTH OF FIELD CHART that corresponds to the focal length of your lens. The chart that some manufacturers supply for each particular lens, as the one shown here for Nikon 50mm f/1.4 lens, is very exacting. Often it is inconvenient and time-consuming to check depth of field charts, so most photographers make do with the depth of field scale on the lens or check the limits of focus visually by using the depth of field preview control.

Besides understanding the common characteristics of lenses, such as depth of field, focal length, and angle of view, each type of lens has distinct features and functions, and these will be described separately.

## Normal Lenses

A 35mm camera's normal lens is called that because the image it produces shows subjects in size relationships that are similar to what you see with your eyes. A normal lens is considered the prime optic for the camera(s) it was designed to be used with, and that means it gives the most perfect picture possible, with few if any of the common lens aberrations that can affect the sharpness, shape, or color of an image.

A normal lens usually has the widest maximum aperture of any type of lens. At the very least, this will be f/2, but more than likely the f/stop will be as large as f/1.8, 1.7, 1.4, or even 1.2. Because it lets in so much light, a lens with a wide maximum aperture is called a

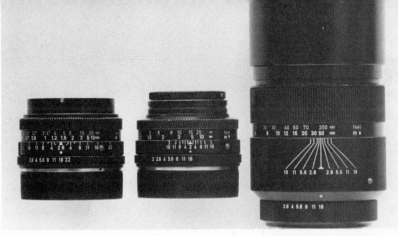

Lenses with shorter focal lengths, and those used at smaller lens openings, give greater depth of field. Compare the depth of field scales on these lenses (28mm, 50mm, 180mm) at a very small aperture, f/16. The infinity mark (∞) on each lens focusing ring has been turned to the right-hand "16" (representing f/16) on the depth of field scale to set the farthest point that will be in focus at infinity. Now, looking opposite the left-hand "16" on the three depth of field scales, you'll see that the nearest point in focus on the 28mm wide-angle lens (left) will be 30 inches, on the 50mm normal lens (middle) it will be 8 feet, and on the 180mm telephoto lens (right) it will be about 80 feet.

| Focused distance | Depth of field | | | | | | | |
|---|---|---|---|---|---|---|---|---|
| | f/1.4 | 2 | 2.8 | 4 | 5.6 | 8 | 11 | 16 |
| 1.5 | 1'5-7/8"– 1'6-1/16" | 1'5-13/16"– 1'6-1/8" | 1'5-3/4"– 1'6-3/16" | 1'5-11/16"– 1'6-1/4" | 1'5-9/16"– 1'6-3/8" | 1'5-7/16"– 1'6-9/16" | 1'5-3/16"– 1'6-13/16" | 1'4-7/8"– 1'7-1/4" |
| 1.7 | 1'8-1/4"– 1'8-1/2" | 1'8-3/16"– 1'8-9/16" | 1'8-1/8"– 1'8-5/8" | 1'8"– 1'8-3/4" | 1'7-13/16"– 1'8-15/16" | 1'7-5/8"– 1'9-3/16" | 1'7-3/8"– 1'9-1/2" | 1'6-15/16"– 1'10-1/8" |
| 2 | 1'11-3/4"– 2'3/16" | 1'11-11/16"– 2'1/4" | 1'11-9/16"– 2'3/8" | 1'11-7/16"– 2'9/16" | 1'11-3/16"– 2'13/16" | 1'10-7/8"– 2'1-3/16" | 1'10-1/2"– 2'1-11/16" | 1'9-7/8"– 2'2-9/16" |
| 2.5 | 2'5-5/8"– 2'6-5/16" | 2'5-1/2"– 2'6-7/16" | 2'5-5/16"– 2'6-5/8" | 2'5-1/16"– 2'6-15/16" | 2'4-11/16"– 2'7-3/8" | 2'4-3/16"– 2'8" | 2'3-5/8"– 2'8-7/8" | 2'2-5/8"– 2'10-3/8" |
| 3 | 2'11-1/2"– 3'1/2" | 2'11-1/4"– 3'11/16" | 2'11"– 3'1" | 2'10-5/8"– 3'1-7/16" | 2'10-1/8"– 3'2-1/16" | 2'9-3/8"– 3'3-1/16" | 2'8-1/2"– 3'4-3/8" | 2'7-1/8"– 3'6-13/16" |
| 3.5 | 3'5-5/16"– 3'6-11/16" | 3'5"– 3'7" | 3'4-5/8"– 3'7-3/8" | 3'4-1/16"– 3'8-1/16" | 3'3-3/8"– 3'8-15/16" | 3'2-3/8"– 3'10-3/8" | 3'1-3/16"– 4'5/16" | 2'11-7/16"– 4'3-7/8" |
| 4 | 3'11-1/16"– 4'7/8" | 3'10-11/16"– 4'1-5/16" | 3'10-3/16"– 4'1-7/8" | 3'9-1/2"– 4'2-3/4" | 3'8-9/16"– 4'3-15/16" | 3'7-5/16"– 4'5-15/16" | 3'5-3/4"– 4'8-9/16" | 3'3-1/2"– 5'1-11/16" |
| 5 | 4'10-9/16"– 5'1-1/2" | 4'9-15/16"– 5'2-1/8" | 4'9-3/16"– 5'3-1/16" | 4'8-1/16"– 5'4-1/2" | 4'6-5/8"– 5'6-1/2" | 4'4-11/16"– 5'9-13/16" | 4'2-3/8"– 6'2-7/16" | 3'11-1/16"– 6'11-13/16" |
| 7 | 6'9-1/8"– 7'3-1/16" | 6'7-15/16"– 7'4-7/16" | 6'6-7/16"– 7'6-5/16" | 6'4-5/16"– 7'9-3/8" | 6'1-11/16"– 8'1-13/16" | 5'10"– 8'9-5/16" | 5'5-15/16"– 9'8-9/16" | 5'3/16"– 11'10" |
| 10 | 9'6-1/8"– 10'6-7/16" | 9'3-13/16"– 10'9" | 9'7/8"– 11'2" | 8'8-3/4"– 11'9" | 8'3-1/16"– 12'7" | 7'9"– 14'2" | 7'1-7/8"– 16'10" | 6'4-3/16"– 24'9" |
| 15 | 13'11"– 16'3" | 13'6"– 16'11" | 13'0"– 17'9" | 12'3"– 19'4" | 11'5"– 21'10" | 10'5"– 27'3" | 9'5"– 39'5" | 8'0"– 160' |
| 30 | 25'11"– 35'8" | 24'6"– 38'9" | 22'10"– 43'11" | 20'8"– 54'11" | 18'5"– 82'5" | 15'10"– 338' | 13'6"– ∞ | 10'10"– ∞ |
| ∞ | 188'– ∞ | 131'– ∞ | 93'11"– ∞ | 65'10"– ∞ | 47'1"– ∞ | 33'1"– ∞ | 24'1" ∞ | 16'8"– ∞ |

Instructions for lenses usually include a specific depth of field chart, like this one for Nikon's 50mm f/1.4 normal lens. It indicates the precise near and far limits of focus at various f/stops when the lens is focused at various distances (in feet). For example, when the lens aperture is set at f/8 and the lens is focused at 10 feet, everything between 7 feet 9 inches and 14 feet 2 inches from the camera—or more exactly, from the film plane—will be in focus.

A normal lens is frequently 50mm or 55mm for 35mm single lens reflex (SLR) cameras, and somewhat wider— often 40mm—for 35mm rangefinder cameras. It represents a subject or scene as normally seen by your eyes.

Wide-angle lenses offer considerable depth of field, as well as giving a feeling of depth.

"fast" lens. Such a lens is ideal for shooting in low-light situations or when you must use a slow film.

The wide aperture also permits the easiest focusing because it transmits the brightest image possible to the camera's viewfinder. With the aperture wide open, a normal lens has such limited depth of field that it is ideal for shooting situations when you want a very limited part of your subject in focus. In addition, a normal lens is a frequent choice of photographers who use extension tubes or bellows to make extreme close-ups, including images that are life size or larger.

## Wide-Angle Lenses

When photographers purchase a "second" lens, very often it is a wide-angle type. Such lenses have short focal lengths and cover a wider field of view than a normal lens. They range from 35mm to 13mm, with those of 28mm and 24mm focal length being especially popular. Wide-angle lenses are frequently used for interior, architectural, and landscape photography. One reason is that they provide great depth of field, which means it is possible to have both foreground and background objects in sharp focus. (Of course this can be a disadvantage in situations when you want only a limited part of the picture area to be in focus.)

Photojournalists like wide-angle lenses because they can work in cramped quarters and still cover a wide subject area. Also, when the action happens quickly and there's no time to focus precisely, the photographer can stop down to a small lens opening for great depth of field and know his subject will be recorded in sharp focus.

There are some wide-angle zoom lenses and these make composition

A wide-angle lens can create distortion of parallel lines, as with this building, which was taken with a 28mm lens and seems to lean inward.

easier. That's because you can frame the subject exactly as desired simply by adjusting the zoom lens' focal length instead of changing the camera's position or switching lenses. The optical design of wide-angle zoom lenses is complex, and one of the widest ranges available is 24-48mm (see page 92).

Objects in the foreground become more prominent than background objects when a wide-angle lens is used. This helps create the illusion of depth, because background objects appear to be a greater distance from foreground objects than they actually are. Wide-angle lenses, particularly those with very short focal lengths, create distortion, which can be detrimental in some situations and used effectively in others. The closer the subject is to the lens, the greater the distortion, so wide-angle lenses are rarely used for close-up portraits of people unless you want your subject to look grotesque.

Distortion also is more evident at the edges of your picture, especially when the plane of the lens is not kept parallel to the plane of the subject. For example, if you are photographing a building and the wide-angle lens is aimed upward, the building's vertical lines will tilt inward toward the top of your picture. When the camera is pointed downward, vertical length at the edge of your picture will slant inward toward the bottom of the photo.

Regarding the maximum lens opening on wide-angle lenses, the shorter the focal length, the smaller the widest f/stop. A 28mm lens, for example, may have a maximum aperture of f/2.8, but on a 15mm lens it may be f/5.6, which is two stops less. Usually, the smaller the f/stop, the more difficult it is to focus a lens while looking through the viewfinder of a single lens reflex camera. However, this is not much of a concern with wide-angle lenses because the shorter their focal

Many fish-eye lenses are characterized by a circular format and extensive distortion.

length, the greater the depth of field. What is more of a problem with short focal length lenses with small maximum f/stops is making exposures when the light is dim or when slow film is in the camera.

## Fish-Eye Lenses

Extreme wide-angle lenses are known as fish-eye lenses because their front optics bulge out. The shortest of their focal lengths is 6mm, which has an angle of view of 220°. That means the lens actually can see behind itself, so the photographer must be careful not to get his feet, hands, or possibly his hat in the picture. More commonly, fish-eye lenses are of 7.5mm or 8mm and cover an area of 180°. They produce a circular image on the film. The maximum aperture on fish-eye lenses can be as wide as f/2.8.

Because of their great depth of field, some fish-eye lenses have *fixed focus,* which means focusing is not required. A few have a rear lens element that protrudes so far into the camera that the SLR's viewing mirror must be locked up out of the way. Of course, that prevents you from seeing through the viewfinder, so an accessory fish-eye viewfinder should be mounted on the camera for more exacting use of the lens.

Fish-eye lenses were originally created for surveillance work and industrial photography, where extra wide views inside confined quarters were required. Later they caught on with advertising and commercial photographers. For use in general photography, however, pictures made with fish-eye lenses quickly become monotonous because of their circular format and small, distorted images. They are quite costly as well, so photographers who like to make occasional pictures with the

Some fish-eye lenses produce rectangular images rather than circular ones, but some distortion is still evident.

fish-eye effect are usually content to use a less expensive fish-eye lens attachment (see page 132).

With the advancement of camera lens technology and construction in recent years, there are other types of extreme wide-angle lenses available now that are also included in the fish-eye category. However, they do not have the bulging-optic look and they do not produce circular images. Such lenses still give extremely wide coverage, as much as 170° or 180°, but they are more useful for general photography because they fill the full film frame with a rectangular image, and their edge distortion is minimal. Curvature of straight lines is still a characteristic, however, that gives a "roundness" to the subject or scene and is a clue that the picture was taken with a fish-eye lens.

There may be some confusion regarding focal lengths of fish-eye and "regular" wide-angle lenses. You'll recall a rule of thumb: the shorter the focal length, the wider the angle of view. This is not necessarily an accurate guide to follow when selecting fish-eye lenses that produce a full frame rectangular (rather than circular) format. For example, Nikon's 16mm Fisheye-Nikkor lens has an angle of view of 170°, while a "regular" wide-angle of shorter focal length, the 15mm Nikkor, covers just 110°. So, despite its longer focal length (16mm vs. 15mm), the fish-eye lens gives a wider angle of view (170° vs. 110°).

The important thing to remember is that fish-eye lenses, in order to cover such extremely wide angles of view (which range from 170° to 220°, regardless of circular or rectangular format), have an inherent characteristic: straight lines in the subject will appear curved. Thus, you know that any lens labeled a "fish-eye" by its manufacturer will produce images with curving lines.

Compared to fish-eye lenses, "regular" wide-angle lenses can be *linearly corrected*, which means the subject's straight lines will be straight in the picture (however, those lines will still appear distorted in relation to one another if the lens plane is not parallel to the subject plane when the picture is taken). There are optical limitations to producing lenses with linear correction, and the shortest focal length of such lenses is 15mm, which gives a 110° angle of view.

Also, because of necessary limitations in their optical design, linearly corrected lenses of short focal lengths have smaller maximum apertures. Nikon's 15mm wide-angle lens only has a maximum opening of f/5.6, for example, while Nikon's 16mm fish-eye (rectangular format) has a maximum aperture of f/3.5 and its 8mm fish-eye (circular format) can be opened up to f/2.8.

As a general rule regarding wide-angle lenses, the wider the angle of view, the greater the distortion—unless the lens is linearly corrected. Linearly corrected lenses are available in the more extreme wide-angle range, between 15mm and 21mm (excluding fish-eye lenses), but they are considerably more expensive than ordinary wide-angle lenses of identical focal lengths.

## Telephoto Lenses

Telephoto lenses have longer focal lengths than wide-angle or normal lenses, thus their angle of view is narrower and they produce subject images that are larger. They are ideal to use when you can't move your camera close enough to the subject to get the size of image you desire.

Telephoto lenses have other characteristics that are important to know. First, depth of field is shallow, thus making it easy for you to

A telephoto lens helps you get close-up pictures of subjects without physically getting closer to them.    **Top**   This photo of lazy lions in a zoo was taken with a normal lens and included the uninteresting lioness at the lower right.    **Bottom**   The composition is improved and the impact is greater in this picture, which was taken with a telephoto lens.

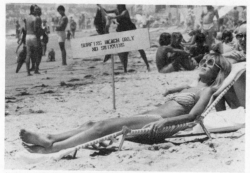

400mm long telephoto lens                    100mm telephoto lens

Perspective changes according to the focal length of the lens you use. A telephoto decreases the illusion of depth between foreground and background subjects, while a wide-angle lens increases it. Study how the background has been affected in these photos, which were made with 400mm, 100mm, 50mm, and 21mm lenses. The camera was moved forward each time to keep the foreground subject, the sunbather, the same size in all four photos.

With a telephoto lens of fixed focal length or the zoom type, you don't have to be close to the action to capture it.

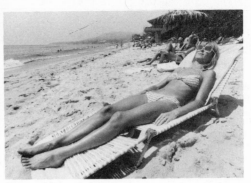

50mm normal lens                21mm wide-angle lens

separate the main subject from the foreground or background. Conversely, this means focusing with a telephoto lens is especially critical.

Also, because the subject image is more magnified, it is imperative that the camera be very steady, or that a very fast shutter speed be used, to avoid getting a blurred image. (As a rule of thumb, when hand-holding the camera use a minimum shutter speed that is closest in number to the telephoto lens focal length, such as $\frac{1}{125}$ second for a 105 or 135mm lens, $\frac{1}{250}$ for a 200mm or 300mm lens, and a $\frac{1}{500}$ for a 500mm lens.)

The *perspective* you get with a telephoto lens is characterized by a flattening or compression of the distance or space between the foreground and background objects. This minimizes the illusion of depth. The differences in scale between near and distant objects also are reduced by the use of a telephoto lens.

Telephoto lenses range in focal length from 85mm to 1200mm. Figuring which ones are most practical for your photographic interests is not easy because of the great variety available. Traditionally, the most popular telephoto for casual use has been the 135mm. In addition, many photographers favor an 85mm or 105mm telephoto for portraiture work because they do not have to get uncomfortably close to their subjects to fill the film frame. Also, those short telephotos give a perspective that is quite flattering to the portrait subject. Telephotos of longer focal length, usually from 180mm or 200mm and longer, are preferred for sports and wildlife photography. (Photographers who can't seem to decide which telephotos are best for them often decide on a telephoto zoom lens so they have a choice of focal lengths in a single lens—see page 92.)

Besides focal length, purchasers of a telephoto should consider its

Mirror lenses have larger diameters and unusual optical design.

length, weight, maximum aperture, sharpness, construction, and, of course, cost. New computer-designed telephotos, particularly those for the more recent compact 35mm cameras, are shorter and lighter than many of their predecessors, and they have larger maximum apertures as well. This makes them much more convenient to carry and to use in low light conditions. Sharpness has also been improved in the newer lenses, which is especially appreciated when shooting at the wider apertures.

Construction of a telephoto lens, and also the term of its warranty, should be carefully checked, because a long lens often receives greater, although unintentional, abuse. With their extended length, telephotos inadvertently get banged into things. Also, rather extensive turning of the lens barrel is required to cover a telephoto's full range of focusing, and the elements in a poorly constructed lens can go out of optical alignment with aggressive or constant adjustment of the focusing ring.

Minimum focusing distances are greater for telephoto lenses than for normal or wide-angle lenses. For example, with a 135mm telephoto, the closest focusing distance to a subject is 5 or 6 feet.

Some telephoto lenses are called MACRO or CLOSE FOCUS TELEPHOTO LENSES. They can be focused at shorter distances to the subject and thus will produce larger sized images than ordinary telephoto lenses of comparable focal lengths (see page 96).

## Mirror Lenses

There is another category of telephoto lenses called MIRROR or REFLEX LENSES. Using mirrors with conventional optics, they are like many of the modern astronomical telescopes of catadioptric (mirror-reflex) de-

Advantages of mirror telephoto lenses include their short length (and lighter weight). Compare the 500mm mirror lens at top with the longer but less powerful 400mm telephoto lens with conventional optics. Using a tripod when shooting with such long telephoto lenses assures steadiness, and fastening it to a special tripod socket on the lens instead of the camera body gives better balance and support.

sign. The incoming light is bent twice by mirrors in the lens, which allows the lens to be shorter in length and lighter in weight than regular telephotos of the same focal length.

The most common mirror lenses are 500mm and 1000mm, although Nikon makes one that is 2000mm. Celestron Corporation even offers a mirror lens of 3900mm, which means it magnifies the image almost 80 times more than a normal (50mm) lens and has an angle of view little more than ½°.

Mirror telephotos have a fixed f/stop, usually no wider than f/8, and this means you have to control exposure by adjusting the shutter speed, using neutral density filters, or both (see page 120).

One advantage of mirror lenses is their ability to focus on subjects at closer range than conventional telephotos. For example, the Pentax Reflex (mirror) 1000mm lens will focus as close as 26¼ feet, while the minimum focusing distance of the regular Pentax 1000mm lens is 100 feet.

Interestingly, you can tell whether a picture was made with a mirror lens by looking at out-of-focus spots of bright light, because they will be recorded as doughnutlike rings with dark centers that actually are silhouettes of the circular mirror mounted near the front lens element.

There are particular problems to consider when using telephoto lenses of long focal length. Because the subject is so greatly magnified, steadiness of the lens and camera are required or the image will be blurred. A tripod becomes almost a necessity. Frequently it is screwed to a tripod socket on the lens itself to provide balance of the camera and telephoto lens. Most convenient are lenses with the tripod socket mounted on a rotary collar so the camera and lens can be turned to either vertical or horizontal format without readjusting the tripod. For

more freedom, there are shoulder braces and riflelike mounts that photographers can use to help hold long lenses steady and to distribute the considerable weight of non-mirror telephoto lenses. Also, to avoid blurred images, fast shutter speeds are recommended when using telephoto lenses (see page 89).

Atmospheric conditions, including air pollution, can cause distortion in telephoto pictures and significantly reduce image quality and contrast. Mirage effects are common when lenses of long focal length are used on hot days.

## Zoom Lenses

Zoom lenses are becoming increasingly popular with photographers because you can vary the focal length—and thus alter the image size—without changing from one lens to another. There are other reasons why they are gaining favor. Primarily, new computer-designed optics make it possible for modern zoom lenses to maintain sharp focus while the focal length is being changed, so you don't have to refocus. Also, they are lighter in weight, less bulky, and have wider maximum apertures than zoom lenses of early manufacture. Although somewhat expensive, they are bargains when you consider the alternative of buying separate lenses in a variety of focal lengths. Additionally, there are some special effects you can get only by zooming during an exposure, or by making multiple exposures at different focal lengths on the same frame of film.

A greater variety of zoom lenses with a wide range of focal length combinations are being manufactured these days. There are zooms that

cover medium wide-angle to near normal, such as Nikon's 28-45mm; near normal to medium telephoto, like Pentax's 45-125mm; short telephoto to long telephoto, like Vivitar's 80-200mm; and medium to extremely long telephoto, such as Minolta's 100-500mm. Nikon even makes a very expensive 360-1200mm zoom. In addition, some of the latest zoom lenses have a macro or close-focusing capability, which makes them even more versatile because you can get the camera closer to the subject to make larger images on the film.

To accomplish all that they do, the maximum aperture of zoom lenses can never be as wide as the maximum aperture on conventional lenses of comparable but fixed focal lengths. The maximum apertures of zoom lenses are commonly no wider than f/3.5, f/4, or f/4.5, although a few in the medium wide-angle to normal to short telephoto range are f/2.8.

Adjusting the focal length on a zoom lens is done in one of two ways: You push-pull on the same lens ring that you turn to adjust the focus, or you twist a zoom ring that is separate from the focusing ring. Some photographers find zoom lenses with the single control ring (push-pull for zoom, twist for focus) are more convenient and faster to adjust than lenses with separate rings to turn for zoom and focus.

Some zoom lenses are called MACRO or CLOSE FOCUS ZOOM LENSES, which means they can produce larger images than ordinary zoom lenses of comparable focal lengths. As you know, the closer a lens can be focused to a subject, the larger the subject image will be on the film. For some comparisons, Vivitar's 85-210mm close focusing zoom lens has a minimum focusing distance of 5½ feet in its regular telephoto zoom mode, but when switched to close focus operation, the lens

Changing the focal length of a zoom lens during a long exposure can produce a variety of interesting results, including abstract images. One photo shows how the illuminated sign on top of a disco club really appeared. For the other four shots, a 75-150mm zoom lens was adjusted at varying rates of speed, from its shortest focal length to its longest focal length and vice versa, with the camera supported by a tripod at different distances from the sign.

can be focused as close as 12½ inches to the subject. At that distance, the subject will be magnified to one-fourth life size, which is a considerable achievement for a lens that also provides a range of telephoto focal lengths from 85mm to 210mm.

Zoom lenses with focal lengths in the long telephoto range, like conventional long telephoto lenses, require solid support, and they usually are equipped with a tripod socket. The best ones to use have the socket mounted on a rotating collar so the lens and camera can be turned easily to either the horizontal or vertical format.

You should be aware that there are some so-called zoom lenses that are more accurately termed VARIABLE FOCAL LENGTH LENSES. Unlike true zoom lenses, they do not maintain sharp focus when the focal length is changed. Check carefully when purchasing a zoom lens to make sure it stays in focus when the zoom control is adjusted.

## Macro Lenses

Photographers have always found close-up photography fascinating, but it was long considered a chore to get life-size images that are sharp and correctly exposed. Until recently, close-up photography required that a normal or telephoto lens be used in conjunction with extension tubes or a bellows, or a series of supplemental close-up lenses. Ever since the introduction of macro lenses, however, photographers can make life-size close-up images with ease and confidence.

Photographing subjects to produce images that are at least life size, and up to ten times larger, is called MACROPHOTOGRAPHY or PHOTO-MACROGRAPHY, which are synonomous terms. When a microscope is

used with a camera to produce greatly magnified images (from 10 to 250 times life size with a regular microscope), it is more correctly termed PHOTOMICROGRAPHY (see page 108).

Every lens has a minimum focusing distance (about 18 inches for a normal 50mm lens), and this necessarily limits the size of the image recorded on the film. A macro lens is specially designed for close-up work, however, and enables you to get very close to the subject (about 9 inches with a 50mm macro lens). Moreover, it can be used to photograph distant subjects, which means a macro lens also is suitable as a normal or telephoto lens for general photography. Technically speaking, however, it performs best in its intended role as a lens for close-up photography. When mounted in reversed position (see page 103), a macro lens is ideal for photographing flat subjects, such as stamps and documents, and for copying slides, because the images will be sharp from corner to corner.

The most convenient macro lenses allow you to make life-size images on the film without extra attachments. This means the subject will measure the same size on the film as it is in real life. Lens specification sheets describe life size as 1:1 MAGNIFICATION or REPRODUCTION RATIO. Most macros, however, will magnify the image only one-half lifesize, 1:2, *unless* an extension tube is inserted between the lens and camera to provide 1:1 magnification. When considering purchase of a macro lens, always check whether such a tube must be added in order to get life-size images.

Macro lenses are available in a wide range of focal lengths, and some are even part of zoom lens designs that provide variable focal lengths. The most popular macros are of the normal lens type, with a

50mm or 55mm focal length, and short telephoto lens types, with 100mm or 105mm focal length. In the macro zoom category, the 70-210mm telephoto type is a frequent choice of photographers.

One thing to consider is that macro lenses of longer focal length can be used at greater distances to the subject. For example, a 100mm macro can be twice the distance to the subject as a 50mm macro and still produce the same image size. This is a benefit in nature photography because you are less likely to frighten your subjects, such as insects or birds. The perspective will appear more natural, too. Also, because you don't need to get so close to the subject, there's less chance that you or your camera will block the light or cause shadows on the subject.

Because depth of field becomes more shallow as a lens gets closer to the subject, stopping down to the smallest aperture for the maximum depth of field possible is often desired when taking close-ups. Thus a macro lens with a minimum opening of f/32 is usually preferred to one that only closes to f/22, a one f/stop difference.

Also keep in mind that the most convenient macro lens is one that has automatic aperture control, which means the lens is always at its widest aperture (for easy focusing and viewing) until the shutter is released. Then the lens automatically stops down to the aperture selected for the exposure, regardless of whether your camera has automatic exposure control or the exposure is pre-set manually.

Mention must be made that any lens that includes *macro* in its name implies that it will reproduce subjects at least to one-half (1:2) life size without the use of an extension tube *and* up to life size (1:1) with or without the extension adapter. This is not necessarily true of lenses that include the term CLOSE-FOCUS in their names. In addition,

macro lenses have reproduction scales engraved on their lens barrels so you will know or can set the exact magnification.

One consideration in regard to using a macro lens for general photography is that its maximum aperture is one or more f/stops *smaller* than a non-macro lens of equivalent focal length. For example, the widest opening on the Pentax 50mm macro is f/4, while normal 50mm Pentax lenses are available with maximum apertures up to 3½ stops wider, f/1.2. Likewise, the Pentax 100mm macro has a maximum opening of f/4, while the regular Pentax 100mm opens to one f/stop wider, f/2.8.

## Perspective Correction (PC) Lenses

Normally, when a wide-angle lens is pointed up or down, vertical lines appear to converge at the top or bottom of the picture, causing annoying distortion of the subject. There are special lenses that can be adjusted to straighten the subject and keep it in proper perspective, and these are called PERSPECTIVE CORRECTION, PERSPECTIVE CONTROL, or just PC LENSES. Other names include SHIFT and TILT LENSES.

PC lenses are the choice of architectural photographers who use 35mm cameras instead of the larger-format view cameras that also permit perspective control.

The optics in PC lenses can be shifted off center so the camera does not have to be tilted and the film plane remains parallel to the subject. A rotating mount allows the lens to turn so the shift can be made in any direction in order to achieve correct perspective, all of which can be done while you look through the SLR's viewfinder.

PC lenses are of 35mm or 28mm focal length, with maximum apertures from f/2.8 to f/4. They do not have automatic aperture control, so the image will get darker in your viewfinder when you stop down the lens to set it for correct exposure. PC lenses also can be used as regular wide-angle lenses when locked in the centered position.

## Tele-Extender Attachment

A tele-extender is an optical lens attachment that is used to increase the focal length of normal and telephoto lenses and therefore increase image size. It is also known by other names, including TELE-CONVERTER, LENS EXTENDER, MULTIPLIER, or CONVERTER. There are commonly two types of these secondary lenses, which you mount between the camera and the main (prime) lens. The 2X type will double focal length (and thus double image size), and the 3X type will triple it. As examples, a 2X tele-extender attached to a 50mm lens will effectively make it a 100mm lens. Similarly, a 3X extender will increase a 50mm lens to a focal length of 150mm.

Since most tele-extenders are fairly inexpensive and can be adapted to a number of different brands of cameras and lenses, shouldn't they be part of every photographer's equipment? Perhaps, except for these drawbacks. First, a 2X extender requires an increase of two f/stops in exposure, and a 3X extender requires a three f/stop increase. This can seriously affect your shooting in low light conditions, the extent of depth of field in your picture, and tele-extender use with electronic flash.

Additionally, the quality of the image will never be as good as that taken with a regular telephoto lens of comparable focal length. (Excep-

tions include the Nikkor tele-extenders designed for Nikon cameras, which are comparatively expensive and produce images of exceptional quality.)

Tele-extenders are an alternative to purchasing long focal length lenses that you may need only occasionally. For instance, if you think you might take a few wildlife pictures on a vacation trip, a 3X extender will convert your 135mm telephoto into the equivalent of a 405mm telephoto. Tele-extenders can be used with some zoom lenses, but the combination of optics frequently reduces image quality in terms of sharpness, uniform exposure, color, and contrast.

If you are going to purchase a tele-extender, make sure it couples to the automatic aperture and/or automatic exposure control features of your particular camera. Try it before you buy it, because a tele-extender that doesn't connect with a camera's automatic features is a nuisance to use.

## Close-Up Lenses

Until macro lenses were introduced and became popular, the most general way for making close-up photographs was to attach SUPPLEMENTARY CLOSE-UP LENSES to the front of the camera's normal lens. Close-up lenses are available in a series of magnifying powers, called diopters. Strength is indicated by numbers: +1, +2, +3, +4, +5, +6, +8, and +10. The higher the number, the greater the magnification of the close-up lens. Two or more close-up lenses can be combined for more extreme magnification, and the stronger lens should be attached to the camera first. Three close-up lenses in +1, +2, and +4 diopters are often sold as a set because you combine them for various magnifica-

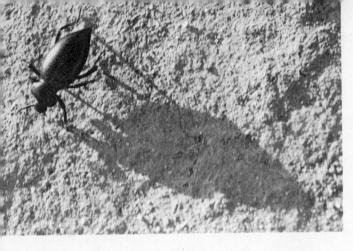

**Below** Size of subject area covered by close-up lenses of various diopters with the camera lens focusing ring set at various distances. **Left** Close-up lenses are often used for nature photography, particularly for small creatures like this beetle.

| Close-up Lens Diopter | Focus Setting (ft.) | Lens-to-subject Distance* (in.) | Approximate Size of Subject Area Covered (in.)† |
|---|---|---|---|
| +1 | INF | 39 | 18 × 26¾ |
|  | 3½ | 20⅜ | 9⅜ × 13¾ |
| +2 | INF | 19½ | 9 × 13½ |
|  | 3½ | 13⅜ | 6⅛ × 9⅛ |
| +3 | INF | 13⅛ | 6 × 8⅞ |
|  | 3½ | 10 | 4⅝ × 6¾ |
| +4 (+3 plus +1) | INF | 9⅞ | 4½ × 6⅝ |
|  | 3½ | 8 | 3⅝ × 5⅜ |
| +5 (+3 plus +2) | INF | 7⅞ | 3⅝ × 5⅜ |
|  | 3½ | 6⅝ | 3 × 4½ |
| +6 (+3 plus +3) | INF | 6⅝ | 3 × 4½ |
|  | 3½ | 5⅝ | 2⅝ × 3⅞ |

\* Measured from the front rim of the close-up lens.
† 50mm lens on a 35mm camera.

tions, up to the equivalent of +7 diopters (+1, +2, +4 = +7). Some manufacturers indicate the strength of their close-up lens in millimeters instead of diopters. The accompanying chart shows the subject area covered by close-up lenses of various diopters on a 50mm lens.

Optically, close-up lenses do not produce the sharpest possible pictures; when the subject's center is in focus, its edges may be fuzzy. Image quality is reduced even more when two or more close-up lenses are used together. In all cases, it's best to shoot at a small lens aperture to increase depth of field.

An advantage of using close-up lenses is that they are placed in front of the camera lens and thus do not require an increase in exposure; when a device for making close-ups must be inserted between the camera and the main lens, such as extension tubes or bellows, light has to travel a greater distance to reach the film, which means a greater exposure is required. (Most built-in camera meters compensate to give correct exposure readings, however.)

It is easiest to use close-up lenses with single lens reflex cameras, because you can focus and frame your subject directly through the camera's viewfinder. They can also be attached to rangefinder cameras with permanently mounted lenses, but you must be concerned about parallax error (see page 6). This means framing must be done by an alternate method instead of through the camera's viewfinder, and the distance to the subject must be measured from the close-up lens (or film plane) so that the camera can be placed in an exact position that will put the subject in focus.

## Lens Reversing Ring

Besides purchasing close-up lenses, the most inexpensive way to make close-up pictures is to detach your normal lens from the camera and turn it around so the lens elements are reversed. Importantly, in reversed position the optics are best suited for close-up work and give sharper results than close-up lenses.

After reattaching the lens to the camera with an accessory lens reversing ring or adapter, you can focus much closer to the subject than when the lens is mounted regularly, and you can produce an image

For an inexpensive way to make extreme close-up photographs, SLR camera lenses can be turned end for end and mounted to the camera with a lens reversing ring (see text).

that's about four-fifths life size. Instead of being a minimum of 18 inches or so from the subject, your reversed normal lens will let you focus just 2 or 3 inches away.

Because adjustment of the lens focusing ring has little effect when the lens is in reverse position, image size can be varied only slightly. Magnification is so great that the best way to focus is to slowly move the camera forward and backward until the subject appears sharp in the viewfinder. For greatest overall sharpness, shoot with a small lens aperture.

To check the close-up range before buying a lens reversing ring, simply hold the lens in reverse position on the camera. Be careful not to scratch the front lens element. The aperture should be wide open so that the subject will appear as bright as possible in your viewfinder when framing and focusing.

One problem when reversing the lens is that its automatic aperture control will be disconnected, so you must stop down the lens manually before making an exposure. A camera with aperture-priority automatic exposure will still function in the automatic mode, but one with shutter priority will not.

## Extension Tubes

Another way to make close-ups is to mount extension tubes (also called extension rings) between the camera and its lens, whether wide-angle, normal, telephoto, macro, or zoom. That's because the greater distance the lens is from the film, the greater the subject's image size will be. Extension tubes are fairly inexpensive because they are simply metal

tubes and do not have any lens elements. They come in a variety of lengths and are sometimes sold in sets of two or more so you can combine them to achieve magnifications up to life size and larger.

Extension tubes are measured in millimeters, and you can figure a tube's effect on image size by dividing the focal length of the lens being used into the length of extension. For example, if a 25mm extension tube is added to a 50mm lens, it will have a 1:2 reproduction ratio, meaning it will magnify the subject to one-half life size. A tube (or tubes) of 50mm extension will reproduce the subject 1:1, meaning life size. With 100mm of extension, the ratio is 2:1, which means the subject will appear two times life size.

Because extension tubes extend the distance light must travel from the lens to reach the film, exposure must be increased. The camera's built-in meter usually will give accurate exposure readings when extension tubes are used, but make some test exposures to be sure.

Extension tubes are designed in four styles, but all of them are not available for all camera models. The best (and most expensive) ones have couplings that connect the camera directly with the lens' automatic aperture control. This means the lens stays wide open while viewing, focusing, and making exposure readings, then closes automatically to the selected f/stop when the shutter is released.

The semiautomatic type has a push button that will open the lens to its widest aperture for viewing and focusing. When the button is released, the lens closes down for exposure readings or for taking a picture at the preselected f/stop.

Another type requires a *double* cable release for automatic aperture control during exposure. One cable from the release is attached to the

extension tube, the other to the camera's shutter release. The lens aperture is always at its widest for focusing and viewing, but a button can be pressed to stop down the lens for making exposure readings or checking depth of field. When the cable release plunger is pressed, it first stops down the lens to the preselected aperture, and then it trips the shutter to take the picture.

Of course the basic, least costly type of extension tubes or rings has no aperture connections whatsoever, which means the lens must be manually opened up for viewing and focusing, and manually closed down when making exposure readings, checking depth of field, and taking the picture.

## Extension Bellows

More versatile than extension tubes is an extension bellows, because it can be adjusted at a variety of lens-to-camera distances for more precise framing and exact magnifications. Used with a 50mm lens, an extension bellows produces images as much as 4½ times life size. (Wide-angle, telephoto, macro, and zoom lenses also can be used.)

Mounted between the camera and lens, an extension bellows has a flexible body without lens elements that rides in a track. A few types have a lens mount that can be shifted and twisted left and right to improve depth of field when shooting unflat objects. The extension bellows should be mounted on a tripod; most bellows have a rotating camera mount so you can turn the camera to either a vertical or horizontal format.

Some models of bellows can be connected to the camera with a

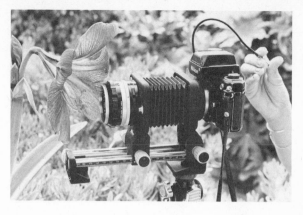

For versatility in making close-up pictures, an extension bellows can be attached between the camera and its lens. Here it is being used to make a full-frame image of a flower's stamen. Because of the great magnification, the bellows is mounted to a tripod for support; a cable release prevents the camera from being moved inadvertently during the exposure.

double cable release for semiautomatic lens aperture control, as was described for extension tubes. Like extension tubes, a bellows extends the distance light must travel from the lens to reach the film, so exposures must be increased. The camera's built-in meter should give accurate exposure readings when the bellows is in place, but make some exposure tests to be sure.

Patience is required when using an extension bellows for the first time, because there are independent front and rear focusing controls that require coordinated adjustment to get the exact framing and image size you desire. If you plan to do considerable close-up photography, an extension bellows combined with a macro lens offers versatility and images of outstanding quality. Without a macro lens, an extension bellows used with a normal lens in *reversed* position is the second best combination.

Remember that extension bellows and extension tubes can be used with most types of lenses: wide-angle, normal, telephoto, macro, and zoom. Of course, the shorter the lens focal length, the closer you can get to the subject with an extension bellows or tubes. However, with wide-angle lenses of very short focal length, you virtually must get on top of the subject to produce the largest image sizes. This causes problems. For one thing, the lens is so close that it blocks the light illuminating the subject. Also, you're likely to frighten some subjects, such as insects, when the lens is so close. To permit even illumination and a greater working distance from subjects, as well as more natural perspective, a short telephoto lens is frequently used with an extension bellows or tubes, although the magnification will not be as great as with a lens of shorter focal length.

## Microscope Adapter

For the ultimate in close-up work, you can attach your SLR camera to a standard laboratory microscope. The camera lens is removed and replaced by a fairly inexpensive microscope adapter that is then attached to the microscope's eyepiece. This opens an exciting world for photographers who want to create colorful, abstract images. Close-up photography through a microscope is technically termed PHOTOMICROGRAPHY. Do not confuse this with MICROPHOTOGRAPHY, which refers to making very small images, as on microfilm.

You'll see the greatly magnified subject directly through the single lens reflex camera's viewfinder, and the SLR's built-in meter can be used to make exposure readings. Exposure is adjusted by turning the shutter speed dial. Test exposures should be made to determine the meter's accuracy with different subjects and light sources. The microscope's mirror must be carefully adjusted so the subject will be evenly illuminated. The microscope adapter has a rotating collar so the camera can be turned to either vertical or horizontal format.

If your camera's meter won't work when the lens is detached and replaced by the microscope adapter, you can connect the camera and its lens to the microscope's eyepiece with a homemade light-tight collar. Use small sections of cardboard mailing tubes in diminishing sizes, and support the camera with a tripod. Focusing is done with the microscope, not by adjusting the camera's lens, which should be set at infinity. Keep the lens aperture wide open, and adjust exposure by changing the shutter speed.

Most of all, have patience, and be sure you know how to set up and

adjust a microscope and its light source for regular use before attaching a camera to make photographs.

## Telescope Adapter

As with photomicrography, there are special but rather inexpensive adapters available for attaching a SLR camera body to a telescope so you can get close-up photographs of the moon, planets, and star-filled sky. This is called ASTROPHOTOGRAPHY or ASTRONOMICAL PHOTOGRAPHY, and the image size of the extraterrestrial subjects depends on the power of the telescope you are using.

The telescope adapter mounts to the camera in place of the lens and is attached to the telescope's eyepiece. Focus the telescope while you view the subject through the SLR's viewfinder. The moon is particularly bright and the camera's built-in metering system can be used to determine exposure. You control exposure by adjusting the camera's shutter speed. Be sure to bracket (deliberately make extra exposures that are at least one and/or two shutter speeds faster and slower than the meter reading), especially when shooting a full moon, because you'll have to wait a month before it is fully illuminated again. Test exposures are recommended for other subjects. Remember that stars record as streaks unless exposures are short (or unless the telescope is equipped with a motor to keep pace with the earth's rotation).

You can also photograph through a telescope (or binoculars) without removing your camera's lens, but the lens and telescope eyepiece must be precisely aligned and fitted with a light-tight collar. Although the image will be somewhat larger, it will not be as sharp or as bright

as when the camera lens has been removed and the telescope is connected directly to the camera body with an adapter. When shooting through a telescope with a lens on the camera, open the lens to its widest aperture, set its focus at infinity, and adjust the telescope's focusing controls until the subject appears sharp in the camera's viewfinder.

## Special Lens Attachments

All of the lens attachments previously discussed—tele-extenders, close-up lenses, reversing rings, extension tubes and bellows, and microscope and telescope adapters—allow you to get larger images on the film than when lenses are just used in the regular way. There are some other lens attachments that also alter the image and create special effects. For example, filters of various types are attached to the front of lenses to change the colors of light the film records, cut through haze, darken skies, emphasize clouds, or reduce reflection. Additionally, different lens attachments can be used to diffuse the subject, create star patterns, produce multiple images, or give a fish-eye effect. Filters and lens attachments for special effects are discussed in the next chapter.

## Lens Mounts

As mentioned in the previous chapter, the most convenient way to connect a lens with a camera is with a BAYONET MOUNT, because alignment is easy and a slight turn locks the lens into position. SCREW MOUNT lenses take more time to align with threads on the camera and more turns to get them tightly into position. Camera manufacturers make

lenses with mounts that fit their particular cameras, but there are other lens manufacturers that produce a variety of lenses with screw mounts that can be threaded to a number of different bayonet mount adapters so lenses can be used on many different models of cameras.

The important thing to remember is that any lens you buy should make proper connection with the camera's mechanisms that provide automatic aperture control or automatic exposure control. Otherwise, you must adjust everything on the lens manually, which robs you of features that were built into the lens to make photography more spontaneous and enjoyable.

## Lens Care

Most modern photographic lenses are of computer design, precision optics, and excellent engineering, and some even cost more than the camera body itself. It makes good sense to give your lenses proper care so their performance will not be affected by dirt, scratches, or other physical abuse.

When not in use, a lens should be given protection in some sort of case. Foam-lined LENS CASES of hard or soft leather are commonly used, or lenses are placed in special compartments in the photographer's gadget bag. A leather camera case helps protect a lens mounted on the camera. The best camera cases have a snap-off front cover that can be removed when you are shooting, while the remaining part of the case continues to give protection to the camera body. Camera cases with nonremovable front covers tend to get in the way unless the camera is completely removed from the case during shooting sessions.

Even when a lens is in its own case or a gadget bag, most photogra-

Sunlight that shines directly on your lens can create flare, bright spots that show up in your images. They can be dramatic, or distracting: using a lens hood can help prevent them.

phers use LENS CAPS to protect the front and rear lens elements from dust or damage. When the lens is mounted on the camera, a popular and inexpensive alternative is to use a clear UV filter (see page 118) instead of a front lens cap. This way the camera is instantly ready for use without having to remove a protective lens cover. When you're out shooting, constantly removing and replacing a lens cap or opening and closing the camera case can inhibit your photography, so using a UV filter for lens protection is ideal. Also, a filter can be cleaned with less concern than when you clean the lens itself, and if the filter gets scratched or otherwise damaged, its replacement cost is a fraction of the cost of a new lens.

A LENS SHADE or LENS HOOD offers protection, too. Its main purpose is to shade the lens from direct light that may cause flare in your picture, but it also will help keep your lens from getting wet when you're shooting in rain or snow. A lens shade can absorb shocks if a lens is knocked into something or dropped on its front, and it will prevent the threaded lens ring that holds filters and other front lens attachments from getting bent.

Lens shades are built in, or they push on or screw into the lens. Some are made of metal and others are rubber. The built-in and rubber types are collapsible, so the lens can be conveniently covered by a case. Lens shades come in different shapes and sizes for different lenses. Keep in mind that the lens shade should not interfere with the angle of the view of the lens, or it will cause dark corners (vignetting) in your pictures.

Lenses should be carefully cleaned so dust or fingerprints will not affect the light rays and reduce the quality of your images. For dust, use a hand-squeezed dust blower, a camel's hair brush, or special photo-

Camera lenses should be cleaned carefully with special liquid cleaner and lens tissue. Lenses on SLR cameras can be removed to clean the inside element.

graphic LENS CLEANING TISSUE (not eyeglass cleaning tissue because it contains chemicals detrimental to the lens coatings). If you dust with a brush, keep it *exclusively* for lenses; if used on other parts of the camera, it may pick up dirt particles that can scratch the lens. For smudges, use lens cleaning tissue moistened with photographic LENS CLEANER (some lens makers say never to use dry lens tissues because they might scratch the lens surface).

Remember that dirt or dust that appears in sharp focus in the viewfinder of a single lens reflex camera is on the camera mirror or focusing screen and not on the lens itself. To check a lens on an SLR camera for dirt or dust, remove it from the camera, open the f/stop wide, look through the lens, and then be sure to clean both front and rear elements.

Constant lens cleaning is probably more harmful than helpful because of the danger of scratching the flare-reducing lens coatings, so clean a lens only when it really needs it. Occasionally, use a cloth to wipe the lens barrel, and be sure the flanges on a bayonet mount or threads on a screw mount are free of dirt so the lens will mount smoothly on the camera.

Blowing dust away with pressurized air from aerosol cans usually sold in camera stores is not recommended because sometimes their propellants cause moisture to condense on the camera or lens if the equipment is too close to the nozzle.

Because films do not interpret colors exactly as our brains do, filters can be used to alter the colors or gray tones in photographs to make them appear more like what we saw originally. Filters also can be used to change colors for bizarre, unnatural effects. There are other lens attachments, sometimes also called filters, that do not change colors but create special effects, like softening the image, producing star effects around points of bright light, and creating multiple images of the same subject.

### Filter Types and Sizes

For general photography, filters are most often placed over the camera lens to alter the light reaching the film. In studio situations, they are sometimes mounted in front of the light sources to change the light illuminating the subject. Some portable electronic flash units have filter attachments that fit on the flash reflector to do the same thing. For color printing, and when making black-and-white prints on variable contrast paper, filters are used with the enlarger, just below the enlarger lamp or over the enlarger lens, to change the light reaching the printing paper.

Filters used on camera lenses are made of optical glass so they will not distort the image. Filters used in front of light sources are squares or discs of gelatin film or plastic. The filters discussed in this chapter are the types used on a camera lens. They can be attached in several ways and come in various sizes.

Most filters are screw-in or series types. SCREW-IN FILTERS have a threaded metal band and screw directly to the lens. SERIES FILTERS

have metal rims and are held in place by a FILTER RETAINING RING that screws into the lens. In some cases, the lens shade or hood will hold them in place.

Filters can also be mounted by using an adapter ring that screws in or slips on the lens. STEP-UP ADAPTER RINGS are a good investment because you can use filters of one size for lenses of different diameters. Say the filter size required for your telephoto lens is 58mm, for your normal lens it's 52mm, and for your wide-angle it's 49mm. By buying filters in the 58mm size, and two step-up rings in 52-58mm and 49-58mm sizes, you can use the same filters on all three lenses.

Filter sizes may be indicated in millimeters (mm) or a *series number*, like 4, 5, and 6, which will be marked on the metal ring surrounding the filter. The filter size required for a specific lens is given in the instruction sheet packed with the lens. It also may be engraved on the retaining ring or lens shade that accompanies the lens or comes as an accessory. (Do not confuse filter size with the lens focal length size inscribed in millimeters on the lens.)

## Filter Brands and Identification

Filters are made by camera manufacturers for their specific cameras, but many camera stores and photographic supply houses stock a variety of other brands, such as Tiffen, Hoya, Soligor, Vivitar, Samigon, and Spiratone. As long as they fit your lens or adapter ring (filters of too small a diameter will cause vignetting), any brand or type of filter can be used on your camera.

Filters are identified by their color, but they also are designated

| Filter Factor | Increase f/stop | Filter Factor | Increase f/stop |
|---|---|---|---|
| 1 | 0 | 5 | $2\frac{1}{3}$ |
| 1.2 | $\frac{1}{3}$ | 6 | $2\frac{2}{3}$ |
| 1.5 | $\frac{2}{3}$ | 8 | 3 |
| 2 | 1 | 10 | $3\frac{1}{3}$ |
| 2.5 | $1\frac{1}{3}$ | 12 | $3\frac{2}{3}$ |
| 3 | $1\frac{2}{3}$ | 16 | 4 |
| 4 | 2 | | |

more specifically by numbers and letters. For instance, a No. 23A filter is light red, a No. 25 is red, and a No. 29 is deep red. Some manufacturers, such as Nikon, assign their own identification numbers or letters, but most filters have universal designations. These are listed later in the chapter when each filter's use is described.

## Filter Factors

Because filters block some of the light reaching the film, additional exposure usually is required. The specific amount of extra exposure is indicated by a number called the filter factor. For example, a filter with a factor of 2 means twice as much exposure is required. So, for a correct exposure when that filter is on your camera, you would open up the lens aperture one f/stop, as from f/8 to f/5.6, *or* slow down the shutter speed, as from $\frac{1}{250}$ to $\frac{1}{125}$ second (see page 55).

Most commonly, the lens aperture is opened up to adjust exposure for the filter factor. Above is the increase required, in terms of f/stops, for specific filter factors.

For all practical purposes, if your camera has a built-in, through-the-lens metering system, it will adjust for the filter over the lens, and you don't have to make any other exposure changes. Some camera instruction booklets note if the meter will not accurately compensate for filters of certain colors, as is frequently the case when red filters are used.

Besides making actual exposure tests, you can check whether your camera meter is giving accurate readings with a filter by first making a reading without the filter. Afterward, using the filter factor, figure

the f/stop increase that should be required. Then mount the filter on the lens and make a second reading of the same subject to compare the results. For example, if your meter reads f/11 without the filter, and the filter's factor is 4—which means an increased opening of two f/stops is required—the meter should read f/5.6 when the filter is on the lens.

If you are shooting with filters and using a hand-held or non-through-the-lens camera meter to make exposure readings, there is a shortcut for figuring the increased exposures required. Just divide the film's ASA by the filter factor and set that revised film speed on your meter. Whatever exposures are indicated by the meter can be set on your camera without further calculation.

For instance, if your film's ASA is 400 and you are using a filter with a factor of 4, set the meter's film speed dial to 100. All the meter's readings now compensate for the filter. Of course, if you took off the filter or changed to another filter with a different filter factor, you'd have to adjust the film speed on your meter accordingly.

You should be aware that filter factors may vary with the light source, whether daylight or tungsten. Also, filter factors may change according to the type of black-and-white film being used. The data sheet in packages of black-and-white film gives specific filter factors for daylight and tungsten, as does the description sheet that accompanies the filter.

There are filters that are normally used with black-and-white films, and others especially for color films. These will be discussed separately, but first you should know about three types of filters that can be used with both black-and-white and color film.

As shown in these two comparison pictures, a polarizing filter will help darken a blue sky and make clouds stand out, as well as cut down glare from water.

## Ultraviolet (UV) Filters

While ultraviolet light is invisible to our eyes, most all films are sensitive to it. UV radiation becomes most evident in pictures of distant scenes, especially those made on hazy days. An ultraviolet (UV) filter absorbs that radiation and cuts down the haze that would otherwise appear in the photograph. For this reason, it is sometimes called a HAZE FILTER.

Because UV filters are virtually clear and do not alter any colors, many photographers use them as a lens protector (see page 112). Another reason is that these filters have a filter factor of 1, which means no additional exposure is required. To avoid vignetting of the subject's image, they usually are removed when other filters are used or when lens attachments are added for close-up photography. Unless the filter is removed when the lens is pointed at the sun or toward a bright light, reflections from the filter may cause ghost images on the film.

A similar filter cuts UV radiation and also reduces the bluishness that appears in distant landscapes and scenes taken with color films in open shade or on overcast days. It is called a SKYLIGHT FILTER (No. 1A) and has a slight pinkish tint. Its filter factor is 1, so no exposure increase is necessary. Like UV filters, skylight filters are frequently used as lens protectors because it is easier and safer to wipe dust, dirt, and fingerprints from a filter than from the lens itself.

Something to remember: UV, haze, or skylight filters will not cut through smog, fog, or mist, and there are other types of filters better suited for reducing the effects of haze on black-and-white films (see page 124).

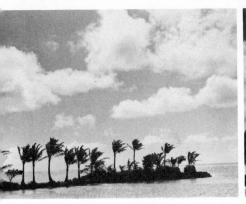

## Polarizing Filters

Photographers who shoot either black-and-white or color film find that a polarizing filter is very useful because it can diminish and even eliminate reflections, darken a blue sky, and penetrate haze. Sometimes called a polarizing screen or polarizer (and, incorrectly, a Polaroid filter), it rotates in its lens mount so you can control the degree of its effect.

A light ray vibrates in all directions until it strikes any nonmetallic surface, then it is reflected as polarized light, which means it vibrates only in one direction (or plane). When a polarizing filter is adjusted to block this polarized light, it will reduce or completely cancel the reflection. Thus any annoying reflections or glare from glass, water, and other shiny surfaces, including glossy *painted* metal, can be controlled by the photographer. Colors also look richer because color saturation improves as reflections are diminished. Foliage, for instance, appears a deeper color when light reflected by the leaves is absorbed by a polarizing filter.

A blue sky can be darkened for the same reason, because the blue light we see actually is polarized sunlight that has been reflected off particles in the atmosphere. Since haze also appears because dust, water, and other vapors in the atmosphere reflect and thus polarize the sunlight, a polarizing filter will absorb the polarized light and allow the film to see through the haze.

The degree of haze penetration, darkening of a blue sky, or reduction of reflections depends on your camera's angle to the subject and on how much the polarizing filter is rotated. Because you can see the

effect by looking through the filter, it is easiest to use on a single lens reflex camera. With a rangefinder camera, rotate the filter in front of your eye until you like the effect, then mount it on the camera lens in exactly the same position. (If you turn your camera from a horizontal to a vertical position, or vice versa, the polarizing filter must be readjusted.)

The sky-darkening effect will be greatest when your camera is aimed at right angles to the sun, as when the sun is overhead, or low to the horizon on your right or left side. To eliminate reflections, the filter works best when the angle of your camera to the reflecting surface is equal to the angle of the light source (sun or tungsten light) to the reflecting surface.

Because a polarizing filter blocks some of the light reaching the film, exposure must be increased. Its filter factor is 2.5, so the lens should be opened by $1\frac{1}{3}$ f/stops. An additional $\frac{1}{2}$ stop may be required for proper exposure, because the subject area generally is darker when reflections are eliminated. If your camera's exposure meter reads through the lens, as is usual on SLR models, it should compensate for the polarizing filter and give the correct exposure without special calculations or other f/stop adjustments. (Some models of Canon, Praktica, Yashica, and Mamiya cameras are exceptions; consult your instruction manual.) Remember to remove an ultraviolet or skylight filter when using a polarizing filter.

## Neutral Density Filters

Another type of filter that works with both color and black-and-white films is a neutral density filter, which is used to reduce the amount of

light reaching the film. These colorless filters do not change the image in any other way. They come in various densities so you can reduce exposure by a fraction of an f/stop or by several full stops. Commonly available are 2X, 4X, and 8X neutral filters (their identity numbers also indicate their filter factors), which cut the light by one, two, and three f/stops respectively. The filters can be combined for greater exposure reduction.

Neutral density (ND) filters can be useful in a number of situations, particularly under bright light conditions and/or when you are using high speed film. For instance, if your meter indicates overexposure even when you are using the camera's fastest shutter speed and smallest lens opening, neutral density filters will cut the light so a correct exposure can be made.

Perhaps you need to use a wide f/stop so depth of field will be shallow, or a slow shutter speed so your subject will be blurred (or, if you pan with the subject, so the background will be blurred). If the settings you want to use would result in overexposure, put on some ND filters. In close-up nature photography with electronic flash, neutral density filters can cut the light that might otherwise be too bright (sometimes ND filters are fitted over the flash instead of over the camera lens). SLR through-the-lens meters will determine the correct exposure.

If you have two polarizing filters, they can be mounted together for use as neutral density filters. Rotating them varies the amount of light polarization and thus the amount of exposure reduction.

Besides ultraviolet, polarizing, and neutral density filters, there are filters specifically for use with black-and-white films, and others for color films. These are discussed separately.

| Filter Color | Colors Absorbed |
|---|---|
| Red | Blue + green (cyan) |
| Blue | Red + green (yellow) |
| Green | Red + blue (magenta) |
| Yellow (red + green) | Blue |
| Magenta (red + blue) | Green |
| Cyan (blue + green) | Red |

## Filters for Black-and-White Films

The filters previously described are colorless, but most filters are of a certain color in order to change the light in a certain manner before it reaches the film. Specifically, a filter allows light of its own color to pass through and it blocks (i.e., absorbs) all other colors.

To figure out just how filters of different colors will affect your film, it's important to know that white light, whether coming from the sun or from a light bulb, is a mixture of three primary colors: red, blue, and green. Each primary color has a secondary (or complementary) color, cyan, yellow, or magenta, which is really just a mixture of the other two primary colors. (Do not confuse the primary colors of light with the primary colors of pigments, which are red, blue, and yellow.)

Filters are produced in these primary and secondary colors, in various densities, and they affect the colors of light in the manner shown above.

Because black-and-white films record colors in various gray tones, you use filters to lighten or darken those tones for the effect you want. The rule to remember is: *To lighten a color, use a filter of the same color; to darken a color, use a filter that absorbs that color.*

Here is a list of various filters used for black-and-white photography. They are listed by the most current identity numbers, as well as by color. Former designations are given because older filters are marked in that manner, and because a few filter manufacturers still use them, sometimes in combination with the newer identity numbers. Filter factors for daylight and tungsten light (i.e., incandescent lamps) also are given, but check your film's data sheet because factors for some filters vary for some emulsions.

| FILTER NUMBER | FORMER DESIGNATION (IF ANY) | FILTER COLOR | FILTER FACTORS | |
|---|---|---|---|---|
| | | | Daylight | Tungsten |
| 3 | | Light yellow | 1.5 | 1.5 |
| 6 | K1 | Light yellow | 1.5 | 1.5 |
| 4 | | Yellow | 1.5 | 1.5 |
| 8 | K2 | Yellow | 2 | 1.5 |
| 9 | K3 | Deep yellow | 2 | 1.5 |
| 12 | | Deep yellow | 2 | 1.5 |
| 15 | G | Deep yellow (orange) | 2.5 | 1.5 |
| 11 | X1 | Yellow-green | 4 | 4 |
| 13 | X2 | Dark yellow-green | 5 | 4 |
| 23A | | Light red | 6 | 3 |
| 25 | A | Red | 8 | 5 |
| 29 | F | Deep red | 16 | 8 |
| 47 | C5 | Blue | 6 | 12 |
| 47B | | Deep blue | 8 | 16 |
| 50 | | Deep blue | 20 | 40 |
| 58 | B | Green | 6 | 6 |
| 61 | N | Deep green | 12 | 12 |

Filters for black-and-white photography are considered to be of two types: correction filters and contrast filters.

CORRECTION FILTERS help make the gray tones in your picture appear with same relative brightness with which the colors they represent appeared in the scene or subject you photographed. Today's films are *panchromatic*, which means they are sensitive to all colors, but the film emulsion does not record all colors with the same relative brightness that your eyes see. Specifically, in daylight scenes, skies appear lighter and foliage appears darker in black-and-white pictures than in real life.

**Left** The red leaves of this poinsettia plant photographed a dark gray. **Right** They were lightened considerably in this photo by using a red filter over the camera lens.

When a yellow (No. 8) filter is used over the lens, it absorbs some of the ultraviolet and the blue light of the sky, so the sky appears darker in the picture and looks more natural. Also, foliage reflects not only green light but small portions of blue and red light. The yellow filter blocks the blue light, which makes the green and red colors reflecting from the foliage appear brighter and thus achieves a more natural tone in the photograph (a yellow-green filter absorbs red as well as blue and lightens the foliage even more).

A common correction filter to use with tungsten light is yellow-green (No. 11), because it absorbs some of the excess of red light, as well as ultraviolet and blue light, which is produced by the tungsten light.

CONTRAST FILTERS are frequently used with black-and-white films, not to render the colors of the scene or subject in gray tones that represent their natural brightness, but to make one color stand out more from another. For instance, red flowers and green grass appear in similar tones in a photograph, so you can increase contrast between the two colors by using a filter. A red (No. 25) filter absorbs green and transmits the red, so the grass will be a darker tone and the flowers a lighter tone in your black-and-white picture. If you use a green (No. 58) filter instead, the tones would be reversed; the red flowers would appear dark and the grass would be light.

While a yellow (No. 8) filter is used to make a more natural rendition of sky in black-and-white prints, deep yellow-orange (No. 15) or red (No. 25) filters will darken the sky more dramatically and make any white clouds stand out in detail. The same filters are best for reducing atmospheric haze because they absorb ultraviolet light and the bluish color of the haze. Atmospheric haze that can spoil landscape

photography is completely penetrated when you use Kodak's High Speed Infrared film (see page 195). To absorb the blue and green light to which this black-and-white film is sensitive, you should use a red (No. 25 or 29) filter. If for some reason you want to increase the haze in your landscape shots, shoot through a blue (No. 47) filter.

### Filters for Color Photography

Color films are made for use under specific types of light, and their colors will appear unnatural if other light sources are used. For instance, a daylight color film used indoors with regular household lights will give subjects an orange or reddish cast. However, a CONVERSION FILTER can be used on the camera so a film will produce good color renditions when used with other light sources.

The two general types of color film are daylight and tungsten. Daylight films are balanced for sunlight, electronic flash, and blue flashbulbs, while tungsten films (sometimes called Type B films) are designed for use with lights that have a color temperature of 3200K, such as photographic studio lights or reflector-type photolamps. Another type of tungsten film, known generally as Type A film, is balanced for 3400K light, such as photoflood bulbs or tungsten-halogen-type movie lights. (See Chapter 7 for an explanation of color temperature.)

A color film's data sheet shows what filters should be used to balance the film for different light sources. Instead of giving filter factors, it lists the film's revised ASA film speed when a filter is used. For instance, Ektachrome 200 is a daylight color slide film with a speed of ASA 200. When a filter is used so the film will be balanced for 3400K (photoflood) lights, its effective film speed is reduced to ASA 64. When a

| | LIGHT SOURCE | | |
| --- | --- | --- | --- |
| FILM TYPE | Daylight | Tungsten (3200K) | Photoflood Tungsten (3400K) |
| Daylight | | 80A | 80B |
| Tungsten (Type B) (3200K) | 85B | | 81A |
| Type A (3400K) | 85 | 82A | |

different filter is used to balance the film for tungsten (3200K) light, the film's speed is ASA 50. A camera that has a through-the-lens metering system should compensate for the filter, so set the meter for the film's regular speed, ASA 200. See the camera's instruction booklet for advice about metering with filters. To check the camera's meter without making an exposure, first make a reading with the filter, using the film's normal ASA. Then reset the meter with the ASA recommended for that specific filter, remove the filter and make a second reading, and compare the results.

Conversion filters all are identified by numbers in the 80s, followed by a letter. Nos. 80A and 80B are bluish filters that convert daylight films for use with tungsten light. Nos. 85 and 85B amber filters convert tungsten films so they can be used with daylight; No. 81A is a yellowish filter that balances tungsten film (3200K) for 3400K light, while No. 82A is a bluish filter that balances Type A (3400K) film for 3200K light.

Above is a summary of the conversion filters necessary to use different color films and light sources.

Because of a reduction in film speed that occurs when a conversion filter is used, most photographers shoot with color film that is balanced for their light source so they can avoid using filters. In addition, color negative films, like Kodacolor and Fujicolor, can be corrected later during printing by using filters in the enlarger to change colors so they look more natural.

Color slide films make direct positive images, however, so color corrections must be done at the time the picture is taken (unless prints are made from the slide or the slide is copied while using filters to alter its colors). An example is a new electronic flash, which may cause

bluishness in the subjects taken with daylight film. A yellowish No. 81A filter will diminish the bluish results, and a No. 81B absorbs the blue color even more.

A bluish filter, No. 82A, can be used with daylight color films to reduce the yellowish or reddish cast that appears when pictures are taken in the early morning or late afternoon.

There are some COLOR COMPENSATING (CC) FILTERS used mostly in the color printing process but sometimes when exposing film. These yellow, magenta, and cyan filters come in various densities for precise control of colors in your photograph. When shooting through green tinted glass, for instance, use a magenta filter to absorb the green color of the glass so your picture will have good color balance.

Also, color compensating filters can be used together to cancel out annoying color casts caused by fluorescent lights. Easier to use are the special FLUORESCENT LIGHT FILTERS that prevent the greenish tinge on daylight films and bluish tinge on tungsten films. They have a filter factor of 2 (requiring an exposure increase of 1 f/stop) and usually are designated as FL-D (for use with daylight films) and FL-B (for use with tungsten Type B films).

Besides using filters to record colors just as you saw them when taking the picture, they can be used to create a special mood or effect. Experiment with the filters that are normally used with black-and-white films. For example, a deep blue (No. 47B) filter and deliberate under-exposure can make a sunlighted scene appear to have been taken by moonlight. Likewise, red (No. 25) or deep yellow/orange (No. 15) filters can enhance an ordinary sunset. Unusual multiple exposures can be made on the same film frame when each exposure is taken through a different colored filter.

To reduce the harshness of the light from an electronic flash used for this informal portrait, a soft focus filter was placed in front of the camera lens.

Kodak's Ektachrome Infrared color film produces some unexpected results when shot through various filters. Try all colors and different times of the day because infrared radiation will vary. Even with the recommended deep yellow (No. 12 or 15) filter, green-colored subjects become red or magenta, red records as yellow, and skin turns greenish. Blue skies stay blue, however. (Also see page 188.)

## Filters for Special Effects

Besides effects you can create with regular filters, there are other filters and lens attachments that will alter the images on your film. Most are made commercially, but some you can devise yourself.

Subjects and colors can be softened by shooting through a SOFT FOCUS FILTER that diffuses the light rays reaching the film. No exposure adjustment is necessary. These are popular for portraiture work, particularly when photographing women and children, and for static subjects like flowers. They also are known as DIFFUSION FILTERS, and can be purchased in five grades that vary the degree of the soft focus effect. You can make your own diffuser by placing a transparent material, such as cellophane or a clear plastic bag, in front of the lens. A piece of dark nylon stocking will diffuse images, too. The number of layers you use over the lens determines the degree of diffusion.

Another method is to apply a thin layer of Vaseline to a clear filter or a piece of glass. If you keep a circle in the center clear of the petroleum jelly, or cut a hole in the cellophane or piece of plastic, you create what is sometimes called a SPOT FILTER. The subject in the center of your picture remains sharp, but the surrounding images are diffused. Keep homemade spot filters as close to the lens as possible,

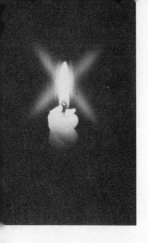

Cross screen filters can be used in front of the camera lens to create four- or six-pointed star effects from bright sources of light, like this candle.

especially when using a wide-angle or normal lens, so the sharp area blends with the soft areas without an obvious edge. If the edge of the clear circle shows, use a wider lens opening or change to a telephoto lens. Spot filters also are made commercially, and some are colored glass so you can change the mood of your picture even more.

Some filter makers supply FOG FILTERS, available in five densities, which give natural fog effects to your scenic pictures. Use them on an overcast day or to enhance actual fog.

Favorites with many photographers, amateur and professional, are CROSS SCREEN or STAR FILTERS that create starlike patterns from bright points of light, such as the sun, light bulbs, and reflections off water and other shiny surfaces. The best ones are commercially made, with fine lines etched on clear glass, and they come in two varieties that will produce four- or six-pointed star effects.

You can make your own star filter by placing one or two pieces of window screen in front of the lens. This technique, however, also diffuses the subject, and the stars and overall image will not be as sharp as when a glass-etched cross screen filter is used. (Another way to make star patterns in your pictures, without using any special filter, is to stop down the lens to its smallest opening and expose for the bright light source. The overall picture will be darker than the actual scene, and if you photographed the sun, it will appear as the moon or a bright star.)

VARIABLE CROSS SCREEN or STAR FILTERS can be purchased that allow you to control the star configurations. These are two pieces of etched glass that can be rotated in their mount; you also can use two regular cross screen filters together. A single lens reflex camera is

One rose became five roses when shot through a multiple image filter. Sharpness of the secondary images depends on the quality of the filter's optics; a large lens aperture and contrasting background are recommended for the best results.

easiest to use with such filters because you can see the effects directly through the viewfinder.

Photographers also like to experiment with MULTIPLE IMAGE FILTERS, which reproduce identical images in a variety of patterns. These actually are multifaceted lenses in rotating mounts that attach to the camera lens; no increase in exposure is required. The type you purchase determines the number of identical images, usually 3, 5, or 6, and the repeating pattern: concentric, linear, radial, diamond, or parallel.

There are DIFFRACTION GRATING FILTERS that break up points of bright light like a prism and produce one or a number of rays in a rainbow of colors. They are made of acetate and can be rotated to vary the direction of the ray(s).

VARIABLE COLOR FILTERS will produce different hues as they are rotated—such as red to violet to blue, or red to amber to green—so you can change the mood of your images on color film. When used with a polarizing filter, the shades of the colors can be varied, too.

There also are DUAL COLOR FILTERS that give one half of your image a certain color and the other half another color. Other types are GRADUATED FILTERS, with one-half neutral density to darken part of your picture, such as the sky, or one half in color, such as blue to add color to an overcast sky. The edge of the colored or neutral density half is faded so that a line between it and the clear half will not be obvious in your picture.

You can create your own dual color or graduated filters by holding a gelatin (acetate) filter or filters over half of the lens. Use a wide lens opening so the filter edge will not be distinct in the photograph. Exposure will vary according to the color and/or density of the filter.

A SPLIT FIELD LENS is similar to a graduated filter except that half the lens is optically designed for close-ups. Since the other half is clear, this lens attachment enables both close and distant subjects to be in sharp focus. It is best used on a single lens reflex camera because you can look through the viewfinder as you focus the camera lens to be sure near and far subjects are simultaneously in focus. Like regular close-up lenses, split field lenses are available in several diopters (i.e., magnifying powers), although the most common is +1 (see page 101). No exposure compensation is required.

For other effects, you can use a FISH-EYE LENS ATTACHMENT that is mounted in front of the camera's normal or wide-angle lens. It gives the same circular and distorted image as regular fish-eye lenses (see page 84), but its cost is far less. The fish-eye lens attachment can give up to 180° angle of view, depending on the camera lens being used. Because its depth of field is so great, focusing is not a problem. Sharpness of the image, however, is never as good as with a regular fish-eye lens. For exposure, set the camera's lens at its widest opening, and use the fish-eye attachment's own aperture control to set the correct f/stop.

Another lens accessory, for candid photography with normal or telephoto lenses, is a RIGHT-ANGLE MIRROR ATTACHMENT, which looks like a lens but photographs subjects that are 90° to the direction your camera is aimed. People don't know you're taking their picture because the attachment has a hole in its side where the mirror receives the image; the lens in front is a fake. Focusing and metering are done normally, but it takes practice to aim the camera and frame the subject reflected to you at right angles by the special front-surface mirror. Because it has no real optics, this attachment is much less expensive than an actual lens.

In most cases, lens attachments and filters can be used in combination to produce different effects. This gives the photographer many ways to experiment and create eye-catching images.

# 5
## Flash Systems
## for 35mm
## Cameras

Until more sensitive films were made, photographers frequently had to rely on flash to provide enough light to make pictures possible. In the old days, that meant carrying a gadget bag full of flash bulbs. Then electronic flash came along to replace bulbs with a gas-filled tube that produced bright flashes and never had to be replaced. Unfortunately, a strobe light, as it was then called, required large and heavy high-powered batteries. Over the years, however, electronic flash units have become smaller, lighter, and so sophisticated that many models compute exposure automatically.

Do you really need flash these days, now that there are fast films with very sensitive emulsions to use when the existing light is low? Can't you get by with films of ASA 400, which are now available in black-and-white, color negative (for prints), and color positive (for slide transparencies)? Perhaps, but there are times when there is not enough natural light to get the picture you want, and often there are occasions when flash can be used to fill in shadows or highlight portions of your subject.

The light from electronic flash can be very brief, with durations of 1/1000 to 1/50,000 second. This makes it ideal for stopping action, particularly sports, and even for babies and children, who change their expressions so quickly.

Wedding photographers use flash to capture candid moments of the bride and groom and guests and because the natural light indoors and outdoors varies so much.

Nature photographers like flash for close-ups because it is a bright directional source of light that illuminates the subject just as they wish, and because it allows a small f/stop to be used for greater depth of field and sharper images. With many subjects, flash is a convenient

Electronic flash provides a convenient and compact source of light that enables you to capture any event or expression instantly.

way to add light to areas with unwanted shadows, as when you're taking a portrait with the sun overhead and the person's eyesockets are shaded.

Flash makes it possible to get pictures at night and when interiors are dark. Also, a single flash can be disconnected from the camera and flashed manually a number of times from different positions, while the shutter is kept open, to illuminate large dark areas outdoors or indoors.

After deciding that an electronic flash will be useful, you must figure which of the current 150 models is best for the kinds of photography you do. Then you must learn to use the flash successfully. Because the electronic flash market is so competitive, the numerous flash manufacturers advertise features that are supposed to make their units particularly unique. You may be confused by the wide choice of models, so we will list and then describe the basic features of electronic flash and the options available on various units.

EXPOSURE CONTROL
  Automatic
    Camera-coupled (integrated)
    Flash controlled
  Manual

LIGHT OUTPUT
  Automatic
    Aperture selection
    Distance range
  Manual
    Beam-candlepower-seconds
      (BCPS)
    Flash guide numbers

FLASH DURATION
ANGLE OF ILLUMINATION
  Zoom feature
  Wide-angle attachment
  Telephoto attachment

POWER SOURCE
  Batteries
    Replaceable alkaline
    Rechargeable nickel-cadmium
  AC operation

RECYCLE TIME
  Ready light

NUMBER OF FLASHES
CAMERA CONNECTIONS
  Mounting bracket
  Hot shoe
  PC plug with cord
SIZE/WEIGHT
COST
OPTIONS
  Energy saving thyristor circuitry

Variable power control
Remote automatic sensor
Automatic exposure signal
Open flash button
Tilting or swiveling head
Bounce light diffuser
Illuminated calculator dial
Filter attachments
Remote control slave cell

## Electronic Flash Features

A basic feature of electronic flash units these days is automatic exposure control. This makes flash photography quite easy, but not foolproof. Before explaining how autoflash works, here is some background on flash exposure in general.

For taking pictures by existing light, you recall that exposure is determined by the camera's shutter speed (which controls the duration of the light) and lens aperture (which controls the intensity of the light). When pictures are taken with electronic flash, exposure *time* is really determined by the duration of the flash rather than shutter speed. Because the duration of the flash is so very brief (the light lasts only 1/1000 second, or even less), the shutter speed you choose would seem unimportant. With a single lens reflex, however, the shutter speed you set *is* important, because the camera's focal plane shutter (see page 21) must be fully open when the flash goes off. If the camera's shutter speed is too fast, one of the shutter's curtains may be in the way and block light from the flash.

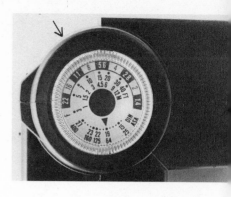

To manually figure exposure for electronic flash, the unit's exposure calculator dial is set to the speed of the film in your camera; here it is ASA 64. After determining the distance the flash is from the subject, find that distance on the dial and look opposite to determine the f/stop to set on the camera lens. As an example (arrow), if the flash-to-subject distance is 10 feet, the correct aperture setting would be midway between f/8 and f/11.

For proper flash synchronization with SLRs, there is a *maximum* shutter speed you can use, which usually is $\frac{1}{60}$ or $\frac{1}{125}$ second, or in between, as stated in the camera's operation manual. Additionally, the maximum shutter speed for flash may be indicated in a special color or with an "X" symbol on the shutter speed dial. Of course you can use any *slower* shutter speed with the flash, but other light that is present might have time to register on the film, too, which may overexpose the film or cause ghost images. Unless they are shooting by existing light and using flash only for *fill-in*, photographers usually set the camera's shutter at the maximum speed that is synchronized for electronic flash.

With rangefinder cameras, because their shutters are not the focal-plane type (except Leica), you can use any shutter speed when shooting with flash.

After the shutter speed is pre-set, you must decide what f/stop will give the best exposure. This depends on the light output of the flash (its intensity), the distance the subject is from the flash, and the speed (ASA) of your film. To make things simple, flash manufacturers put an EXPOSURE CALCULATOR DIAL or SCALE on the unit. It lists film speeds, f/stops, and distances in feet and/or meters. Some flash models feature an *illuminated* calculator dial for easier reading in the dark.

To use the calculator, first you set the ASA of the film you are using. Then you determine the distance your subject is from the flash, usually by focusing on the subject and noting the indicated distance on your lens focusing ring. You locate this distance on the calculator's dial or scale, and note the f/stop number opposite it. That's the aperture opening to set on your lens for correct flash exposure. Easy enough? Yes, except when you're in a hurry.

A sensor at the front of an electronic flash unit with automatic exposure control reads the light reflected by the subject and regulates the flash duration.

There are some special light meters that figure flash exposure (see page 166), but more popular are the so-called autoflash units with AUTOMATIC EXPOSURE CONTROL that does the figuring for you by incorporating a tiny computer inside the flash unit. It relies on a sensor located at the front of the flash unit to receive the flash light reflected by the subject. Then it miraculously adjusts the duration of the flash to allow just enough light to reach the subject for a correct exposure.

All you have to do is first set your film's ASA on the unit's exposure calculator dial and note the f/stop that appears opposite the dial's AUTOMATIC EXPOSURE INDEX MARK. This is the f/stop to set on your camera lens. The flash sensoring system does the rest, giving extremely brief flash durations (as little as 1/50,000 second) when subjects are close, and longer flash duration (as much as 1/1000 second) when subjects are distant.

There are some limitations. Light from a flash will travel only so far, so your subjects must not be beyond a certain distance or they will be underexposed. Also, the flash computer is limited in regard to its briefest durations, so subjects usually can't be closer than 2 or 3 feet to the flash or they will receive too much light and be overexposed. The MINIMUM-MAXIMUM AUTOFLASH OPERATING RANGE is stated in the flash unit's instruction booklet and sometimes is indicated on the calculator dial. Remember that tele-extenders, extension tubes and bellows, and most filters require additional exposure, so the f/stop must be opened up accordingly when these lens attachments are used with autoflash.

Some other problems can occur when you're counting on the flash to figure exposure automatically. First, if the sensor is accidentally covered, perhaps by your fingers or the flash cord, exposures will be

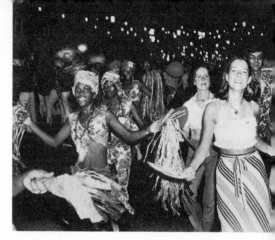

Nighttime action shots are easily captured with electronic flash; if your unit has automatic exposure control, experiment to see how it performs when the background is very dark (or very light).

inaccurate. Also, any object between the flash and your main subject, or a very light or very dark background, can deceive the sensor and cause incorrect exposures.

In the first case, when a foreground object reflects the flash light back to the sensor, duration of the light is cut before the light has had time to reach and fully illuminate your subject, so it will be underexposed. In the other situations, when there's a light background, more light will be reflected from the background than from the subject itself, so the sensor signals for a shorter flash duration which results in the subject being underexposed. With a dark background, or outdoors at night, much of the flash is absorbed and less light is reflected, so the sensor allows a longer flash duration, which may cause the subject to be overexposed.

So far our discussion has been limited to the most basic types of automatic exposure flash units. Because many photographers are concerned with depth of field, more advanced units offer a choice of two or three f/stops you can use with automatic exposure control. If you want limited depth of field, choose a wide lens aperture. For greater depth of field, set the aperture to a smaller lens opening. The maximum range for automatic exposure changes according to the f/stop you select, and this distance will be indicated on the unit's calculator dial. At smaller f/stops, flash output is less, so your subjects must be closer. When a wider f/stop is selected, subjects can be a greater distance from the flash.

The maximum distance range(s), and therefore the f/stop(s) you must set for automatic flash control, depends on the unit's specific LIGHT OUTPUT. Light output is rated in BEAM-CANDLEPOWER-SECONDS, commonly abbreviated BCPS, and it is given in the technical data list-

ings found in flash brochures, camera store product catalogs, and the flash unit's instruction booklet. BCPS ratings range from 350 to 8000. The higher the BCPS number, the greater the light output, and thus the greater distance subjects can be from the flash. Obviously a flash unit with great light output is the most useful in many flash situations.

Some manufacturers also give a FLASH GUIDE NUMBER as an indication of a flash unit's light output. Commonly it is for the slowest speed film in popular use, ASA 25, but a guide number for current fast films, with ASA 400, may be listed too. When using flash guide numbers to compare the light output of various units, remember that the higher the guide number, the greater the light output. Be warned that the guide number is established by the flash unit's manufacturers and it may be exaggerated; make your own flash exposure tests to see if the guide number is accurate.

The practical use for a flash guide number is to determine what f/stop will give a proper flash exposure. You just divide the flash guide number by the distance your subject is from the flash, and the answer is the f/stop number to set on your lens. For example, if a flash unit has a guide number of 28 for ASA 25 film, and your subject is 10 feet from the flash, you should set the lens aperture to f/2.8 (28 ÷ 10 = 2.8). Similarly, if another flash unit has a guide number of 40 for ASA 25 film, a subject 10 feet from the flash should be exposed at f/4 (40 ÷ 10 = 4).

By comparing f/stops in this manner, you can compare the light output of the flash units. In our example above, the unit with a flash guide number of 40 has twice the light output of the flash with a guide number of 28, because the first requires one f/stop less exposure (when subjects are at the same distance).

## Flash Guide Numbers

| BCPS | 350 | 500 | 700 | 1000 | 1400 | 2000 | 2800 | 4000 | 5600 | 8000 |
|------|-----|-----|-----|------|------|------|------|------|------|------|
| Number | 20 | 24 | 30 | 35 | 40 | 50 | 60 | 70 | 85 | 100 |

Also, you can figure whether a specific unit is adequate for your photographic purposes. For instance, if you shoot with ASA 25 film and know your subjects will sometimes be 20 feet from the flash, a unit that has a guide number of 28 requires a lens opening of f/1.4. If your lens doesn't open that wide, or you want more depth of field and must use a smaller lens opening, that particular flash is incapable of giving you a properly-exposed flash picture.

When a flash unit's instruction booklet indicates light output in BCPS but gives no flash guide number, you can find it in the electronic flash guide number chart included on the data sheet packed with the film you are using. The one reproduced above is for Kodachrome 25 (ASA 25) film.

The unit's exposure calculator dial also can be used to determine flash guide numbers. Just set the ASA of your film and then multiply any f/stop number by the distance number that appears exactly opposite it.

Although BCPS and flash guide numbers tell you the specific light output of a flash unit, its physical size gives a general indication of the power it packs. Besides the PORTABLE ELECTRONIC FLASH UNITS that attach in some manner to your camera, there are also AC-connected STUDIO ELECTRONIC FLASH UNITS mounted on stands. These are larger, heavier, and more powerful, and they often incorporate a regular tungsten lamp, called a MODELING LIGHT, so the photographer can check the lighting as he arranges the flash units in the studio.

As for the portable flash units, the most powerful ones have a big flash head and a handle and frequently are attached to the camera with an accessory bracket that fastens to the tripod socket. Because of their looks, head-and-handle units have been nicknamed "potato mashers."

For greater light output and faster recycling, many professionals use an electronic flash unit with a large separate battery pack. So-called potato masher models have handles that can be detached quickly from the camera mounting bracketing for off-camera use.

The early models required a separate battery pack that hooked on the photographer's belt or hung from the shoulder, but many of the newer units use batteries that are installed in the head or the handle.

The most popular electronic flashes are medium-sized units that give medium light output. They slip into the camera's accessory shoe, which is commonly called a HOT SHOE when it makes a direct electrical connection with the flash. These medium units are sometimes mounted to the camera with an accessory bracket so they can be easily removed and aimed for off-camera flash.

Least powerful are the inexpensive palm-sized portable flash units that mount in the camera's hot shoe and are convenient for occasional use when subjects are not far from the camera. Some photographers carry them just for fill-in flash.

Whatever their size, autoflash units can be switched to *manual* exposure control by moving a built-in cover over the flash sensor. Then the flash operates at full light output, and you adjust the lens aperture for each exposure, depending on the distance your subject is from the flash. At close range, the light may be too bright for your needs (as when you want to use a wide aperture for shallow depth of field), so some units have a HIGH-LOW SWITCH to reduce the light output.

More versatile units have a VARIABLE POWER CONTROL, which allows selection of full, one-half, or one-quarter light output, and sometimes even smaller fractions, such as ⅛, ⅟₁₆, ⅟₃₂, and ⅟₆₄ power. Variable power control is built into some units and available as an optional accessory on others. It is particularly helpful when using the flash for fill-in light because the flash output can be easily adjusted to avoid overpowering the existing light. Also, for studio use and when two or more units are used to illuminate the subject, you can control the flash

lighting very precisely. Another benefit of the variable control is that the unit's RECYCLING TIME will be shorter when light output is reduced, so you can flash again with minimal delay.

All flash units require a certain time to recycle, which means building up the electrical charge in the unit's *capacitor*, a device that stores the current needed to spark the gas-filled tube that produces the flash. A READY LIGHT glows on the unit to signal you when the flash capacitor is fully recharged (i.e., recycled) and set to go; some photographers wait a few seconds longer to be certain the capacitor is up to full power. (The flash can be fired *before* the ready light goes on, but the light output will be weak and your subject will be underexposed.)

Technical data accompanying the flash indicates its recycling time, which is determined by the unit's power source (whether AC or batteries) and the light output. Units that have only manual exposure control, and autoflash units switched to the manual mode, use the full light output and therefore require the longest recycling times. With fresh batteries, recycle times on various units range from 4 to 14 seconds, with most taking from 8 to 10 seconds to be fully recharged.

Recycle times can be reduced when a flash unit has automatic exposure control, or variable power control, or a high-low power feature, because it takes the capacitor less time to recharge when less power is used. With autoflash, recycle time is only reduced when the unit has something described as ENERGY-SAVING THYRISTOR CIRCUITRY. Although flash duration will vary according to the distance of your subject, the capacitor's full charge will be drained off unless there is thyristor circuitry that returns the unused portion of power back to the capacitor. When power is returned to the capacitor, it recharges faster, so recycle

time is reduced, sometimes taking just one second or less. Another benefit from units that will produce flashes at reduced light output is that batteries last longer, and you can get more flashes before replacement or recharging is required.

Most electronic flash units operate on battery power, except large studio models, which are AC-operated and plug into regular 110-volt electrical current. Some portable flash units can be switched to AC operation and connected to an outlet with an extension cord, but the majority of the popular medium-sized units that mount in the camera's hot shoe use four AA-size 1.5-volt batteries. Pocket-size units take two to four AA cells, while the larger flash guns with handles use four to six AA cells, larger C size batteries, or high-voltage battery packs.

The commonly used AA batteries are of two types, REPLACEABLE ALKALINE CELLS or RECHARGEABLE NICKEL-CADMIUM CELLS. Nickel-cadmium batteries (nicknamed ni-cads) will recycle the flash unit faster than alkaline batteries, but the alkaline type gives more flashes per set than the ni-cads give per charge.

However, you have to be concerned whether alkaline batteries are fresh when you buy them and with the fact that they lose power when not in use. (Ni-cads do too, but they can be recharged.) In a long run, it will probably be more expensive to replace alkaline batteries than it is to purchase ni-cads and their battery charger. While some units require the flash manufacturer's special nickel-cadmium batteries and recharger, General Electric makes less expensive ni-cad batteries in popular sizes, with companion rechargers that give a full charge in 16 hours.

Photographers often buy two sets of nickel cadmium batteries and carry fully-charged spares in case the batteries in the flashgun become

exhausted during a shooting session. Some manufacturers permanently seal ni-cad batteries into their flashguns, but this can cause a problem if they run down while you're shooting. If you buy a unit with non-interchangeable batteries, at least be sure it has a quick-charge feature that permits a partial recharge of the batteries in a matter of minutes so you can continue taking flash pictures without too much delay (the time for full charges can range from 1 to 15 hours).

As for the number of flashes a unit will give before batteries must be replaced or recharged, hot shoe mounted flash units using four alkaline AA batteries offer from 75 to 250 full-power flashes per set, with most of them delivering 120, 150, or 200 flashes. When using an autoflash with energy saving thyristor circuitry and shooting subjects only a few feet away, flash manufacturers claim from 800 to 2400 flashes per set of batteries are possible, with most units averaging 1200 flashes.

With four AA nickel-cadmium batteries in hot shoe-mounted flash units, 50 to 80 flashes are average before recharging is required. When using autoflash with energy saving circuitry, while subjects are 2 to 3 feet away, ni-cad batteries will give an average of 600 to 700 flashes per charge.

It is important to read the technical data about a specific unit for exact information regarding the number of flashes that are possible with different types of batteries, both when the flash is used at full power in the manual mode and at reduced power for nearby subjects in the automatic exposure mode.

A recent advance is CAMERA-COUPLED (or INTEGRATED) AUTO-MATIC FLASH. These are special units made by a few camera manufacturers for specific cameras. The flash mounts in the camera's hot shoe,

A connecting cord permits a flash unit to be removed from the camera's hot shoe for more versatile use; coiled cords should not be overstretched.

making connections through extra prongs and contact plates to automatically set the camera's shutter speed for proper flash synchronization.

Most offer a choice of two or more f/stops you can use when the flash is in the automatic exposure mode. Some activate a tiny ready light in the camera's viewfinder so you know, without ever taking your eye off the action, when the flash unit is recycled and ready to shoot again. To prevent underexposed flash pictures, one model even switches back to automatic exposure control for the existing light until the flash is fully recycled.

When the camera is used with an auto winder or a motor drive, its compatible flash unit will recycle in a fraction of a second to allow rapid-fire, properly exposed flash pictures, as long as the subject is within a specified minimum distance. These camera-coupled flash units are designed to make automatic flash more foolproof and versatile than ever before. There's one limitation to consider, however. Most of these units cannot carry out their special automatic functions unless mounted directly in the camera's hot shoe or connected to the hot shoe by a special cord.

There are a few options when you are mounting and connecting any flash unit to a camera. The camera's ACCESSORY SHOE is the simplest choice, unless the unit is too heavy or is a head-and-handle type that requires a mounting bracket. Any accessory shoe that has electrical contacts, which makes a flash connecting cord unnecessary, is called a hot shoe. Most medium- and palm-sized flash units have contact on the base that makes proper connections with any hot shoe.

If the camera does not have a hot shoe, or if the flash is removed from the hot shoe, a FLASH CONNECTING CORD is required. This plugs

into the camera's flash cord socket, usually with a PC-TYPE (PUSH-CONTACT) PLUG. One caution: These plugs have the annoying habit of pulling free from the camera socket, unless they are the threaded type. Also beware of faulty connections with *coiled* flash cords, because there is considerable strain on their plugs and wiring when the cord is stretched. If the camera has two flash cord sockets, use the one marked "X" for proper synchronization with electronic flash. Even when there is just one socket, some cameras have a flash synchronization switch, which must be turned to the "X" position for use with electronic flash.

If the camera has no flash cord socket and you want to remove the flash from the hot shoe, there are socket adapters that can be slipped into the hot shoe so a flash cord can be connected there.

Why remove the flash from its convenient location in the camera's accessory shoe or hot shoe? Sometimes this must be done to avoid "RED EYE," an annoying pink or red coloration of the subject's widely opened eyes which occurs when the flash is mounted too close to the camera lens and its light reflects directly back from inside the eyes. The main reason is that flash direct from the camera position is rather harsh, unnatural, and often unflattering. It's termed FLAT FLASH, and it doesn't enhance the shape or texture of your subjects.

When the flash is removed from the camera's hot shoe, more pleasing and dramatic lighting is possible. For general shooting, holding the flash at least a foot above and to the right or left of the camera creates enough shadow to reveal more of your subject's form and add extra dimension to the picture. Such off-camera flash is said to give more "modeling" to your subject.

Especially effective is the use of BOUNCE FLASH to diffuse the light and make it less harsh and directional. Commonly this is done by aim-

ing the flash at an angle toward a light-colored ceiling so the light bounces down on your subject more naturally. An optional attachment for some flash units is a BOUNCE LIGHT DIFFUSER, a white card that reflects the flash and also produces softer lighting. Other units will accommodate a DIFFUSION FILTER that covers the flash reflector and softens the light.

A FLASH BRACKET, which attaches to the camera's tripod socket, is required for head-and-handle flash units. Medium and small hot shoe-mounted units also can be mounted on a bracket for off-camera use. Some brackets feature a quick-release handle so the flash can be detached easily and aimed accurately.

When an automatic flash unit is removed from the camera, its built-in sensor frequently fails to produce proper exposures because it is not in position to react to the flash light reflected back to the camera. To solve the problem, you can buy a REMOTE AUTOMATIC SENSOR that is connected by cord to the flash unit and slips into the camera's hot shoe, where it receives the light and correctly controls the flash duration.

Because bounce light is so often desired, the more versatile flash units have a TILTING HEAD so the light can be aimed at the ceiling (or directed into a bounce light diffuser) without taking the flash off the camera. This also means bounce flash is possible with some autoflash units without using a remote automatic sensor, because the unit's built-in sensor remains in the same position on the camera while the head is tilted. The heads on a few hot shoe-mounted units also swivel, which means on-camera bounce light will still be possible when the camera is turned to make vertical pictures.

Whether the head is swiveled or tilted for bounce light, or directed

As you can detect from the direction of the shadows, the flash unit that illuminated this potter was not in the camera's accessory shoe or hot shoe, but held slightly above and to the left of the camera.

straight at the subject, how do you know if there is enough light reaching the subject to make a correct automatic flash exposure? Some of the better autoflash units have an AUTOMATIC EXPOSURE SIGNAL, a LED check light (usually green) that glows momentarily if the light received by the sensor is sufficient to make a proper exposure. You also can test if there will be enough light before making an actual exposure. Just press the unit's OPEN FLASH BUTTON to fire the flash and then watch the automatic exposure check light to see if it glows. Another way to determine or check correct flash exposure is with a flash meter (see page 166).

An important thing to know about any flash unit, automatic or manual, is its ANGLE OF ILLUMINATION. This tells you, in degrees (°), the specific area the flash will cover. Most flash reflectors are oblong, so coverage usually depends on whether the flash is mounted or held horizontally or vertically. The instruction booklet accompanying the flash unit states both the horizontal and vertical angles of illumination and sometimes indicates the widest wide-angle lens the flash will cover. Commonly, light from a flash with its reflector in a horizontal position is at least broad enough to use with a 35mm lens.

Many units have special WIDE-ANGLE AND/OR TELEPHOTO FLASH ATTACHMENTS that slip on the flash head to spread or concentrate the light. With a wide-angle attachment, coverage can be broadened to accommodate a 28mm or 24mm lens. Without such a wide-angle attachment, the edges of your picture will be dark (unless the flash is a greater distance from the subject than your camera). The telephoto attachment is used to narrow the flash unit's angle of illumination and to extend the light so subjects at a greater distance can be photographed with flash.

A few flash units feature a ZOOM FLASH HEAD that can be adjusted to change the angle of illumination, spreading it out for use with wide-angle lenses and concentrating it for use with telephoto lenses. With one zoom model, for instance, adjustments can be made to provide flash coverage for 35mm to 85mm (and longer) lenses. With a wide-angle attachment, the flash also can be used with a 24mm lens.

Some flash units will accommodate FILTER ATTACHMENTS. These can include red, blue, green, and yellow filters that fit over the flash reflector to change the color of light. Also available are neutral density filters that reduce the intensity of the light (for close-up work) but do not alter its color.

The color of the light from electronic flash units is balanced for use with daylight color films; for use with tungsten color films, a color correction filter (85B) can be placed in front of the flash reflector (or put over the camera lens).

When photographers use two or more electronic flash units to illuminate a subject, the extra SLAVE UNIT(s) can be fired through remote control slave cells. Instead of using cords to connect the units together so they'll all flash at the same time, each extra unit is attached to a light-sensitive photo cell. When the main unit is fired by the camera, the cells pick up the flash and instantaneously trigger the slave units in total synchronization.

When frontal, almost shadowless lighting is required for recording precise details, photographers can use a RING LIGHT, a special electronic flash unit that encircles the camera lens and requires a separate power pack. It is designed for close-ups and frequently is used by dentists and doctors who want explicit photographs of their dental or

When electronic flash is used with SLR cameras, the shutter speed must be set for proper synchronization—usually 1/60 second (see your camera manual). If the shutter speed is too fast, as shown in this example, the focal plane shutter will be partially closed and will block the film when the flash goes off.

medical operations. Nature photographers doing macro work have found uses for ring lights, too.

It should be pointed out that electronic flash units have virtually replaced flashbulbs, even on the latest models of Instamatic and Polaroid-type cameras. Some of the miniature full-frame 35mm rangefinder cameras now have built-in electronic flashes that pop up or pull out and automatically set the exposure. As with any autoflash, you must know its minimum-maximum operating range to be sure your subjects are not too close or too far from the camera.

If FLASHBULBS are used with 35mm cameras, whether rangefinder or SLR, automatic exposures generally are not possible. A flash guide number must be divided by the flash-to-subject distance to figure out the f/stop to set on the lens. Flash guide number charts are included on the data sheets packed with film and are also found on flashbulb packages.

Synchronization usually is different for flash bulbs and for electronic flash; if "X" synchronization for electronic flash is used with flashbulbs, the shutter speed should be set no faster than $\frac{1}{30}$ second, because flashbulbs take longer to reach peak brilliance than electronic flash units do. Camera flash sockets or switches marked "M" or "FP" indicate synchronization that is designed for flash bulbs (M for Medium peak bulbs and FP for Focal Plane bulbs), and faster shutter speeds can be used.

Most flashbulbs and flashcubes sold today are blue. They are balanced for use with daylight color films but also can be used with black-and-white films. The smallest flashbulbs available are AG-1B (B for Blue); those of larger size and greater light output are M3B, 5B, and

25B. Two other types, 6B and 26B, have an extended peak intensity and are especially designed for cameras that have focal plane shutters and FP synchronization.

After selecting a shutter speed, you can make a simple SYNCHRONIZATION TEST, with electronic flash or flashbulbs, by opening the back of an empty camera and putting your eye just behind the shutter where the film would normally be. Then open the lens aperture to its widest f/stop, aim the flash and camera at a white or light-colored wall a foot or so away, and trip the shutter. If you see a *full*, bright circle of light, the shutter is opening when the flash is most intense, which means flash and camera are correctly synchronized.

If your flash ever fails to fire, there are some things to check. A frequent problem is dirty contacts, so inspect and clean the hot shoe, all connecting cord plugs and camera sockets, and the battery or AC connections. The wires in connecting cords are sometimes broken, so pull the plug from the camera and short circuit it to see if the flash will fire. The trouble may even be easier to solve: the batteries could be exhausted or the unit may simply be turned off.

Flash can be an important part of any photographer's equipment, as long as you know how it operates and the best ways to use it for the results you want. Since firing an electronic flash isn't expensive, practice with a roll or two of film so you know the possibilities as well as the limitations of your particular unit.

# 6

## Accessories for 35mm Cameras

A camera, a lens, and a roll of film are all you really need to take pictures, but the extent and enjoyment of your photography often depends on having additional equipment. Extra lenses are usually the first consideration for photographers who have 35mm single lens reflex cameras, and Chapter 3 covers normal, wide-angle, telephoto, zoom, and macro lenses, as well as fish-eye, mirror, and perspective correction (PC) lenses.

Close-up photography is a favorite of many 35mm camera users, and Chapter 3 also describes the special equipment that makes it possible to get larger images on the film: close-up lenses, lens reversing rings, extension tubes and bellows, adapters for microscopes and telescopes, and tele-extenders.

In Chapter 4, you'll find a discussion of filters and lens attachments for special effects, which include correction, contrast, conversion, color compensating, fluorescent light, soft focus (diffusion), spot, fog, cross screen (star), diffraction grating, variable color, dual color, and graduated filters, as well as split field lenses and fish-eye lens converters. Electronic flash can be very helpful in your photography, and those popular and sophisticated artificial light sources are covered in Chapter 5.

Additional accessories that often benefit photographers will be discussed in this chapter, including various support devices like tripods, unipods, copy stands, C-clamps, beanbags, chain links, tent stakes, pistol grips, and shoulder braces. Also covered are gadget bags and camera cases, interchangeable viewfinders and viewfinder adapters, hand-held exposure meters, gray cards, changing bags, remote control devices, underwater housings for cameras, flash and exposure meters, and more details about motor drives and auto winders.

## Camera Cases

Camera equipment usually represents a considerable investment, and most photographers expect it to give many years of service, so naturally they want to protect their cameras and accessories. Some buy a camera case made of soft or hard leather or plastic with a swing-down front cover, a shoulder strap, and a ¼-inch threaded knob that screws the case to the camera's tripod socket. The case protects the camera, but there are some drawbacks. For one thing, a front cover that cannot be completely detached is awkward and frequently gets in the way during shooting, especially when you turn the camera to make vertical shots. With rangefinder cameras, just like lens caps that are left on inadvertently, it may even block the lens without the photographer being aware of the problem if he's looking through the viewfinder. Also, when a telephoto or zoom lens is mounted on a SLR, the camera case may not close unless it is designed for long lenses. The case has to be removed to load and unload film in the camera, and this can be a nuisance if you are in a hurry. It's also best to remove the case when you're using a tripod because the tripod mounting screw frequently gets turned too tightly in the mounting knob of the case and must be freed with a pair of pliers.

Since most photographers have some sort of a gadget bag for their cameras and equipment, many do without a case and just fasten a shoulder strap directly to the strap mounts on the camera. This makes the camera unencumbered and ready for use, and the camera can be stored and protected in the gadget bag when not needed. Be sure the CAMERA STRAP is strong, wide enough for comfort, and fastened well; snap locks come open easily and your camera may drop and be dam-

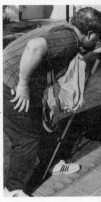

**Left** All types of cases can be used for carrying your camera equipment. On hikes, this photographer wears a pack frame to tote his large gadget bag and tripod and to keep his hands free to hold his camera. **Right** A waterproof knapsack serves well as a gadget bag, but lenses should be carried inside in their own cases for extra protection.

aged. The best things for fastening a strap to the camera are "O" rings.

## Gadget Bags

Gadget bags of various sizes are made of many materials, including hard and soft leather or plastic, and aluminum. The latter type is more correctly called an EQUIPMENT CASE and comes with a suitcase-style handle; some models have eyelets for attaching an accessory shoulder strap.

The important things to consider regarding any gadget bag are whether its size is adequate for your equipment, whether the padding is sufficient to offer protection, and whether its strap and/or handle are strong and are securely attached.

Certainly you want a gadget bag that is large enough to handle your equipment, but it shouldn't be awkward or a burden to carry. Nothing takes the fun out of photography as much as hauling around a huge and heavy case of equipment, especially when on a vacation trip. Whatever the case, use a padded shoulder strap to ease the load and to keep your hands free for shooting.

Most gadget bags are padded with foam and lined with material like corduroy or velveteen. If padding is insufficient for the type of handling your case receives, add some more foam to make sure camera bodies, lenses, and flash units are well cushioned. Some bags have partitions that can be adjusted or removed, and others have elastic or leather straps with fasteners to hold equipment in place.

Placing lenses in their own cases within the gadget bag gives them extra protection but makes them less accessible when you're in a hurry.

Be sure your equipment is handy to reach but won't fall out if the case accidentally opens. As a precaution, carry the gadget bag so the opening latch on its top or side flap is next to your body.

For heavy-duty handling or shipping, the aluminum Halliburton equipment cases are preferred by the pros. They are fitted with a block of foam that can be custom cut for your particular equipment, and their covers seal tightly to resist moisture and dust. When handling won't be rough and weight is of special concern, some photographers put their lenses in individual hard or soft lens cases and carry everything in an airline-type bag or a small backpack. Be certain to put some identification on or in your gadget bag, in case it is lost or stolen.

## Tripods

An almost indispensable accessory for photography is a tripod or other device that provides sturdy support for your camera. There are many times when the camera must be steadier than you can possibly hold it. For instance, when a lens of long focal length is used, a distant subject is greatly enlarged and there is a greater chance it will be blurred unless the camera has solid support. Also, if you need to use a slow shutter speed, the camera must be steady throughout the exposure time. When there are windy weather conditions, a tripod that is braced or weighted down will enable you to take sharp pictures.

A tripod-mounted camera makes it easier to keep your subject precisely framed and to maintain exact camera-to-subject distance, as when doing close-up or copy work or shooting portraits. Sometimes you'll want to leave the camera, perhaps to hold a flash away from the camera for a special lighting effect, and a tripod can be used to keep the

A tripod with its legs held together was used to raise the camera above spectators' heads at this religious festival in India; the camera's self-timer tripped the shutter.

camera in position. Or you can mount a flash on a tripod, and hand-hold the camera. If your subject is difficult to see from your location, the tripod's legs can be held together and you can raise the tripod and camera overhead or beyond an obstacle. By using the camera's self-timer, you'll have time to position the camera before the shutter is released.

There are many models of tripods available from dozens of manu-facturers. Popular brands include Gitzo (with over 60 models), Slik, and Vivitar. Size, ruggedness, special features, and price are the main considerations when purchasing this important accessory. Compact, light-weight tripods are ideal for travel and field work, while large and heavier types are better suited for studio use.

Tripod construction varies, so check models carefully for sturdiness and durability. Make sure the leg mounts are strong and can be tight-ened if necessary. Legs are usually two to four telescoping sections of tubular or C-channeled aluminum that feature twist or flip locks. Some have a center brace for extra support. Tripod legs have rubber or nylon tips, and some come with retractable or interchangeable metal spikes for slippery surfaces. The legs should not spread, bend, or wiggle when you apply pressure with your hand on the top of the tripod at the spot where the camera will be mounted.

Be sure the tripod extends high enough for your purposes; five feet is about average for general photography. An ELEVATOR COLUMN ex-tends the height of the tripod and allows for easier and more precise up-and-down adjustments, especially if the column is gear operated. The most useful elevator columns also can be reversed for low-level work beneath the tripod legs.

Always consider the length of a tripod when it is folded to see how

A ball-and-socket head on a tripod permits the camera to be angled to any position. For easy height adjustment this tripod has an elevator column.

conveniently it can be carried. Small tripods may fit inside your gadget bag or be attached to the outside. Otherwise, a wide nylon shoulder strap can be fastened to any tripod so you can carry it independently and keep your hands free.

Cameras are mounted to a tripod "head," and a versatile type to use with 35mm cameras is a BALL-AND-SOCKET HEAD with a single lock control. You can readjust the camera very quickly to any position by releasing the lock. A PAN AND TILT HEAD may have two or more knobs or long handles that are independent lock controls for vertical and horizontal camera adjustments.

Most cameras are mounted to the tripod head with a ¼-inch threaded bolt, although some older European camera models have a ⅜-inch size tripod socket and require a larger bolt. When using a heavy or long telephoto or zoom lens, always attach the tripod to the tripod socket on the lens instead of the camera (see page 91). Be sure the bolt is long enough to grip the camera or lens securely to the tripod. Some tripods have a quick release feature so the bolt and camera and lens can be lifted from the tripod head without having to be unscrewed.

There also are small TABLETOP TRIPODS (or MINIPODS) that are suited for low-level work. With a ball-and-socket head, one of these miniature tripods can be rested on the photographer's chest to give extra support to a hand-held camera. A UNIPOD (or MONOPOD), with a single leg that can be adjusted for height, lends support to hand-held cameras by helping keep them at a certain level. Sometimes it is attached to a very long telephoto lens to help balance the weight while you hold the camera.

There is a so-called HANDY STAND with an open circular mount that

When camera support is needed and a tripod is not available a cloth bag filled with styrofoam pellets can be used to cradle the camera on any solid support. To avoid camera movement during exposure, the camera's self-timer is activated to trip the shutter.

screws into the threads on the front of a camera lens and is generally used for copy work or close-up photography. It's light weight, has four adjustable legs, and can be used in the field. For copy work at home, a larger COPY STAND is preferred. The camera is mounted on a right angle arm that can be adjusted to various heights along a column that is attached to a sturdy baseboard.

A special C-CLAMP with a ¼-inch threaded bolt for mounting a camera is convenient to carry and can be attached to a variety of sturdy objects indoors and outdoors. The best models have a ball-and-socket head for making camera adjustments, and a set of retractable legs that will convert it into a low-level minipod. Be sure the C-clamp is strong enough to support your camera and lens and that it is fastened well enough to an object so your equipment doesn't fall and get damaged.

Some homemade gadgets can help support your camera for field work when a tripod isn't convenient to carry. Very useful is a BEANBAG filled with styrofoam pellets, which can be placed on a firm object like a fence post or the car roof. Wiggle the camera around until it settles securely in the bag in the direction you're aiming. When not used for support, it can be placed on the bottom of a backpack or gadget bag as a cushion for your camera equipment.

Another idea is to weld or otherwise fasten a ¼-inch threaded bolt onto a strong metal TENT STAKE that can be screwed into the camera's tripod socket and then shoved into the ground for support.

When a photographer uses his body to brace a camera, a PISTOL GRIP or SHOULDER BRACE (or RIFLE MOUNT) can help balance the camera better and hold it steadier, particularly when a long telephoto

Pressing the plunger at the end of a flexible cable release prevents the possibility of moving the camera while tripping the shutter.

or zoom lens is being used. A trigger in the grip or mount is connected by a cable release to the camera's shutter release.

A six-foot length of light-weight CHAIN also may be helpful when a ¼-inch thread eyebolt is attached to one end and screwed to the camera. Let the chain hang down to the ground, and step on it. As you pull up on the camera, the tension created by the chain can contribute extra steadiness to your hand-held camera.

## Cable Releases

As mentioned earlier, a cable release is an important accessory because you can use it to trip the shutter without jarring the camera. The more flexible vinyl- or cloth-covered release is better than the spring metal-covered release because the latter type is rigid enough to move the camera when you press its plunger. Cable releases with locking devices are preferred for long time exposures with the shutter set at "B"; otherwise you'd have to hold in the plunger to keep the shutter open. Cable releases are available in various lengths, ranging from 5 to 20 inches. As a general rule, you should use a cable release whenever a camera is not hand held. (As an alternative, the camera's self-timer can be activated to trip the shutter, unless a time exposure is being made and the camera does not have automatic exposure control.)

When you must be a greater distance from the camera, a PNEUMATIC SHUTTER RELEASE can be used. You squeeze a rubber bulb to force air through a 15-foot or longer rubber or plastic tube and trip the shutter. There also are battery-operated ELECTRIC SHUTTER RELEASES with cords that can run to distances of several hundred feet, which may be necessary for some kinds of wildlife photography.

## Interchangeable Viewfinders

When cameras are on tripods or are used in awkward positions, it may be difficult for the photographer to keep his eye in the viewfinder. Some camera models permit viewfinders to be interchanged or fitted with adapters to aid in viewing.

The types of interchangeable viewfinders include pentaprism, waist level, magnifying, and action (or sports) finders. The PENTAPRISM FINDER is identical to nonremovable viewfinders on other SLR cameras and presents the image at eye level and right side up to the photographer.

A WAIST-LEVEL or TOP-VIEWING FINDER is really a collapsible hood that keeps extraneous light from striking the focusing screen and lets you view the image from positions other than at eye level. It is ideal when using the camera at low levels or when holding it upside down above you to shoot over people in a crowd or other obstacles. This type of finder also is convenient to use when the camera is mounted on a copy stand. A flip-up magnifier in the hood assists in sharp focusing. Because there is no pentaprism, images are reversed from left to right.

For very critical focusing, there is a MAGNIFYING FINDER that enlarges the image area up to six times. Its eyepiece can be adjusted to correct for the photographer's eyesight. As with waist-level finders, the subject will appear in reverse left-to-right position on the focusing screen.

An ACTION or SPORTS FINDER is an extra large finder that makes it easier to follow moving subjects and to anticipate the best action shots. That's because the photographer can keep his eye about 2½ inches from the viewfinder and still see the full image, and all the while use

his peripheral vision to be ready for upcoming action. It incorporates a pentaprism, so the images appear correctly, left to right.

## Viewfinder Attachments

Far more common than interchangeable viewfinders are viewfinder attachments, especially for SLR cameras that have a nonremovable pentaprism viewfinder. A number of cameras can be fitted with a RIGHT-ANGLE VIEWING ATTACHMENT, which makes viewing and focusing easier in low-level, close-up, or copy work. It slips or screws into the viewfinder's eyepiece. The best of these right-angle viewers feature a pentaprism instead of a mirror, so images are viewed right side up and correctly left to right. Some can be rotated for easy sighting from any camera position. Other features may include a magnifier to enlarge the image up to two times for more critical focusing, and an eyepiece that can be adjusted for individual eyesight. (See page 132 for a description of a right-angle lens attachment.)

Another useful viewfinder attachment is an EYEPIECE MAGNIFIER that doubles the size of a central portion of the image for sharpest focusing. The most convenient types are on a hinged mount and can be raised out of the way so you can also view the entire image as normally. Some magnifiers are adjustable for the photographer's eyesight.

Whether or not an attachment is used on a viewfinder, an EYEPIECE or DIOPTRIC CORRECTION LENS often can be ordered from the camera's manufacturer to make adjustment for a photographer who is near- or farsighted. Depending on your camera, the correction lens is screwed into the viewfinder's eyepiece or slipped into an eyepiece adapter. The camera's operation manual should have more information about the

correction lens diopters available. An EYECUP is another viewfinder accessory that can aid in focusing and viewing, particularly for photographers who wear glasses (see page 42).

You can also buy or make a NON-OPTICAL AUXILIARY VIEWFINDER that slips into the camera's accessory shoe or hot shoe and enables you to follow and frame fast-moving subjects more easily than with the camera's optical viewfinder. An auxiliary viewfinder is especially useful when panning and using a slow shutter speed, because a SLR's regular viewfinder goes dark during the exposure and you can't see or follow the action.

## Hand-Held Exposure Meters

While the exposure meters built into 35mm cameras work well for many kinds of photography, some photographers prefer to use a hand-held meter. One reason is that its large circular dial displays the various f/stop-shutter speed combinations that can be used to make a correct exposure.

Additionally, hand-held meters have a wide range of sensitivity, particularly those using silicon cells; some models will indicate exposure times ranging from 1/8000 second to 8 hours! Also, you have greater freedom in making exposure readings with a hand-held meter, especially when your camera is mounted on a tripod.

Meters vary considerably in features and price. Some are made by camera manufacturers, like Minolta, Pentax, and Vivitar models, but other well-known brands include Grossen, Spectra, Sekonic, and Weston.

Hand-held meters read reflected light (like a camera's meter) or

incident light, or both. REFLECTED LIGHT METERS, which are pointed toward the subject from the camera's position, make overall or spot readings. The most commonly used hand-held meters are the reflected overall reading type.

Meters that make INCIDENT LIGHT READINGS measure the intensity of the light falling on the subject instead of the light reflected by it. Unlike reflected light meters, they are not affected by the color, brightness, or contrast of the subject itself. Incident meters have a dome-shaped light receptor with a 180° angle of acceptance.

Incident readings are made from the subject's position by pointing the meter toward the camera, or by holding the meter so the light falls on its spherical light receptor in the same way it falls on the subject. Many hand-held reflected light meters can be converted to incident light meters by covering the meter's measuring cell with a white translucent plastic diffuser that is built in and slides into place or is an accessory that clips on.

Although very bright or very dark areas in a scene can wrongly influence a reflected light meter reading (unless you aim the meter to compensate—see page 65), an incident reading avoids this problem and gives an average reading of all the light reaching your subject. Incident metering is frequently done in studio work because it is an easy and accurate way to measure the overall illumination produced by several studio lights. Most incident meters have an accessory attachment that will convert them for use as reflected light meters.

There also are HAND-HELD SPOT METERS, often used to make separate reflected light readings of highlights and shadows, which are then averaged for the best exposure. The spot meter's angle of acceptance may be as narrow as one degree (1°), so you can remain at the camera's

An incident exposure meter is held near the subject so its dome-shaped receptor reads the light falling on the subject. This model is a combination type; its head can be turned around and used to make reflected light readings.

position and make pinpoint light measurements anywhere in the subject area. Spot meters have a viewfinder so you can see the exact area being measured, and some are a zoom type that allow you to adjust the angle of acceptance.

The more expensive models of hand-held averaging meters can be fitted with a SPOT METER ATTACHMENT that narrows their usual 30° or 40° angles of acceptance to 15° or even 1°. A viewfinder is included for precise aiming of the meter when spot readings are being made.

Other attachments enable professional models of hand-held meters to make accurate light readings through microscopes for photomicrography and from enlargers to determine print exposure times. Small and inaccessible areas can be read when a flexible fiber optics probe is attached to the meter, and another accessory gives exact exposure values when copying documents, photographs, and similar flat materials.

Three types of light-sensitive cells are used in hand-held meters: selenium, cadmium sulfide (CdS), and silicon. The most rugged but least sensitive is the selenium cell, which operates without batteries. It is of little use in dim light or for night photography. The other cells are battery powered, and the silicon type has greater sensitivity and faster response than the CdS type.

As with built-in camera meters, you must calibrate hand-held meters according to the speed of the film you are using. Some film speed calibration dials offer settings from ASA 0.10 to ASA 25,000, which far exceeds the limits of today's film emulsions. The range of apertures, like shutter speeds, is extensive, with some meters listing f/stops from f/0.7 to f/90.

Most hand-held meters have an on/off switch that also locks the

meter's light indicator needle in position so you can refer to it anytime before pressing the switch to take another reading. Because their sensitivity range is extensive enough to measure in both sunlight and moonlight, some meters have a high-low switch that you activate according to whether light conditions are bright or dim.

Other features you may find on hand-held meters include an adjustment screw to realign the meter needle when necessary, a battery test button, and an eyelet to which a neckstrap can be attached. The scales on some meters give additional information, including exposures for movie cameras (f/stops and frames per second), numbers that correspond to the exposure value (EV) or light value (LV) scales, and special indications for over- and underexposure. A few hand-held meters present exposure information in LED displays, but the meter's usefulness is reduced unless all f/stop-shutter speed combinations are included so you can easily make a choice.

While many of the electronic flash units used on 35mm cameras have light sensors that automatically control exposure, there also are special FLASH METERS, and flash metering attachments for a few hand-held meters, that read the brief, bright burst of flash light and indicate the correct exposure. When you test fire the flash, an indicator needle reacts to the light and then remains stationary on a scale so you can read the f/stop required (the shutter speed is predetermined by the type of shutter in your camera—see page 136). Some flash meters have a cumulative feature and will register a series of flashes, which may be required in certain lighting situations in which an off-camera flash is fired several times.

For more precise control of color balance when shooting color films, some pros use a COLOR TEMPERATURE METER or a color temperature

attachment on a regular hand-held exposure meter. It analyzes the color content of the light so they can tell what filters, if any, are required to accurately reproduce the colors of the subject on film (also see pages 126 and 184).

## Gray Card

To assist them in making reflected light exposure readings, some photographers use a simple accessory called a gray card. It is a neutral colored cardboard that gives 18 percent reflectance of the light that falls on it, which closely matches the amount of light reflected by "average" subjects. This means you can take a meter reading of the gray card instead of the subject to determine exposure. This is very helpful when a subject of average light reflectance is surrounded by very light or very dark areas and you can't get close enough to the subject to make an accurate reading. Also, exposure readings are frequently made from a gray card when doing copy work.

Make sure you hold the gray card so the light falls on it exactly as it falls on your subject. Keep the meter about six inches from the card so it reads only the card; be sure you or the meter do not cast a shadow on the card. An exposure reading of the gray card must be adjusted if your actual subject is not of average reflectance. For very light subjects, increase exposure by ½ to 1 f/stop, and for very dark subjects, reduce exposure by ½ to 1 f/stop.

Most camera stores sell Kodak Neutral Test Cards, 8×10 inches in size, that have one gray side with 18 percent reflectance. The other side is white and gives 90 percent reflectance, and it can be used in low light to give higher meter readings. For the correct exposure when

metering the white side, compensate by increasing the meter reading by 2⅓ f/stops. Or you can divide your film's speed by 5, set the meter at the revised ASA, and use the direct meter reading of the white side for your exposure.

## Batteries

As a reminder, this summary of accessories includes batteries, because all too often your exposure meter or electronic flash will go dead just when you need it. Be sure to carry fresh spare batteries in your gadget bag, and if your flash unit uses nickel-cadmium batteries, take the recharger with you too. Remember that meter batteries do extra duty in cameras that have automatic exposure control, and they may become exhausted very quickly if you accidentally leave the battery switched on. See your camera's operation manual for any special battery advice or warnings, especially during cold weather, and remember to replace batteries *only* with the type and size specified.

## Changing Bag

A handy item to have for emergencies is a changing bag, which is really a shirt-sized, fold-away darkroom. This light-tight bag is double layered with a zippered entrance and two arm openings with elastic bands. If the film jams in your camera, or if it is accidentally pulled from its cassette spool, you can zip the camera into the changing bag, slip your hands in through the arm holes, and open the camera's back to solve the problem without needlessly exposing your film. If you do your own 35mm film developing, the bag also can be used to load exposed film

from its cassette onto a reel that goes into a light-tight developing tank, so processing can be done with the room lights on.

## Motor Drives and Auto Winders

One SLR camera attachment of recent popularity, the auto winder, was briefly described in Chapter 1, along with its big brother, the motor drive. Both units automatically advance the film and cock the shutter immediately after an exposure is made. However, their differences, as well as their potential uses and drawbacks, are worth additional discussion.

Motor drives have long been the province of the pros. These expensive accessories, which make it possible to expose up to five frames per second, permit the photographer to keep his eye at the SLR's viewfinder and concentrate on his subjects instead of manually moving the film advance lever after each exposure. Photojournalists and sports photographers use motor drives because of the fast-paced events and action they must photograph. Portrait and fashion photographers like them, too, because the spontaneous expressions and movements of their subjects or models can be instantly captured. Motor-driven cameras also can be set up, left unattended in hidden positions, and triggered by remote control, for surveillance and nature photography. Or they can be connected to an interval timer and periodically fired for time-lapse photography required by scientific, industrial, or nature studies.

Auto winders represent an attempt by camera manufacturers to offer all photographers a less expensive way to quickly and automatically wind the film and cock the shutter after every exposure. Most models do this with enough speed to expose up to two frames per sec-

ond. Like motor drives, auto winders let you concentrate on the subjects and composition, and they assist in capturing the best moments of action. Some photographers also say the auto winder attachment gives better balance to the camera and permits a steadier grip, so pictures made at slow speeds or with telephoto lenses are less likely to be blurred by a shaky camera. Panning is more easily accomplished too. When doing close-up work, there's no fear of upsetting your precise framing and focusing, which sometimes happens when the shutter is cocked manually. Additionally, some camera-coupled (integrated) electronic flash units permit rapid-fire flash pictures to be made with an auto winder when subjects are nearby. Another bonus, some photographers confide, is that using a camera with an auto winder makes them look and feel more like a pro.

If you think a motor drive or auto winder may be a worthwhile accessory, there are some other things to consider. First, only certain camera models will accept such units, and you must buy the unit specified for the camera. The cameras that accept auto winders outnumber those that accept motor drives; very few cameras accept both. (A couple of models have an auto winder or motor drive built in.)

In general, motor drives cost more, weigh more, expose more frames per second, have more features, and are built for heavier duty than auto winders. More specifically, an auto winder costs about the same as a camera's normal lens, while the price of a motor drive may be two or three times higher. Auto winders weigh from 10 oz to 1 lb with batteries, and battery-equipped motor drives are $\frac{1}{2}$ to 1 lb heavier.

Because of their heavy-duty construction and the internal design of the cameras they fit, most motor drives advance the film more rapidly than auto winders. In either case, the maximum number of

Some motor drives accommodate separate battery packs, like this model, so you can switch from replaceable alkaline batteries to the rechargeable nickel-cadmium type.

exposures per second depends on the shutter speed being used. Remember that for each exposure the viewfinder's mirror flips out of the way, the lens aperture closes down, the shutter opens and closes, the lens aperture reopens, the mirror returns to viewing position, and the film is moved to the next frame. At a shutter speed of 1/500 or 1/1000 second, motor drive units can make an average of four exposures per second, while auto winders can manage just two.

A few winders will only expose a single frame when the unit's shutter release button is pressed, but most models also can be switched to a continuous mode so that additional exposures will be made for as long as you keep the release button depressed. Motor drives also offer a choice of single or continuous (sequential) exposures. Additionally, motor drive units often have a power rewind feature that returns exposed film into its cassette in only a few seconds; auto winders require that the film be rewound manually.

Auto winders are usually less expensive to operate because they require just 4 or 6 AA-size batteries. Motor drives need 8 to 16 AA cells, which accounts for much of their additional bulk and weight, but they also can be used with optional power sources, including rechargeable nickel-cadmium batteries or AC house current. Both types of units have an on/off switch to conserve battery power. Usually there's a small LED that lights up momentarily to signal when an exposure has been made, which is especially valuable when using remote control so you know the unit was triggered.

Sophisticated accessory equipment is available for some motor drive units, including wireless REMOTE CONTROL DEVICES that are activated by light or radio signals. There also are interval timers that trigger single exposures periodically or continuous exposures for predetermined

Some cameras are specially designed for underwater photography, like this Nikonos, but regular 35mm cameras also can be used in water with the protection of an underwater housing.

amounts of time. Remote control cables of varying lengths also can be used to activate most motor drives, as well as some auto winders.

With their various uses and advantages, are there any reasons not to have a motor drive or auto winder? For photographers who purposely purchase a compact 35mm SLR in order to cut down the size and weight of their camera equipment, a motor or winder unit just brings back those old problems. There is also the cost of 4 to 16 batteries, and the continuing concern of whether they are fresh enough or need to be replaced before a shooting session. A significant consideration for photographers who like to be unobtrusive, particularly when taking candid pictures of people, is the noise created by the motor drive or auto wind unit. It alerts everyone to the photographer's presence and makes it obvious when he takes a picture. Also, there is one special problem for cameras with automatic exposure control that are designed to lock in the exposure as the shutter button is pressed. When you are shooting with an auto winder in the continuous mode and are following subjects in variable light conditions (like sun and shade), the exposure cannot automatically change because the shutter release remains depressed.

## Underwater Housings

Underwater photography can be an exciting experience and can produce fascinating results. There are special 35mm cameras designed for underwater use, like Nikon's Nikonos models, but you also can purchase waterproof housings for your regular camera and electronic flash unit. Large controls on the rigid housings connect to camera and lens and allow you to focus, adjust f/stops and shutter speeds, and

advance the film. There are also some flexible plastic pouch-type housings, which can be used to depths of 35 feet.

Housings of hard plastic can be taken to a maximum depth of 200 feet, while aluminum housings can go to 300 or 400 feet underwater. Up to 30 feet below the surface, daylight is adequate for underwater exposures, but an electronic flash (or floodlight) gives you better light control and better color rendition.

With existing light, cameras with automatic exposure control are easiest to use. Otherwise, a hand-held meter is most reliable, and it can be installed in a waterproof housing. Without an underwater meter, you can make a reading above the water's surface and open up one f/stop to shoot just below the surface in calm and clear water.

For 35mm cameras, the most popular underwater housings are hard plastic (about $80 for rangefinder-type cameras and about $170 for SLRs) made by Ikelite Underwater Systems, P.O. Box 88100, Indianapolis, IN 46208. The flexible waterproof camera pouches for limited underwater use (about $30 to $60) are available from Spiratone, 135-06 Northern Blvd., Flushing, NY 11354.

# 7
## 35mm Films

The selection of films that can be used in 35mm cameras is consider-able. Of course there are both black-and-white and color films, with some being the negative type for making prints and others the positive (or reversal) type for making slide transparencies. Films also are typed by their speed (i.e., sensitivity to light)—slow, medium, fast, and ultra fast (B&W only). Special infrared films are available, too, in black-and-white and color. You also can buy black-and-white copy films for copying maps, photos, drawings, and printed matter, as well as color duplicating film for making copies of color slides. There is also a special slide film for taking color photographs through a microscope. All films can be processed in a home darkroom or commercially, except Koda-chrome, which requires processing by Kodak or other specially-equipped labs.

Although films are designed for making prints or slides, and you should use them accordingly, several alternatives are possible. For in-stance, color negative films should be used when you want color prints, but, after processing, color negatives also can be used to make direct black-and-white prints, or they can be copied to make color slides. Like-wise, color positive films should be used when you want color slides, but color prints can be made from them, too, either directly or by making a copy negative first. Color slides also can be copied on black-and-white films to make black-and-white prints or slides.

## Film Characteristics and Care

Before discussing the different types of films, here are some general characteristics of 35mm films, as well as tips for proper storage and handling. Sprocket holes running along both edges characterize 35mm

This motor-driven SLR is equipped with a bulk film back with large round film compartments that can hold enough film for 250 exposures.

film. The width of the film measures 35mm, which is why cameras that use this film are called 35mm cameras. Actually, the size of the rectangular image on the film produced by 35mm cameras measures 24×36mm.

The films are rolled on a spool inside light-tight CASSETTES (Kodak calls them magazines), with a tongue, called the film LEADER, protruding from a black felt-lined slit. Standard lengths produce 20 or 36 exposures, although a few 35mm films are packaged in 24-exposure lengths. After a roll is exposed, the film must be rewound back into the cassette before it is removed from the camera for processing.

Some 35mm films also are only supplied in long rolls, usually measuring 100 feet or so, and these must be cut to desired lengths and loaded by the photographer into reuseable cassettes. This is referred to as bulk loading, and there are special devices called BULK FILM LOADERS that make the job simple and help you avoid scratching the film. Some cameras with motor drive units will accommodate special film backs that hold a bulk film magazine with up to 33 feet of film, enough for 250 exposures.

You'll notice some 35mm films are marked "professional," which indicates they require more cautious storage and handling than other films. For instance, Kodak's Ektachrome 50 Professional film (Tungsten) should be refrigerated at 55°F (13°C) or less, while regular Kodak color films normally can be kept at room temperatures, when 75°F (24°C) or less.

The film's package or box is printed with important information, including the film's speed (ASA and DIN), number of exposures, storage advice, and an expiration date, which indicates the month and year before which the film should be developed. Because all films

Many color films now include the film's ASA number in the name of the film. For example, Kodak's Ektachrome 64 has a film speed of ASA 64. The underside of the film box has other important data.

deteriorate with age, manufacturers guarantee the film's particular characteristics—with proper storage and handling—until that time. Afterward, there can be changes in the film's speed and contrast (and color balance, if it's a color film).

You're also advised to read the FILM DATA SHEET inside the box or package. It gives technical and practical information about the film, such as its special characteristics and suggested uses, film speed (specific ASA ratings are printed for Kodak "professional" films), and exposure guidelines for daylight, electronic flash, flash bulbs, and when filters are used. Facts about developing are included (with details about chemicals and processing times for black-and-white films), as well as storage and handling recommendations.

Storage and handling of any film is important so it won't deteriorate or be harmed before its expiration date. All films are affected by light, humidity, heat, and x-rays. Color films are more easily affected because their emulsions contain color dye layers.

Accidental exposure to light will FOG the film. Avoid fogging by loading the film cassette into the camera in shade or subdued light (black-and-white infrared film must be loaded in total darkness). After a roll is exposed, be sure the film is rewound entirely into its cassette before opening the camera's back. If you do your own processing, make sure there are no light leaks or improper safelights in your darkroom that might fog the film.

HUMIDITY is a major problem because, like heat, it can change a film's speed, contrast, and color characteristics. Changes are more radical *after* exposure, because humidity and heat affect the latent, undeveloped images more than unexposed film. Fortunately, most 35mm films are supplied in factory-sealed cans that are waterproof and

vaporproof. They will protect the film from humidity. However, after a film can is opened, this humidity protection is lost.

If the relative humidity where you are shooting exceeds 60 percent, have the film processed as soon as possible after exposure. If this isn't possible, use a DESICCATING AGENT, such as silica gel, to dry the film after exposure, and then reseal the cassette in its can or jar. Remember that there is considerable moisture in a refrigerator or freezer, so films must be sealed in their cans or a jar before storing them there.

While the cans in which 35mm film cassettes are sold protect films from humidity, they provide no protection from HEAT. Temperatures over 75°F (24°C) will be detrimental to films, so keep them out of the sun and away from heaters. Professional films, and some others, like Kodak's High Speed Infrared (B&W) film, should be refrigerated at 55° (13°C) or less, and Kodak's Ektachrome Infrared (color) film should be stored in a freezer between 0 to −10°F (−18 to −23°C). In order to avoid condensation of moisture on 35mm films that have been refrigerated, allow one to two hours warm-up time at room temperature (or 24 hours if film is frozen) before opening the can.

General color films are designed to mature over a period of time, so refrigeration is neither necessary nor recommended unless temperatures exceed 75°F or unless you want to prolong the expiration date. For more critical control of the emulsions of black-and-white film, maintain lower temperatures when storing them longer. Kodak suggests not exceeding 75°F for B&W films kept up to 2 months, 60°F (16°C) for storage up to 6 months, and 50°F (10°C) for keeping films for 12 months.

When traveling, remember that closed cars really heat up on hot days, so keep your sealed cans of film in a portable ice chest that is 75°F or cooler. Another warning: certain FUMES can harm films, un-

less the cassettes are sealed in their protective cans. These include fumes from engine exhausts, industrial gases, mothballs, paints, solvents, and some glues.

One problem you also can avoid is the STATIC ELECTRICITY that may fog or streak your film with lightninglike marks when the relative humidity is *low*. This occurs most frequently with high-speed films when you advance the film too fast, or rewind the roll too rapidly. When the humidity is likely to be low, as indoors during the winter months or in the southwestern states, slow down your film advancing and rewinding movements.

A frequent worry of photographers who travel is whether the security equipment used at airports is harmful to film. The electronic devices for checking passengers do no damage, but the X-RAY MACHINES that check carry-on baggage may fog, cause shadows, or alter the colors of your undeveloped film.

Fogging will be evident if film is subject to more than five milliroentgens of radiation. X-ray devices in U.S. airports are supposed to produce less than one milliroentgen per inspection, but their effect is cumulative on film, so if you pass through several airports on your trip, x-ray damage to your film is almost certain. In addition, higher radiation levels are likely in foreign airports because of less stringent regulations regarding the output of their x-ray machines.

Some camera stores sell lead-lined bags that shield film from x-rays, but the best advice is always to request a hand inspection of your camera and any gadget bag that is holding extra film, even if signs posted on the x-ray equipment claim it is not harmful to photographic films. Also, never pack films with baggage you check in, because checked baggage is subject to x-raying too. Besides, your luggage may

High speed films are well suited for shooting indoors with existing light, as in this Mexican bar that was illuminated only by light coming through windows.

get lost, or your film could be affected by heat if baggage is being loaded onto the plane under a hot sun.

## Film Speeds

The relative sensitivity of a film to light is indicated by its film speed. This is printed on the film's box, data sheet, and cassette as an ASA number (see page 35). The German number system for rating a film's speed, DIN, may also be given. The ASA (or DIN) number, of course, is what you set on an exposure meter to calibrate it for the film you are using.

To help you know a film's speed more readily, film manufacturers have begun including the ASA number in the names of their color films, such as Agfachrome 64 (which has an ASA rating of 64) and Kodacolor 400 (which is rated at ASA 400). When a film is rated by the photographer at other than its normal ASA, the revised speed is sometimes referred to as the film's E.I., or EXPOSURE INDEX. Some film manufacturers also use the term to indicate the speeds of their films, but E.I. and ASA numbers are identical.

The rule to remember when comparing films for speed is that the higher the ASA number, the more sensitive the film is to light. Refer to our earlier discussion of reasons and methods for comparing the relative speeds of films and their exposure relationships in terms of f/stops and shutter speeds, beginning on page 52.

While ASA numbers indicate specific film speeds, more general terms also are used to describe films: slow, medium-speed, fast or high-speed, and ultra-fast or ultra high-speed.

Because their emulsions were not very sensitive to light, the first

films were quite slow and required long exposures. A tripod was needed to hold the camera steady, and subjects who couldn't keep still were blurred in the picture. Over the years, film makers have continually striven to produce more sensitive films.

Today's 35mm HIGH-SPEED FILMS are quite remarkable, and popular, with ASA ratings from 160 to as high as 400. Those can be increased to ASA 800 and to even higher speeds when fast films are given special processing. These fast films make it possible to shoot more easily in low light levels, indoors and outdoors. They are a good choice when using telephoto lenses or photographing sports events, because fast shutter speeds can be used to stop the action and to avoid blurred images caused by camera movement. High-speed films also permit smaller lens apertures, so greater depth of field is possible. Also, the use of flash is extended to subjects at greater distances because the film is more sensitive.

SLOW-SPEED FILMS, commonly with ASAs of 25, 32, 40, or 50, are especially suited for studio work or bright daylight conditions. Also, when the photographer wants shallow depth of field by using wide f/stop openings or wants to blur moving subjects by using slow shutter speeds, slow films are ideal.

MEDIUM-SPEED FILMS generally have ASA ratings of 64, 80, 100, 125, or 160, and they are favorites of many photographers for general photography, whether black-and-white or color.

ULTRA-FAST FILMS are black-and-white negative films only, and they have ASA ratings of 1000 and higher, which can be extended to ASA 4000 and beyond when special developers are used. These films are very useful for shooting at night and at other times when light conditions are very poor.

Grain is very evident in this enlarged photo of mountain peaks.

Besides choosing a certain film because of light levels or the nature of the subjects you are photographing, there are other important considerations, including the grain, resolution, and contrast that will be evident in your picture.

The faster the film, the larger the GRAIN, because the emulsion must contain more and larger silver particles in order to be more sensitive to light. Ultra fast B&W films are very grainy, while slow B&W or color films show little or no grain at all. Thus, slow- and medium-speed films are preferred to fast and ultra-fast films when you want to make big enlargements. Grain size, by the way, is also affected by the exposure and processing the film receives.

In addition, the RESOLUTION or RESOLVING POWER of a film determines the fine detail that will be evident in your pictures, and this varies according to the film's speed. Generally, the slower the film, the greater its resolution (i.e., the fine detail you can see in the slide or enlargement). Resolution is also affected by the quality of the lenses on your camera and enlarger.

CONTRAST changes according to the film's speed, too, with slower films generally having more contrast than fast films. Also, slide films inherently show more contrast than negative films. Other factors affecting contrast include the subject itself, the lighting used, development of the film, and the paper and developer used for printing.

Another consideration in selecting a film is its EXPOSURE LATITUDE, which means how much exposure error the film can tolerate and still yield acceptable images. In general, medium and fast films have more latitude for exposure mistakes than slow films. Additionally, negative films have more exposure latitude than slide (positive) films. Negative films show much more latitude for overexposure than underexposure.

Black-and-white panchromatic films are sensitive to all colors and represent them realistically in black, white, and varying shades of gray. Visualize and compare the actual colors of the items in this picture. For example, as you'd expect, the red apple appears darker in tone than the orange.

The speed of a film may change when the film is used under different light sources. Although today's popular black-and-white films are PANCHROMATIC, meaning their emulsions are sensitive to all colors, the sensitivity range of a few other films will vary with the type of light source—daylight or tungsten—and this will be indicated on the film's data sheet.

Color films are designed for a specific light source, daylight or tungsten, to produce correct COLOR BALANCE so the colors you see in the photograph will be the same as the colors you saw when taking the picture. If a film is used under a light source for which it was not intended, a specific filter used over the camera lens will restore proper color balance—but the film's speed will be slower. The revised ASAs and filters to use with other light sources are given in the film's data sheet. Also read more about this in Chapter 4.

Another factor affecting film speeds is called RECIPROCITY FAILURE, and this means the relative sensitivity of a film changes when exposures are very short or very long. With color films, color renditions also change from normal, and with black-and-white films, contrast is affected. For all practical purposes, film speeds, colors, and contrast are not altered when you shoot at speeds from $\frac{1}{2}$ to $\frac{1}{1000}$ second.

Some electronic flash units will give very brief exposures, however, and if the flash duration is 1/10,000 second, exposure with Kodak's black-and-white films and Ektachrome color films should be increased by one-half f/stop. Unless the flash speed increases to 1/100,000 second (which is possible only with special electronic flash units), most other Kodak films do not require additional exposure when an electronic flash is used.

With time exposures of one second or longer, Kodak recommends

the following adjustments to compensate for reciprocity failure. With black-and-white films (except infrared and high-contrast copy films), when exposure time is one second, open the lens one f/stop and decrease developer time by 10 percent; for 10-second exposures, open up two f/stops and cut developer time by 20 percent; and for exposures of 100 seconds, open the lens three f/stops and reduce developer time by 30 percent.

For color negative and Ektachrome slide films, when the exposure time is one second, open the lens one-half f/stop; with Kodachrome slide films, open one f/stop. For exposures of 10 seconds and longer, the lens should be opened from one to two-and-one-half f/stops and filters should be used to correct the color balance. Details are available in Kodak's color film handbooks. For most photographers, reciprocity is of little concern unless they take a considerable number of high-speed electronic flash pictures or long time exposures.

## 35mm Color Films

You recall that there are two basic types of color films, those that produce color negatives for making prints, and those that make the direct color positives we call slides. Also, color slide films are designed for specific light sources, daylight or tungsten, so they'll reproduce a subject's colors in the same renditions that your eyes saw.

Films that produce color negatives have greater tolerances for light sources of varying colors, and filters used during enlarging can improve their color balance, so 35mm color negative films are not differentiated as daylight or tungsten types. The newer color negative films, especially

Kodacolor 400, show very good color balance under different light sources, including troublesome fluorescent lighting.

A film's color balance is based on the COLOR TEMPERATURE of the light source. This is a scale, calibrated in KELVINS (abbreviated K), that indicates the relative colors of a light source. For instance, daylight (at high noon) is considered to have a color temperature of 5500K, which means it is in the bluish end of the light spectrum. Electronic flash units and blue flashbulbs produce light of a similar color temperature, ranging from 5000K to 5600K. Since DAYLIGHT COLOR FILMS, both positive (slide) and negative types, are balanced for 5500K light, they give good color renditions when exposed by sunlight, electronic flash, or blue flashbulbs.

The other common light sources in photography are tungsten (artificial) types, including studio lamps that produce light of 3200K, which is in the reddish end of the light spectrum. TUNGSTEN COLOR SLIDE FILMS, sometimes called Type B films, are specifically color balanced for 3200K light. Another type of tungsten light is one that has a color temperature of 3400K, like photoflood bulbs. Currently there is only one special type of color slide film balanced for 3400K light, Kodachrome 40 (Type A).

When other than specified light sources are used with any of these three films—daylight, tungsten (Type B), or Type A—you'll have to tolerate incorrect color renditions in the slides, or use filters over the camera lens to change the color temperature of the light reaching the film (see page 126).

Pages 186 and 187 show lists of current 35mm color negative and color slide films, with their respective ASA film speeds. Note that a

film name with "color" in it usually indicates the film is the color negative type, while the suffix "chrome" tells you the film produces positive images (slides).

There are times when a color film is too slow for the shooting situation and the photographer purposely increases its film speed. When this is done, the entire roll must be exposed at that higher ASA, and the film must be given *special processing*. Picture quality will never be as

## COLOR NEGATIVE FILMS

| MANUFACTURER/<br>FILM NAME | ASA FILM SPEED<br>Daylight |
|---|---|
| KODAK | |
| Kodacolor II | 100 |
| Kodacolor 400 | 400 |
| Vericolor II | |
| Professional, Type S* | 100 |
| FUJI | |
| Fujicolor F-II | 100 |
| Fujicolor F-II 400 | 400 |
| SAKURA | |
| Sakuracolor II | 100 |
| Sakuracolor 400 | 400 |
| AGFA | |
| Agfacolor CNS | 80 |
| Agfacolor CNS 400 | 400 |
| 3M | |
| 3M Color Print Film | 80 |

* S stands for Short; this film should be shot with exposure times of 1/10 second or shorter. Vericolor II, Type L, is a tungsten film for longer exposure times, between 1/50 to 60 seconds, but it is available only in 120 and sheet film sizes.

## COLOR POSITIVE FILMS

| MANUFACTURER/ FILM NAME | ASA FILM SPEED | |
| --- | --- | --- |
| | Daylight | Tungsten |

**KODAK**

| | | |
| --- | --- | --- |
| Kodachrome 25 | 25 | |
| Kodachrome 64 | 64 | |
| Kodachrome 40 (Type A) | | 40 |
| Ektachrome 50 | | |
|    Professional (Tungsten) | | 50 |
| Ektachrome 160 (Tungsten)** | | 160 |
| Ektachrome 64** | 64 | |
| Ektachrome 200** | 200 | |
| Ektachrome 400 | 400 | |
| Ektachrome Infrared Film | 100 | |
| Ektachrome Slide | | |
|    Duplicating 5071 Film† | | |
| Photomicrography Film | 16 | |

**AGFA**

| | | |
| --- | --- | --- |
| Agfachrome 64 | 64 | |
| Agfachrome 100 | 100 | |

**FUJI**

| | | |
| --- | --- | --- |
| Fujichrome 100 RD | 100 | |

**SAKURA**

| | | |
| --- | --- | --- |
| Sakuracolor R | 100 | |

**3M**

| | | |
| --- | --- | --- |
| 3M Color Slide Film | 64 | |
| 3M High Speed Color | | |
|    Slide Film | 400 | |

** Also available as a Professional film.
† ASA depends on tungsten light source.

good as when the film is shot at its normal ASA, because grain and contrast increase, and improper color balance may be evident.

Nevertheless, you can boost the speed of any slide film (except Kodachrome) from two to four times (set your exposure meter's film speed dial accordingly), as long as the film is given extended development. The entire roll must be exposed at the same ASA; do not readjust the film speed dial once you've begun shooting. Develop the film yourself, or ask a custom lab for special processing. Kodak labs will give special processing only to Ektachrome films exposed at twice (2 times) the normal speed. For example, you can shoot a roll of Ektachrome 400 (ASA 400) at ASA 800, and then enclose it in one of Kodak's Special Processing Envelopes (ESP-1), at extra cost, before the film is sent to a Kodak lab.

If a roll of slide film is accidentally underexposed or overexposed, it sometimes can be saved by altering development time. This usually is most successful when the photographer does his own developing, or when a custom lab is given information about the specific film speed you used so development time can be adjusted accordingly.

Purposeful or accidental changes in the ASA rating of color negative films also can be compensated for during development. However, these films have considerable exposure latitude, and normal processing should be adequate if the under- or overexposure is within one f/stop of normal exposure.

One special type of 35mm film that photographers find fascinating is Kodak's EKTACHROME INFRARED FILM, because it produces bizarre "false" colors. Objects that appear one color to the eye appear a different color on the film. Green grass turns magenta, white skin looks

greenish, reds go yellow, yellows look white, and blacks turn red. Blue skies stay blue, however.

The film is sensitive to both visible light and invisible infrared radiation, and it was originally created to detect camouflage during military aerial reconnaissance missions. Canvas painted to look like foliage could be detected easily when looking at an infrared photograph. Today the film has various scientific uses, such as for aerial photography of timber forests to detect trees that are diseased.

Ektachrome Infrared film should be used with filters for the most effective results. Kodak recommends a yellow No. 12 or No. 15, but you should experiment with a variety of filter colors to vary the weird effects, which are quite unpredictable. The daylight film speed is nominally ASA 100 (with a No. 12 or No. 15 filter), but it will change with different filters and according to the time of day and seasons because of variations in the subject's response to infrared radiation. For best results, bracket your exposures (see page 210).

This film is available only in 35mm 20-exposure cassettes. It should be stored in a freezer, at 0 to −10°F (−18 to −23°C). Unlike black-and-white infrared film, Ektachrome Infrared film requires no focus adjustment (see page 196).

Another special 35mm color film is Kodak's EKTACHROME SLIDE DUPLICATING 5071 FILM, which is designed for copying color slides and is available in 36-exposure cassettes and long rolls. Photographers make slide copies for several reasons. Frequently they do it so the original slide can be stored and protected, since transparencies are easily damaged by careless handling or faded by extended exposure in a projector. Professionals often send duplicates instead of originals to stock

photo houses, those companies with vast photography files that supply transparencies to publications, advertising agencies, and other clients. Slides are sometimes copied just to crop out uninteresting or distracting · portions of the original slide. Also, filters can be used to add different color effects in the duplicates.

There are expensive slide copying machines for making duplicates, but many photographers just use their SLR cameras with a simple SLIDE COPIER ATTACHMENT that holds the slide parallel to the camera's film plane. A macro lens or a bellows used with the normal lens in reversed position will make sharp life-size duplicates of original slide images.

Color compensating (CC) filters must be used so the colors of the "dupe" closely match those of the original slide (see page 128). Filter colors and densities depend on the type of slide film being copied, and on the light source you use for copying: daylight, tungsten, or electronic flash.

Ektachrome Slide Duplicating 5071 film is designed for tungsten (3200K) light, with optimum exposure time of one second. Tungsten-halogen lamps are recommended, because they fade less than conventional photo lamps and maintain a more constant color temperature. Film speed varies with the light source, but figure ASA 8 with 3200K lights. You can use the camera's through-the-lens metering system to determine exposure.

When daylight is used as a light source, Kodachrome 25 color slide film usually is preferred for slide copying because it is a sharp, extremely fine-grain film that is balanced for daylight. Point the camera and slide copier attachment toward an overcast (white) sky, or bounce direct sunlight (not light in shade) off a sheet of white cardboard. One

problem encountered when copying slides is an unavoidable build-up in contrast, and this will be more evident with Kodachrome 25 film than with Ektachrome Slide Duplicating film because of the latter's low contrast characteristics. Of course, if you purposely want to increase the contrast of your original, use Kodachrome 25 for copying.

Whether duplicating slides or shooting originals, the color renditions of your images will vary considerably according to the brand and type of slide film you use. Some transparency films have rich color saturation and others tend to reproduce colors in shades that are more pastel. "Cool" colors, like blues and greens, will be emphasized by certain films, while "warm" colors, like reds and yellows, will predominate in others. If you don't have a favorite color slide film, test several kinds until you find the one or two that especially please you. If your color prints have disappointing color renditions, it is usually a problem with the processing lab rather than with the film, because color negatives can be color corrected with filters during the printing process.

## 35mm Black-and-White Films

Most 35mm black-and-white films produce negatives from which prints are made, although some can be specially developed as positive images and projected as black-and-white slides. As summarized earlier, their characteristics vary widely in regard to film speed, grain, resolution, contrast, and exposure latitude. Equally important to keep in mind is that images on black-and-white films can be greatly affected by filters on the camera lens and by the film developer and processing procedures.

The filters you can use with black-and-white films, and their effects, were discussed in Chapter 4. As for specific developers and processing

steps, including developing times and agitation methods, the data sheet accompanying the film is a good guideline if you are going to develop the films yourself. If not, you should make sure the camera store or commercial lab will give your film "custom" processing in a fine-grain developer.

Obviously you will have much more control of the results if you process the film yourself, which is not difficult or expensive. For one thing, photographers who do their own darkroom work have options in regard to the contrast of the negative images. They can overexpose and underdevelop to reduce contrast, or underexpose and overdevelop to increase contrast.

Also, if a film is accidentally underexposed or overexposed, as when the film's ASA is incorrectly set on the exposure meter, then longer or shorter development times can be given to produce more normal negative images and "save" the film.

Sometimes under light conditions that are too low for the speed of their film, photographers will "push" the film to a higher ASA and then overdevelop the film to compensate. Such PUSH PROCESSING will increase the graininess and contrast of your images, but it may be the only way to get a picture under low light conditions. An alternative with films that have been shot at a higher than normal ASA is to develop them in HIGH-ENERGY DEVELOPERS, which produce images with less grain and contrast than when the films are push processed in their normal developers. Whatever your choice, film speeds can be successfully increased two to four times. For example, a film normally rated at ASA 400 can be exposed at ASA 800 or ASA 1600.

Following is a list of current 35mm black-and-white films, with their normal ASA film speeds. When the films are panchromatic, as

## BLACK-AND-WHITE FILMS

| MANUFACTURER/ BRAND NAME | ASA FILM SPEED | |
|---|---|---|
| | Daylight | Tungsten |

**KODAK**
| | | |
|---|---|---|
| Panatomic-X | 32 | |
| Plus-X Pan | 125 | |
| Tri-X Pan | 400 | |
| Recording Film 2475 | 1000 | |
| High-Contrast Copy | | 64 |
| High-Speed Infrared | 50 | 125 |
| Direct Positive Panchromatic | 80 | 64 |

**ILFORD**
| | | |
|---|---|---|
| Pan F | 50 | |
| FP4 | 125 | |
| HP4 | 400 | |
| HP5 | 400 | |

**AGFA**
| | | |
|---|---|---|
| Agfapan | 25 | |
| Agfapan | 100 | |
| Agfapan | 400 | |

**H&W CONTROL**
| | | |
|---|---|---|
| VTE Pan | 50 | |
| VTE Ultra-Pan | 16 | |

**FUJI**
| | | |
|---|---|---|
| Neopan SS | 100 | |
| Neopan SSS | 200 | |
| Neopan 400 | 400 | |

**SAKURA**
| | | |
|---|---|---|
| Konipan SS | 100 | |
| Konipan SSS | 200 | |

**LUMINOS**
| | | |
|---|---|---|
| Lumipan | 100 | |

most are, their COLOR SENSITIVITY extends to all colors of light, but a few emulsions are slower or faster when exposed by tungsten (artificial) light. Unless an ASA speed is listed under Tungsten, the Daylight ASA speed can be used to figure exposure with all light sources, daylight or tungsten.

One of the special black-and-white 35mm films is Kodak's DIRECT POSITIVE PANCHROMATIC, designed for making black-and-white slides. It comes only in long (100-foot) rolls, so you'll have to cut the film into shorter lengths and load your own cassettes. The film has a speed of ASA 80 for daylight and ASA 64 for tungsten light. It should be processed in Kodak's Direct Positive Film Developing Outfit, and the steps include a second developer to reverse the film's initial negative image to positive.

An alternative when you want B&W slides is to use a slow-speed negative film, like Kodak's Panatomic-X (ASA 32), and give it the same special processing as Direct Positive film. When shooting Panatomic-X as a positive slide film, expose it at ASA 80 for daylight and ASA 64 for tungsten light. Other photographers who want B&W slides just make black-and-white prints from negatives and then copy them with fine-grain color slide film, like Kodachrome 25. The positive images that result will be black-and-white, of course, and they'll be returned from the film processer in slide mounts ready for projection.

When you want prints instead of slides and are copying photographs and other materials that have different tones, use regular panchromatic films that have very fine grain and high resolving power. However, for copying line drawings, maps, and printed matter like newspapers and books, there is special LINE FILM. It produces high-contrast images in black and white, with virtually no gray tones in between. One example

in 35mm size is Kodak's HIGH CONTRAST COPY 5069 FILM that is available in 36-exposure cassettes and long (50-foot) rolls. This film is rated at ASA 64 with tungsten light.

If the original material being copied has colored lines or printing, or the background is colored (as with blueprints or old, yellowing newspapers), you can use filters over the camera lens to increase contrast so lines and letters stand out from the background. The copy film has very fine grain and high resolution, which means the copy prints will be sharp and in fine detail.

Another special black-and-white 35mm film is Kodak's HIGH-SPEED INFRARED FILM, available in 20-exposure cassettes and long (150-foot) rolls. It is sensitive to infrared radiation, which is invisible to our eyes. To eliminate most wavelengths of light, a red (No. 25 or No. 29) filter is used over the lens. Actual film speeds vary according to shooting conditions, but a starting point (with the red filter) is ASA 50 for daylight and ASA 125 for tungsten light.

This film has a number of applications in medical, scientific, and police work. For instance, some skin diseases become more evident when a person is photographed with infrared film. Also, it can be used to detect forgeries in documents and paintings. For surveillance work, special lamps or flashbulbs that emit invisible infrared rays are used with infrared film to record subjects in the dark without their knowledge.

Black-and-white infrared film holds interest in general photography, too, because it penetrates haze and produces images with unusual results. For example, in landscape photography, sunny skies appear black, and green grass and foliage become snowy white. The film has considerable grain.

Because infrared rays focus on a different plane than light rays, many 35mm camera lenses have a small red line or "R" to one side of the focusing index mark. After focusing on your subject in the normal way, move that point of focus to the red line or "R" mark so the infrared rays will be in focus on the film. When a lens doesn't have an INFRARED FOCUSING MARK, use the smallest lens opening possible for greatest depth of field.

To prevent fogging, High Speed Infrared film must be kept in its sealed film can and loaded in the camera in total darkness. A changing bag is ideal for this purpose (see page 168). After the roll has been exposed, the film must be unloaded from the camera in total darkness, either back into the film can or into a light-tight tank for developing. Before use, B&W infrared film should be stored in a refrigerator at 55°F (13°C) or less.

Since there are so many brands and types of 35mm films available, in both black-and-white and color, be sure to experiment with a number of them to find the ones that please you, and to add some variety and extra interest to your photography.

Knowing all about the controls and special features of your 35mm camera and equipment adds to your creativity as a photographer. Many people have a good "eye" for a photograph, but only those who fully understand their cameras and can operate them with confidence will be able consistently to capture the images they are after.

The best way to become familiar with your camera is by studying the OPERATION MANUAL supplied with the camera. It includes detailed directions and diagrams, as well as the little tips that may mean the difference between satisfaction or disappointment with your pictures. For instance, the instruction booklet for the Olympus OM-2 warns you to be sure the cap covering the motor drive gear is in place to prevent stray light from entering the opening and fogging the film. The instructions for the Nikon FE tells you to cover the viewfinder eyepiece when using the self-timer with the camera on "auto," or incorrect exposures will result. Underline such important notations so they stand out whenever you review the camera's operation manual.

## Loading and Unloading Film

Loading film in a 35mm camera is not difficult, but it must be done carefully or you will foul up the entire roll. The camera back is opened and the film cassette is placed in the film chamber, with the film's emulsion (dull) side facing the camera lens. Being careful not to touch the shutter with your fingers or the film's end, you insert the film leader into the camera's take-up spool. The film advance lever is cocked and the shutter release button is pressed two or three times until the perforations on *both* edges of the film are engaged in the camera's sprockets. There should be enough tension on the film so it lies flat

**Top** To properly load a 35mm camera, first pull out the film rewind crank and put the film cassette in the film chamber. **Upper center** Next, insert the film leader in a notch in the take-up spool. **Lower center** Then cock and fire the shutter to advance the film until the twin sprockets near the take-up spool are engaged in sprocket holes on both edges of the film. **Bottom** Finally, after closing the camera's back, cock and fire the shutter until the film frame counter indicates the film is on frame No. 1. To make certain the film is properly engaged and being advanced, watch that the film rewind crank is turning in the opposite direction of its arrow.

along the focal plane. (If your camera has automatic exposure control, turn it off or to manual, because prolonged exposure times may result when tripping the shutter to advance the film, especially in dim light or when a lens cap blocks the through-the-lens metering system.)

Trouble often occurs when the film is not properly engaged in the take-up spool and both sprockets, or when it is not lying flat when the camera back is closed. The film may slip or jam and will not advance, although you may think everything is okay because the film frame counter moves to the next number whenever you cock the film advance lever. Remember, however, that the counter works whether there is film in the camera or not. (Also, it resets to zero ("0") or start ("S") automatically when the camera back is opened.)

Unless your camera has a special FILM TRANSPORT INDICATOR, make the following check to be sure the film is advancing. First, take up the tension of the film in the cassette by turning the film rewind crank in the direction of its arrow (clockwise); do not press or turn the rewind release button. Then, as you cock the film advance lever, watch that the rewind crank turns in the opposite direction to indicate the film is being drawn from its cassette. You should also make this check when you are unsure whether there is film in the camera or not. If you feel tension when you turn the rewind crank, there is film inside. Some cameras have a special FILM LOAD INDICATOR that tells you when the camera is loaded.

Sometimes photographers forget what type of film is loaded in the camera, or whether it is a 20-, 24-, or 36-exposure roll. Avoid this by inserting the end flap from the film box into the FILM MEMO HOLDER that is attached to the camera's back or can be purchased as a stick-on accessory.

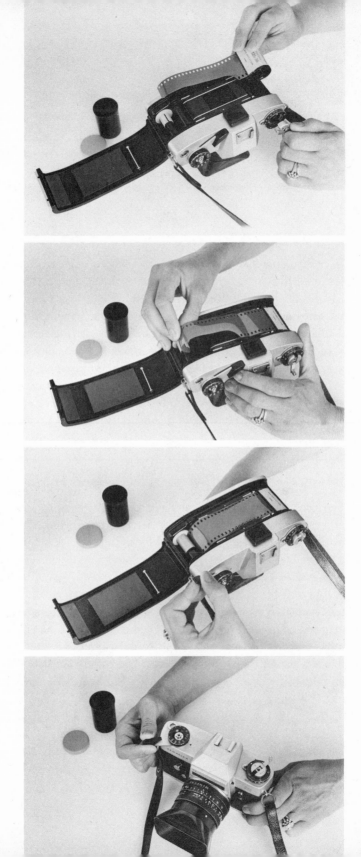

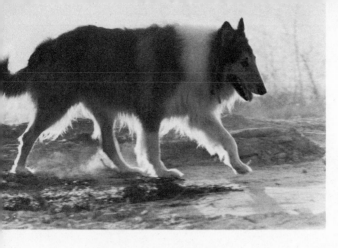

Careful use of your exposure meter is required for back-lighted subjects, or they will become silhouettes.

Also remember that after a roll has been exposed, the film must be rewound into its cassette before you open the camera back, or the film will be fogged. We recommend winding the film *completely* into the cassette until the leader disappears, so you cannot accidentally load the same film into the camera again. Before trying to rewind the film, always be sure to activate the film rewind release button to disengage the take-up spool, or you might damage the film. Also, do not force the film advance lever if you feel resistance near the end of the roll, even when the film frame counter indicates a few exposures remain. Instead, rewind the film before it is accidentally torn from its spool in the cassette.

## Setting the Meter System

Because most 35mm cameras have a built-in exposure meter, you must be certain the film speed dial is set for the ASA of the film you are using. Also note whether the dial locks in the ASA setting securely, or whether it suffers from poor design and is susceptible to accidental changes.

As you become more familiar with a camera and its metering system, you may decide that all your photographs are somewhat under-exposed or overexposed. Instead of spending the time and money for a repairman to make a meter readjustment, you can alter the setting on the film speed dial to compensate. The difference between each ASA number or mark on the dial represents ⅓ f/stop. That means, for example, if you are using ASA 100 film and figure that your pictures are underexposed by ⅓ f/stop, you can reset the film speed dial to ASA

80 to let more light reach the film. For underexposures equivalent to ⅔ f/stop, you'd place the dial at ASA 64, and for a full f/stop, adjust it to ASA 50. Go in the other direction to higher ASA numbers to compensate for overexposures. See page 35 for the full list of ASA numbers found on film speed dials.

Some photographers purposely underexpose color transparency (slide) films by the equivalent of ⅓ f/stop in order to get richer color saturation. For ASA 64 slide films, for instance, they set the exposure meter to ASA 80.

For proper metering, you must also make sure the meter batteries are working. Most camera and hand-held meters have a battery check (except the selenium type). Meter batteries should last one year, unless the meter has been left turned on accidentally for a considerable period of time, or unless the batteries serve double duty as the power source for cameras with automatic exposure controls. Some cameras featuring automatic exposure will not operate at all if the batteries are dead. The camera's instructions will give specific advice about battery life and replacements.

Most cameras have an ON/OFF METER SWITCH, and frequently this is activated when the film advance lever is moved slightly away from the camera body. Cameras with automatic exposure control must be switched to the auto or manual mode; multi-mode models should be set for aperture-priority or shutter-priority (or the programmed exposure mode, when offered).

Look out for the exposure warning signals in the viewfinder that tell you to change the aperture (if a shutter-priority camera) or the shutter speed (if an aperture-priority model) to avoid overexposure or

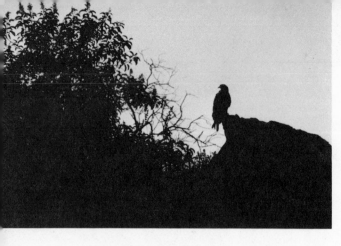

To underexpose the subject and scene to create a silhouette, the automatic exposure camera was aimed mostly at the bright sky for the exposure meter reading, then its auto exposure override button was pressed to hold that reading while the picture was recomposed in the viewfinder.

underexposure. Also study the camera's instructions regarding how and when to use the automatic exposure override and exposure compensator controls.

Remember that a meter can be fooled when the subject is backlighted, or when a large part of the picture area is much lighter or darker than the subject. To get the correct exposure reading, take a close-up reading of the subject so the backlight or light or dark areas will not affect the meter. If you cannot move to the subject to make a reading, temporarily switch to a telephoto or zoom lens that will fill the SLR's viewfinder with the subject so you can make the reading. Or read something close by that is receiving the same illumination and seems to have the same reflectance as the subject. Your opened hand is a convenient substitute for "average" subjects that may be too difficult to read close up, but compensate for the skin's bright reflectance by using one f/stop more exposure than the meter indicates.

Also remember that all pictures should have a center of interest, but composition usually is better when the center of interest is not in the center of the picture. Since most cameras with automatic exposure control have center-weighted meters, you should take a meter reading with the main subject centered in the viewfinder.

When the correct reading of your subject (or substitute subject) is made, lock it in by pressing the AUTOMATIC EXPOSURE OVERRIDE (i.e., MEMORY LOCK) lever or button, then reframe your picture in the viewfinder for the composition desired, and press the shutter release. The reading will be held as long as this memory lock lever or button is pressed.

If the camera does not have an auto exposure override control, or

To cut automatic exposures in half (i.e., reduce them by the equivalent of one f/stop), the exposure compensator on this camera is adjusted to the "1/2" position. Most compensators are marked differently; see your camera's instruction manual.

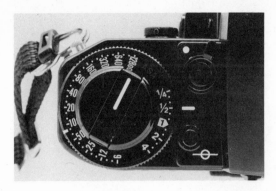

when several automatic exposures are going to be made of subjects that are off-center, backlighted, or surrounded by very light or very dark areas, it is more convenient to use the EXPOSURE COMPENSATOR. Take a reading of the subject in one of the ways previously described, then note the shutter speed and/or aperture indicated in the viewfinder readout. Recompose the picture as you want it, and turn the exposure compensator dial until the *same* shutter speed and/or aperture appears in the viewfinder. This will give you the correct exposure for that particular situation. Don't forget to readjust the dial to its *normal* position afterward so subsequent exposures will not be affected.

Alternatively, you can switch from the auto to manual exposure mode to make readings when subjects are backlighted or when large areas of the picture are lighter or darker than the subject.

Also, remember that you can use the exposure compensator when you want to make automatic exposures that purposely overexpose or underexpose by one-half f-stop or up to one, two, or three f/stops.

## Using Exposure Controls for Various Effects

Besides knowing the different ways to use the camera's exposure meter, be sure you understand the two controls that actually determine exposure: shutter speed and lens aperture. Despite the fact that your 35mm camera takes "still" pictures, some of the most effective photographs portray motion, which is made possible by the choice of shutter speed and the photographer's technique.

For example, fast shutter speeds, like 1/500 and 1/1000 second, make it possible to get STOP ACTION pictures with dramatic results. It

Fast shutter speeds stop the
action and give extra impact
to many different subjects.

is a simple way to "freeze" fast moving subjects, like racing horses or
kids jumping off a diving board, so viewers of your photographs can
study the subjects in detail.

Even when you are forced to use a slower shutter speed, because of
low light conditions or the slow speed of the film you are using, you
can stop the action of some subjects by shooting at the moment of
PEAK ACTION. When a dog jumps up to catch a Frisbee, the instant he
reaches the top point of his jump is the moment to press the shutter
release. You can capture him at the very second his action stops mo-
mentarily, so he will be portrayed in detail, too.

And don't forget that using an electronic flash is an excellent way
to stop action, because the flash duration is as brief as 1/1000 to
1/50,000 second. It works well for moving subjects in dim light, like
children playing indoors, and even for close-ups in daylight, like bees
buzzing around flowers.

Your pictures also can be eye-catching when you slow down the
shutter speed so the moving subject will show BLURRED ACTION. For
example, a river or waterfall often has more impact when the water
appears as soft streaks rather than in crisp detail. Race cars and other
speeding subjects make colorful abstract images when shot at slow
speeds. Remember, when your film speed is too fast or the light is too
bright to allow slow shutter speeds, you can place neutral density filters
over the lens to reduce the light and make it possible to use a slower
shutter speed.

Another way to create the feeling of motion in your pictures, even
with subjects that are not moving, is to use a slow shutter speed and to
change the focal length of a zoom lens during the exposure. Elongated
lines radiate from the subject in the center of your picture in a streak-

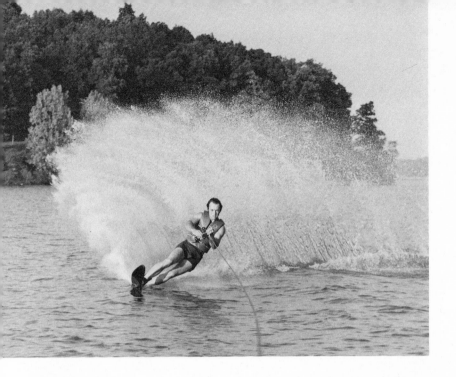

This high-jumping dolphin was caught at the peak of action. (You can tell the shutter speed wasn't especially fast because the drops of water are blurred.)

A slow shutter speed (while the camera was held steady by a tripod) produced an effective blurred motion in the waterfall.

Panning conveys the feeling of motion in your pictures while portraying the main subject in stop action detail.

ing pattern that has considerable impact. Results depend on the extent of the ZOOMING ACTION while the shutter is open (see examples on pages 94 and 95).

A favorite and effective method for showing movement in photographs is called PANNING. This means you move the camera while following the action in your viewfinder, and press the shutter release while the camera is in motion. The effect is to portray the moving subject in sharp detail against a blurred background. That's because your camera is keeping pace with the moving subject and the background is stationary.

The shutter speed must be slow enough that it does not cancel the effect of your moving camera and capture the background in detail, too. Otherwise it becomes a stop action picture. Also be certain you don't stop moving your camera momentarily when you press the shutter release, or the panning effect will be lost. Train yourself by continuing to follow the subject after you shoot.

The shutter speed you choose for panning depends on several factors, including the speed of your subject, the distance the subject is from the camera, and the direction of the subject in relation to the camera. Slow moving subjects some distance away require very slow shutter speeds, or stop action pictures will be the result. Nearby fast moving subjects, traveling parallel to the film plane when you press the shutter release, can be panned at faster shutter speeds. Our advice is to experiment with the same subject at various shutter speeds and then study the pictures to see which speed gives the effect you like best. For a different effect, try panning and zooming at the same time.

Another thing to consider when panning is your stance. Place your feet slightly apart so you can easily follow the action by pivoting your

**Top**  Photographers must anticipate the action. These boys were playing in the ocean surf on a large styrofoam float.  **Bottom** They didn't notice a big wave was coming, but the photographer did.

Perfect timing—the shutter was released just as both flamingos were taking a step. If all feet had been on the ground, the photo would be rather static.

body and not moving your feet. Also, remember that at very slow shutter speeds with a single lens reflex camera, the viewfinder will go dark when the mirror flips up while the exposure is made, and it may be difficult to keep the moving subject properly framed unless you practice. Always set the exposure and focus before panning.

Of major importance is the moment you choose to press the shutter release while panning. Too often the subject has sped past before you react, and the result is a rear-end shot. A good time to shoot is when the subject is traveling almost perpendicular to the direction your lens is pointed.

With any photograph you take, TIMING is one of the most important factors. Pressing the shutter release a second too soon or too late can make the difference between a great or a so-so photograph. Even the time of day should be considered, particularly with color films. Anticipate what your subject is going to do, or what the light will be like, and then be ready to shoot when the moment is best.

Don't think that making continuous exposures with a motor drive or auto winder avoids the concern for timing. All too often the best picture occurs between frames as the film is automatically advancing. Even most pros use their motor drives in the single exposure mode, and their experience helps them react at the best moments to press the shutter release.

Photographers must train themselves in the matter of timing, and this means studying your subjects as well as the light. Look for expressions and action, unless you want images that are static. Ask yourself what impact the light has on the subject. Is the subject better suited for a sunny day with high-contrast lighting, or for an overcast day with light that gives a softer mood? Photographers who envision what the

The difference a second makes. **Left** At one moment this monkey looks cute enough to cuddle. **Right** The next instant he appears mean enough to attack.

photograph should look like before they take it have better results and fewer disappointments than those who just point their cameras and shoot.

Besides shutter speed, the other camera control that determines exposure and relates to the photographer's technique is the lens aperture. Many times you just want to portray the subject as you see it, and use the "average" exposure indicated by the exposure meter. In some situations, however, overexposing or underexposing is done purposely to change the mood of the subject or scene. With color slide (reversal) films, underexposure gives deeper saturation to the colors and contributes to a more somber mood, while overexposure lightens the colors to more pastel shades and gives a brighter feeling to the photograph. Negative films, of course, respond the opposite way.

When you are unsure of the correct exposure, or if the picture might be improved by deliberate over- or underexposure, you should take several varied exposures of the same subject. Such BRACKETING means you usually shoot at the supposedly correct exposure, then deliberately take two or four more exposures that over- and underexpose by half-stops and/or full f/stops. Do this by changing the lens opening while keeping the same shutter speed, or vice versa. For cameras with automatic exposure control, bracket by adjusting the exposure compensator dial (see page 33).

Also, remember that the lens aperture you choose contributes to another important aspect of your photograph, depth of field. The wider the f/stop used, the less picture area that will be in focus, and vice versa. Other factors affect depth of field, too: the focal length of the lens being used and the distance at which the lens is focused.

To be sure of getting some detail in the white swan's feathers, exposure was bracketed (i.e., several shots were taken, each with a different f/stop).

## Focusing and Viewing Methods

Focusing should become second nature to you, and your camera's operation manual may have special advice for the type of focusing system, screen, or aids incorporated in the viewfinder. After focusing and setting the f/stop for an exposure, learn to check the depth of field scale on the lens to see how much of your picture area will be in sharp focus (or activate the depth of field preview lever or button on a SLR camera to check the depth of field visually). If the depth of field is too shallow or too great for your purposes, you can adjust the point of focus on the lens and/or the f/stop to increase or decrease depth of field. (When the f/stop is changed, don't forget to make the compensation for exposure by changing the shutter speed too.) By selective focusing and careful choice of f/stop, you determine what will be in sharp focus in the picture, thus directing people to what you want them to notice most in your photograph. For the sharpest images, always be sure your lenses are clean.

Also pay attention to your viewfinder and how to use it properly. This is especially important for photographers who shoot and project color slides, because whatever is recorded on the film will be seen on the screen. Color and black-and-white negatives can be cropped during the printing process to eliminate undesired portions of the image, but it is always better to fill the film frame only with what you want to appear in the final photograph. Our advice is to crop with the camera and compose the picture carefully in the viewfinder. Most camera manuals advise you exactly how much of the actual film coverage is shown in the viewfinder; usually it is slightly less than 100 percent.

Occupied with the action of his subjects, the photographer forgot to focus carefully. The result, a very poor picture.

This is of little concern, even for color slide photographers, because a fraction of the image's edges are covered by the slide mount.

Of greater concern is that your eye is close to the viewfinder's eyepiece so you see everything inside without moving your head or the camera around. Also, light that enters through any gap between your eye and the eyepiece can diminish the brightness of the image you see in the viewfinder. Stray light in the viewfinder can adversely affect automatic exposures in some camera models too, so make sure you are using your camera's viewfinder properly.

## Holding the Camera

It is worthwhile to practice holding your camera. Your goal is to keep it rock steady during the exposure. Also, be sure the way you hold the camera makes it convenient to adjust the exposure controls. Since inadvertent camera movement is responsible for so many ruined pictures, try several grips on the camera until you find the best way to hold it steady. Usually one hand braces the lens while the other holds onto the camera body.

Do not rest the camera so it pivots on your nose, but press it against one side of your nose and your cheek for support, and position it so your eye is centered in the viewfinder's eyepiece. Hold your arms in, not out; tuck them against your chest for more support. For a long exposure, exhale before pressing the shutter release. Also be sure you are standing with your feet slightly apart and one in front of the other so your body has better balance.

Practice holding the camera when different lenses are mounted;

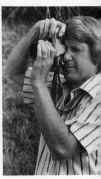

**Left** Practice holding your camera with a strong, steady grip in both horizontal and vertical positions. **Center and right** In the vertical position, see if your camera is more comfortable to operate when it is held with the shutter release at the bottom or at the top.

steadiness is especially critical with long focal length lenses. Also be sure you can conveniently switch the camera from a horizontal format to a vertical position. One of the benefits of a 35mm camera is that it produces rectangular rather than square images, so you can select the format, horizontal or vertical, that is most appropriate for your subject.

Make certain your camera is gripped so your index finger is free to press the shutter release with a slow and smooth motion. Jabbing at the release with your finger contributes to camera movement and blurred images. Practice this simple but important part of taking a picture so your results won't be disappointing. When the camera is on a tripod or other support, use the built-in self-timer or an accessory cable release to trip the shutter release so you won't be touching and unintentionally moving the camera when the exposure is made.

In regard to holding and supporting the camera, remember that the best point of view of a subject is not necessarily at the photographer's eye level, and you should always consider shooting from a higher or a lower angle. Closer to the ground, you can kneel on one knee and brace your upper arm on the other knee, or you can lie on your stomach and use both of your elbows on the ground for support. At low or high positions, try leaning against a solid support, like a wall or tree, to improve your steadiness, or you can press the camera against a solid support while making the exposure. To avoid blurred images because of camera movement, many photographers generally shoot at 1/125 or 1/250 second. With practice, you may be able to hold the camera steady at speeds as slow at 1/15 second, except with telephoto lenses. Make some test shots so you know the shutter speed limits when hand-holding your camera.

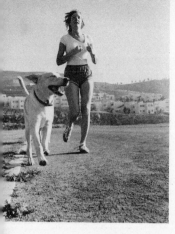

Some pictures are more effective when they are taken from a low angle (as here) or a high angle, instead of the photographer's usual eye level.

## Changing Lenses

A camera's instruction booklet describes the best method for mounting and unmounting lenses, which can be done at any time, whether there is film in the camera or not. Usually, index marks on the lens and on the camera's lens mounting ring are matched before the lens is inserted and twisted to lock into position. Never force or randomly turn a lens in the camera mount trying to make it fit, because damage to the mounting flanges and automatic aperture couplings could result. Some lenses, like those for the older Nikon cameras, require another adjustment after mounting in order to correctly couple the camera's exposure meter with the aperture control ring.

Practice changing lenses so you can do it quickly and safely. Many times lenses must be switched very rapidly if you want to capture some fleeting subject, but take care not to let any foreign matter, like dust or rain, fall into the open lens or camera while you are making the change. Don't let the lens you have just removed get dusty or scratched by depositing it carelessly in your gadget bag. Never be in such a hurry that you might accidentally drop a lens. For safer lens changing, use a neck strap with your camera so both hands will be free to hold the lenses.

## Using Flash and Studio Lights

Chapter 5 was devoted to a discussion of flash. Review it, as well as the camera's operation manual and the flash unit's instruction booklet, so you understand the technical aspects of connecting the flash to the camera and making the correct adjustments for manual or automatic

**Left**   This meditating lady was photographed by the natural light coming **through a** window at the left.     **Bottom**   Harsh sidelight made these gorillas look meaner than they really are.     **Right**   Diffused sunlight on an overcast day produced this pleasant portrait outside in a doorway. The absence of direct shadows enhances the girl's soft features.

exposure use. Always be certain the camera's shutter speed is set correctly for flash synchronization, that the batteries are fresh or recharged, and that the camera or flash unit's ready light signals that the flash unit is fully recycled and ready to shoot. When using the unit's automatic exposure mode, know its minimum-maximum operating range so your subjects will not be over- or underexposed. Remember to turn the flash unit off after a shooting session to prevent drain on the batteries.

Since the word *photography* means drawing, painting, or writing with light, you should be aware of the words photographers use to describe different types of lighting, and the effects created by such lighting. Light that the photographer does not control, whether daylight or artificial light indoors, is described as AVAILABLE, EXISTING, or NATURAL LIGHT. Direct sunlight and spotlights produce what is frequently referred to as HARSH, HARD, or HIGH-CONTRAST LIGHT. Sunlight on overcast days or in the shade, as well as floodlights and bounce light, give illumination described as SOFT, DIFFUSED, or OVERALL LIGHT.

Depending on the direction of the light in relation to the subject, photographers say it is FRONT, SIDE, BACK, or TOP LIGHT. When light is directed at both sides of the subject, it is called CROSS LIGHT. Front light comes from the camera's direction and creates few if any shadows to give depth to a subject, so it is often termed FLAT LIGHTING.

Light that is added to reduce shadows or to illuminate a dark area is FILL-IN LIGHT, and in outdoor shooting situations, an electronic flash is frequently used for those fill-in purposes. Instead of pointing a light directly at the subject, it can be reflected off a white or very light surface, such as a wall, ceiling, piece of cardboard, or a photographic umbrella reflector. This is called BOUNCE LIGHT and it gives softer

The direction of the light profoundly affects the image you record on film. In these close-up comparison shots of macramé, front light provided the illumination in the first photograph, and backlight in the other.

Portable floodlights were used to fill in the existing light (daylight and tungsten bulbs) in this fashion boutique for an advertising photograph.

As a guideline for effective composition, place your center of interest (i.e., main subject) according to the "rule of thirds" (see text).

Leading lines help direct the viewer's attention to your subject.

overall illumination to a subject. Electronic flash is frequently aimed to produce bounce light to avoid the harsh lighting effect that flash gives when pointed directly at a subject.

In studio work, photographers talk about FLOOD, SPOT, and UM-BRELLA REFLECTOR LIGHTS, and these light sources can be electronic flash tubes or tungsten bulbs. Several lights may be arranged to illumi-nate a subject, and the chief one is described as the KEY, MAIN, or MODELING LIGHT. Others are used as ACCENT and BACKGROUND LIGHTS, and fill-in lights.

To become more familiar with lighting and its effects, set up a stationary three-dimensional object as your subject, place the camera on a tripod, and take a series of pictures while aiming one light from different directions: front, side, back, and top. Try this with a flood-light and also with a spotlight. Then use a second light in various ways, as a fill-in, accent, and background light. The more you understand and know how to control lighting, the better your photographs will be.

## Considering Photographic Composition

There have long been "rules" for photographic composition, although more recently—as photography strives to be recognized and accepted as art—such guidelines often are ridiculed. Photographic "artists" insist that their images are very personal expressions, not bound by conventional ideas of what is pictorially pleasing. Those photographers seem to be challenging viewers to discover the subject and meaning of their photographic images.

However, the majority of photographs taken these days still strive

to portray subjects clearly and realistically. Knowledge of the basic elements of composition will help photographers achieve those goals.

Some photographers seem to have an innate sense or feeling for composing pictures, while others require some time and practice to develop an eye for composition. Regardless, it's important to keep in mind that every picture should have a CENTER OF INTEREST. The main subject should be obvious to the viewer, not something he has to search for in your picture.

Surprisingly, perhaps, composition is generally more effective when the center of interest is not in the middle of the picture but is placed according to the "RULE OF THIRDS." When framing your main subject in the viewfinder, imagine the picture area divided horizontally and vertically in thirds, then locate the subject along any one of those imaginary lines or at a point where they intersect.

If your subject is facing left, or moving in that direction, place it on the right-hand side of your frame. Subjects moving or facing right should be located in the left-hand portion of the picture. When shooting scenics, place the horizon in the lower third of the frame if you are emphasizing the sky, or in the upper third of the picture when the sky is not the most important part of the scene.

Always remember to compose the picture so that any horizon appears straight, not tilted. Otherwise the world will seem cockeyed to your viewers.

You should consider LEADING LINES, like a road or fence or anything else in the picture area that will direct the viewer's eyes to the main subject. (Beware of lines that do exactly the opposite, directing the viewer away from the subject and out of the picture.)

Close-up images have strong impact, as shown by these farmer's hands and a zebra's stripes.

Foreground objects often aid in the composition of pictures. In these examples, a sailboat is framed by ropes on another vessel, and newlyweds are framed by palm tree branches in Hawaii.

The format you choose—vertical or horizontal—should be appropriate for the position and direction of your subject.

By including a person in this picture, the photographer helps indicate the size of a Joshua tree in the Mojave desert.

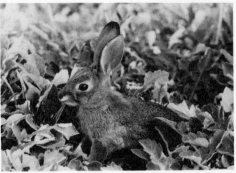

Be sure to FILL THE FILM FRAME with your subject. Close-up composition produces pictures with strong impact and fine detail and also provides opportunities to create abstract images.

Sometimes composition improves when you include an object in the foreground that will FRAME THE SUBJECT at the top, side, or all around in order to direct the viewer's attention toward your center of interest. Tree branches are most commonly used as a natural frame, as well as a way to obliterate uninteresting sky.

Always look out for DISTRACTING BACKGROUNDS OR FOREGROUNDS, and recompose your picture to avoid them. When looking through your viewfinder, study what is in front and in back of your main subject to see if it might distract your viewer.

With SLR cameras, remember that you usually view through the lens with its aperture wide open, which means little depth of field will be evident. However, when the picture is taken, the aperture may close down (depending on the f/stop selected) and bring more of the foreground and background that you see in the viewfinder into focus.

When shooting scenics, include familiar objects so viewers will be able to comprehend the size of your subject. Examples of such SIZE INDICATORS are people, cars, and buildings.

Also remember to VARY THE FORMAT of your pictures by turning your 35mm camera horizontally or vertically to achieve the most effective composition for the particular subject. Compose the subject both ways in your viewfinder to see which format offers the most impact. Tall, vertical subjects frequently are more dramatic when framed diagonally.

The same subject can be photographed in many ways, and you should try various techniques when composing your pictures. A simple

Photographers should try different approaches to photographing the same object. The Lone Cypress at Pebble Beach on the California coast was shot vertically and horizontally from a variety of angles with lenses of various focal lengths.

Remember, the more enthusiasm you have for photography, the better your end results.

but effective technique is to CHANGE THE CAMERA ANGLE to get higher, lower, closer, or farther away. You also can SWITCH LENSES for different effects or ADJUST THE POINT OF FOCUS OR F/STOP or both to alter depth of field.

Many factors affect the impact your picture will have on the viewer. Composition should be considered carefully, whether you follow the "rules" or use your imagination to create eye-catching photographs.

### Storing Your Camera

Many people like photography, but other activities prevent them from using their cameras as frequently as they wish. If you are unfortunately too busy to take photographs regularly, make sure your camera and equipment are stored carefully in a cool, dry place. Be certain exposure meter batteries and flash batteries are turned off; for long term storage, remove the batteries altogether. (Whenever batteries are reinserted, first wipe their contacts with a dry cloth.) Also, don't leave film in the camera if it is to be stored for a considerable time. Most camera manufacturers recommend that the shutter and self-timer not be cocked while the camera is stored, so those mechanisms will not be under tension.

Of course, you'll enjoy photography more, and become a better photographer, if you keep your camera at hand and use it often. Make your 35mm camera your constant companion, and keep taking pictures.

# Address List of
# 35mm Camera and
# Equipment Manufacturers
# and Distributors

Before investing in any 35mm camera or equipment, it is worth comparing the various brands and features. A good way to do this, besides personally handling the equipment, is to study the descriptive literature for specific camera models, lenses, and accessories. If your camera store cannot provide such information, write to the manufacturers and distributors to request brochures. Also, if your current camera's operation manual has been misplaced, order another one.

The addresses that follow are for U.S. manufacturers and/or distributors of 35mm cameras and related equipment, as indicated by brand name. Some distributors handle several brands and types of equipment, as you'll note.

## Cameras

| | |
|---|---|
| ALPA | T.A.G. Photographic, Inc., 800 Shames Dr., Westbury, Long Island, NY 11590 |
| CANON | Canon USA, Inc., 123 Paularino Ave. East, Costa Mesa, CA 92626 |
| CHINON | Chinon Corporation of America, 43 Fadem Rd., Springfield, NJ 07081 |
| CONTAX | *See* YASHICA camera. |
| EXAKTA | Exakta Camera Co., 705 Bronx River Rd., Bronxville, NY 10708 |
| FUJICA | Fuji Photo Film USA, Inc., 350 Fifth Ave., New York, NY 10001; also FUJI film. |
| KONICA | Konica Camera Co., P.O. Box 1102, Woodside, NY 11377 |
| LEICA | E. Leitz, Inc., Link Dr., Rockleigh, NJ 07647; also MINOX cameras. |

| MAMIYA | Bell & Howell/Mamiya Co., 7100 McCormick Rd., Chicago, IL 60645 |
| MINOLTA | Minolta Corp., 101 Williams Dr., Ramsey, NJ 07446 |
| MIRANDA | AIC Photo, Inc., 168 Glen Cove Rd., Carle Place, NY 11355; also SOLIGOR lenses and filters. |
| NIKON | Nikon, Inc., 623 Stewart Ave., Garden City, NY 11530 |
| OLYMPUS | Olympus Camera Corp., Crossways Park West, Woodbury, NY 11797 |
| PENTAX | Pentax Corp., 9 Inverness Dr. East, Englewood, CO 80110 |
| PETRI | PAC, Photo Corporation of America, 7491-93 N.W. 8th St., Miami, FL 33126; also TOPCON cameras. |
| PRAKTICA | Hanimex, Inc., 1801 Touhy Ave., Elk Grove, IL 60007 |
| RICOH | Braun North America, 55 Cambridge Parkway, Cambridge, MA 02142; also BRAUN electronic flash. |
| ROLLEI | Rollei of America, Inc., P.O. Box 1010, Littleton, CO 80160; also VOIGTLANDER cameras; STROBONAR electronic flash. |
| TOPCON | PAC, Photo Corporation of America; see PETRI camera. |
| VIVITAR | Vivitar Corp., 1630 Stewart St., Santa Monica, CA 90406; also VIVITAR lenses, filters, electronic flash, tripods, and other accessories. |
| VOIGTLANDER | See ROLLEI camera. |
| YASHICA | Yashica, Inc., 411 Sette Dr., Paramus, NJ 07652; also CONTAX cameras. |

## Lenses

| SAMIGON | Argraph Corp., 111 Asia Place, Carlstadt, NJ 07072 |
| SIGMA | EPOI, Crossways Park West, Woodbury, NY 11797 |
| SOLIGOR | AIC Photo, Inc.; see MIRANDA camera. |

| TAMARON | Berkey Marketing Co., Inc., 25-20 Brooklyn-Queens Expressway West, Woodbury, NY 11377 |
| VIVITAR | *See* VIVITAR camera. |

## Filters

| HOYA | Uniphot-Levit Corp., 61-10 34th Ave., Woodside, NY 11377 |
| KODAK | Eastman Kodak Co., 343 State St., Rochester, NY 14650 |
| SOLIGOR | AIC Photo, Inc.; *see* MIRANDA camera. |
| TIFFEN | Tiffen Optical Co., 71 Jane St., Roslyn Heights, NY 11577 |
| VIVITAR | *See* VIVITAR camera. |

## Exposure Meters

| GOSSEN | Berkey Marketing Co.; *see* TAMARON lenses. |
| SEKONIC | Copal Corp. of America, 58-25 Queens Blvd., Woodside, NY 11377 |
| SPECTRA | EPOI; *see* SIGMA lenses. |
| VIVITAR | *See* VIVITAR camera. |

## Electronic Flash

| BRAUN | *See* RICOH camera. |
| HANIMEX | *See* PRAKTICA camera. |
| METZ | EPOI; *see* SIGMA lenses. |
| STROBONAR | *See* ROLLEI camera. |
| SUNPAK | Berkey Marketing Co.; *see* TAMARON lenses. |
| VIVITAR | *See* VIVITAR camera. |

## Tripods

GITZO      Karl Heitz, Inc., 979 Third Ave., New York, NY 10022
SLIK      Berkey Marketing Co.; *see* TAMARON lenses.
VIVITAR      *See* VIVITAR camera.

## Film

AGFA      Braun North America; *see* RICOH camera.
FUJI      Fuji Photo Film USA; *see* FUJICA camera.
ILFORD      Ilford, Inc., West 70 Century Rd., Paramus, NJ 07652
KODAK      Eastman Kodak Co.; *see* KODAK filters.
3M      3M Co., 3M Center, St. Paul, MN 55101